D0899122

Monatshefte Occasional Volume 11

Monatshefte Occasional Volumes

Series Editor
Reinhold Grimm
(University of California, Riverside)

Walter F. W. Lohnes and Valters Nollendorfs, editors
German Studies in the United States: Assessment and Outlook

Reinhold Grimm, Peter Spycher, and Richard A. Zipser, editors
From Dada and Kafka to Brecht and Beyond

Volker Dürr, Kathy Harms, and Peter Hayes, editors
Imperial Germany

Reinhold Grimm and Jost Hermand, editors
Blacks and German Culture

Reinhold Grimm and Jost Hermand, editors
Our Faust? *Roots and Ramifications of a Modern German Myth*

Volker Dürr, Reinhold Grimm, and Kathy Harms, editors
Nietzsche: Literature and Values

David P. Benseler, Walter F. W. Lohnes, and Valters Nollendorfs, editors
Teaching German in America: Prolegomena to a History

Reinhold Grimm and Jost Hermand, editors
From Ode to Anthem: Problems of Lyric Poetry

Reinhold Grimm and Jost Hermand, editors
From the Greeks to the Greens: Images of the Simple Life

Kathy Harms, Lutz R. Reuter, and Volker Dürr, editors
Coping with the Past: Germany and Austria After 1945

Reinhold Grimm and Jost Hermand, editors
Laughter Unlimited: Essays on Humor, Satire, and the Comic

Laughter Unlimited

Essays on Humor, Satire, and the Comic

Edited by

Reinhold Grimm

and

Jost Hermand

Published for *Monatshefte*
The University of Wisconsin Press

The University of Wisconsin Press
114 North Murray Street
Madison, Wisconsin 53715

3 Henrietta Street
London WC2E 8LU, England

Library of Congress Cataloging-in-Publication Data
Laughter unlimited: essays on humor, satire, and the comic / edited
 by Reinhold Grimm and Jost Hermand.
 144 pp. cm. — (Monatshefte occasional volume; 11)
 Rev. and/or enl. papers from the nineteenth Wisconsin Workshop
 organized by the Dept. of German, University of Wisconsin–Madison
 and held Sept. 16–17, 1988.
 Includes bibliographical references.
 1. Arts, German. 2. German wit and humor. 3. Satire, German—
 History and criticism. I. Grimm, Reinhold. II. Hermand, Jost.
 III. Wisconsin Workshop (19th: 1988 Madison, Wis.) IV. University
 of Wisconsin–Madison. Dept. of German. V. Series: Monatshefte
 occasional volumes; no. 11.
 NX 550.A1L38 1991
 837.009—dc20 90-50645
 ISBN 0-299-97073-6 CIP

Contents

Preface vii

Klaus L. Berghahn
*Comedy without Laughter: Jewish Characters in Comedies
from Shylock to Nathan* 3

Burghard Dedner
*Satire Prohibited: Laughter, Satire, and Irony
in Thomas Mann's Œuvre* 27

Egon Schwarz
Thalia in Austria 41

Friedemann Weidauer, Alan Lareau, and Helen Morris-Keitel
*The Politics of Laughter: Problems of Humor and Satire
in the FRG Today* 56

Christopher J. Wickham
*Doolsummsä and Berchbläidl: Laughter and Fitzgerald Kusz's
Democratization of Poetry through Dialect* 79

Irving Saposnik
*The Yiddish Are Coming! The Yiddish Are Coming!
Some Thoughts on Yiddish Comedy* 99

Steven Paul Scher
"Tutto nel mondo è burla": Humor in Music? 106

Preface

It should be clear from the very beginning that the title of the present volume is not meant to indicate boundless, boisterous laughter. Our times are hardly fit to evoke unlimited laughter in that sense. Rather, as even a fleeting glance at the table of contents will at once substantiate, what is meant here by "Laughter Unlimited" is the well-known if rarely investigated or documented fact that the boundaries of the comic in its manifold manifestations are not only constantly shifting but, as it were, wide open as well. Hence, the contributions assembled in this volume are devoted, for the most part, to a variety of borderline cases— *Grenzsituationen* and *Grenzphänomene* of sorts—both of the comic at large and of its related genres, or subgenres, of humor, satire, irony, and so on. They examine, for instance, the typical laughter *at* the Other as well as *of* the Other, treating Jewish characters in comedy and Yiddish comedy, respectively; or they deal with forms of art (such as music) and literature (such as dialect poetry) where laughter has been said to be especially elusive, or simply to be plain and uncomplicated, indeed trivial. Other contributions concentrate on the changing modes of the comic either in the work of a single author (e.g., Thomas Mann) or within a given period or geographical area and cultural tradition (e.g., Austria). Together, they ought to offer a variety of pertinent approaches and novel results.

All of these essays were first read and discussed as papers during the Nineteenth Wisconsin Workshop, organized by the Department of German at the University of Wisconsin–Madison and held on September 16 and 17, 1988. Most of the papers—by Klaus L. Berghahn (UW-Madison), Burghard Dedner (Universität Marburg, FRG), Irving Saposnik (UW-Madison and Hillel Foundation, Madison), Steven Paul Scher (Dartmouth College), Egon Schwarz (Washington University), Christopher J. Wickham (University of Illinois at Chicago), and a Student Collective (UW-Madison)—have been revised and/or enlarged considerably for publication. Only one contribution is missing from our collection: namely, that of Karen Jankowsky (UW-Madison). Since in large measure, she had to rely on the showing of films in order to make her point, her presentation, entitled "Does the Revolution of the Body Have a Sense of Humor?" (on "Ausdruckstanz" and "Tanztheater"), unfortunately could not be documented.

As in previous years, the organizers of this workshop and editors of its proceedings have received generous support from various sources. Of course, their most heartfelt thanks, as always, are owed to the Vilas Fund of the University of Wisconsin.

Laughter Unlimited

Comedy without Laughter:
Jewish Characters in Comedies
from Shylock to Nathan

KLAUS L. BERGHAHN

For George Mosse

"Just listen, if you want to play a real trick, let's tell the Jew someone has designs
on his money. That should provide us with a matchless comedy."

Lenz, *Die Soldaten*, II, 2

When the German playwright J. M. R. Lenz wrote this short scene in 1776 and
the obscene one following it, it was no longer a laughing matter. The age-old
comic device of making the Jew the laughingstock of comedy had lost its sting,
if not yet for the audience, certainly for the dramatist. For this prank of the bored
officers is just one more episode to demonstrate how these "soldiers" kill time
in a garrison where they have nothing better to do than drink, seduce women,
or play practical jokes on a poor old Jew. The palimpsest underlying this scene
is Shakespeare's Shylock, the outcast of Venice. For the cheerful gentlemen of
Venice, as for the cruel officers of Lille, the Jew is nothing but a source of money
and an object to tease and to scorn. Whereas the Jew in Shakespeare's comedy
is presented as an exemplum of the baseness of his people, who is laughed at
and banished from polite society, the old Jew in Lenz's *Soldaten* is clearly
presented as a victim with whom the audience has pity, or should have pity. Both
plays are comedies in which a Jew is held up for ridicule; what the audience of
Shakespeare's time, however, considered "merry sport," the bourgeois *parterre*
of the 18th century could only see as a cruel joke which evoked sympathy for
the victim. This paradigmatic shift in comedy—where the Jew changes from a
comical stereotype to a tragic character—became dramatically clear forty years
later on the English stage, when Edmund Kean played Shylock at Drury Lane
Theatre in London. He no longer presented Shylock as "the very devil incar-
nal," as Shakespeare put it (II, 2), but as a suffering human being and the victim
turned avenger. This performance of 1814 changed the reception of *The Mer-
chant of Venice* so drastically that the tragedy of Shylock overshadows the merry
ending of the romance in Belmont.

What these two episodes demonstrate is the simple fact that the understanding
of comedy is a function of its reception. The effect of comedy—laughter—depends

on what a given society and/or its audience consider comical. The phallic jokes of Aristophanes, for instance, did not fit well the moralistic taste of a bourgeois audience. Comedy, more than tragedy, seems to be bound to the mores and societal norms of the time which it satirizes. What is humorous or comical in a certain societal context is not perceived as such in another. The predisposition of society strongly influences what the audience considers comical. Shakespeare's *Merchant of Venice* is a case in point.

But a comedy without laughter seems to be an odd proposition. A major change in taste and sensibility must have occurred when old comedies lose their satirical power and laughter is silenced; or when in new comedies since the middle of the 18th century the laughter of derision is muffled. In the case of German comedy, critics even speak of "serious comedy," in which grave conflicts that could also have a tragic ending find happy resolution.[1] The bourgeois playwrights of the 18th century were no longer satisfied with the trivialized notion that comedy imitates "characters of a lower type" or debased types who are laughed at. It was no longer self-evident that the effect of comedy had to be the production of laughter at the expense of "lower" people. Instead, playwrights like Diderot and Lessing focused the attention of the audience on the contradictions and potential conflicts within bourgeois society, thus teaching them to laugh about themselves. What was lost when the guffaws about fools, outsiders, and pedants were suspended was gained in the recognition of the comical incongruities of society itself. The theory of comedy, which had been occupied with the definition of a comical character and of plot structure for so long, discovered the critical intention and utopian function of comedy. The school of laughter became an institution of criticism and as such an important (and serious) tool of the Enlightenment. It is this shift in the theory of comedy which will be discussed and subsequently exemplified in comedies where a Jew is one of the central characters.

I

The theory of comedy is no laughing matter. This oft repeated pun of literary criticism is an expression of frustration on the part of theorists to come to terms with the aesthetic difference between the simple expectation of laughter in comedy and its philosophical explanation, which seems to be anything but simple. What is so specific about comic laughter and how does it differ from laughter in everyday life? What are the differences between the ridiculous and the comical, and how are they intertwined? The approaches to these questions differ greatly between literary theory and philosophy or psychology. Whereas the theories of laughter—a modern phenomenon in philosophy and psychology—offer broad explanations of laughter in life and use comic literature as examples to illustrate their theses, literary critics concentrate on the theory of the comic genre. These theories have influenced each other, and though the literary critics have eagerly adopted philosophical and psychological interpretations of laughter to explain the

effect of comedy in more general terms, the crux of the matter still rests upon the question of how comedy imitates life and how comic laughter affects the audience. Etienne Souriau cut this Gordian knot by offering the bold solution that the ridiculous belongs to life, whereas the comical is an expression of art.[2] Laughter is part of our daily experience, and there are innumerable incidents that can produce laughter, among them also comedy; but comedy produces laughter in an artificially constructed environment. There, laughter becomes an aesthetic experience. The crude, malicious laughter of life is neutralized, filtered, and cultivated by the structure of comedy so that it becomes an aesthetic pleasure. The fictitious situations of the play on stage and the distance of the theatrical performance break the aggressive spell of laughter and the audience laughs without hurting anyone. Without going further into the details of this differentiation between laughter in life and in art, it should be clear that comic laughter must first be analyzed within the artistic structure of the genre before anthropological, psychological, or social explanations can be used to generalize about the aims or effects of laughter.

The effect of comedy on the audience has been so self-evident that for a long time it was not considered worthwhile to theorize about laughter. Aristotle's *Poetics,* usually the starting point for any theory of drama, says almost nothing about comedy, and few of the things that are mentioned have anything to do with laughter. Although there has been speculation that Aristotle's notion of catharsis might also be applied to the comic emotions, it is not clear which emotions comic catharsis is able to cleanse through laughter.[3] Laughter, it seems, was a given in comedy that needed no further explanation, and the old theories of comedy from Aristotle to Lessing concentrated on the elements of comedy rather than on its effect. The distinctive features of comedy most commonly discussed in these theories are plot, character, and style. Of these, language and diction usually receive the least attention, perhaps because it is taken for granted that jokes, wit, and irony sufficiently distinguish the comic genre. In contrast to the sublime style of tragedy, it is assumed that the diction of comedy must be simple, since it imitates the language of ordinary people and everyday life. Considerations of plot are the delight of the critics, although Aristotle says little on this score. The comic plot should be developed in analogous structure to tragedy.[4] In the absence of classical doctrine, the critics could be prescriptive as well as descriptive; indeed, many became the schoolmasters of the playwrights, giving them recipes for comedies. For our purposes, the conjectures about the comic hero (character) seem to be the most promising aspect of comic theory, especially because Aristotle's *Poetics* contains a few sentences on the subject.

In the second chapter of the first book, Aristotle speaks of the objects of the dramatic genres: "Since the objects of imitation are men in action, these men must either be of a higher or a lower type."[5] At the end of the chapter, he similarly distinguishes tragedy from comedy: "For comedy aims at representing men as worse, tragedy as better than in actual life."[6] Not only do these laconic

sentences leave room for a wide variety of interpretations, but they also do not seem particularly reconcilable. The first sentence suggests that comedy imitates ridiculous objects, and the second, that comedy makes the imitated object ridiculous. In addition, there is the question which will plague the first statement: What or who are "lower types"? Certainly not slaves and women, because they both lack social and comic capital in antiquity. The distinction is clearly moral since the context pitches virtue against baseness; but, as one commentator observes, it is not absolute: "The hero of tragedy is to be good but not a saint and the hero of comedy bad but not a villain."[7] Furthermore, the dichotomy—good and bad—is not just a moral one; in Aristotle's Greece these terms also include the social and political (and sometimes even the economic) spheres. The good are the aristocrats, the elite, the proper and decent people—in short, "we"—and "they" are the rascals, the good-for-nothings, and the outsiders. They are the object of our laughter. Let us not forget, however, that the second chapter deals with persons in action who can become ridiculous and are made so in comedy. Those who behave in a ridiculous manner in society or act "worse" than other people because they are rigid, mechanical, or follow an *idée fixe* are made the laughingstock of comedy. In the old comedy the ridiculous may be a peculiarity of a person who is satirized in his actions; the ridiculous person violates a societal norm and is therefore laughed at.

Comic laughter criticizes ridiculous behavior, but it should not be destructive. Such is Aristotle's opinion, which he laid down in the fifth chapter. It almost amounts to a definition of comedy: "Comedy is an imitation of characters of a lower type; it does not, however, involve the full range of villainy, but only the ridiculous, a subdivision of the ugly or base. The ridiculous consists of some defect or ugliness that is not painful or destructive. To take an obvious example, the comic mask is ugly and distorted but does not give pain."[8] Comedy does not stir painful emotions and the actions of the play do not have destructive consequences. In this respect comedy is the counterpart of tragedy, where the actions of the hero lead to all forms of pathos, on which Aristotle elaborates in his 13th chapter. As in tragedy, the comic character commits an error ($\dot{\alpha}\mu\dot{\alpha}\varrho\tau\eta\mu\alpha$) ; but, in contrast to the tragic errors, the comic mistake caused by the hero's defect or ugliness is small and has no serious consequences: it threatens but does no harm. This also suggests that the comic plot moves from pain to pleasure, from comic entanglement to merry resolution, without harmful consequences for the hero and without painful emotions for the audience.

There is one more general consideration which Aristotle thinks is typical of comedy. In his 9th chapter he contrasts poetry with historiography to make the point that composing poetry is a more philosophical and serious activity than writing history, for poetry expresses the universals, history, the particulars. Then he simply states that "in comedy this is quite obvious, for here the poet first constructs the plot on the lines of probability, and then inserts names that occur to him."[9] Two things are important here: first, the plot of comedy is completely

fictitious, although it has to be probable; second, comedy does not ridicule particular character flaws of real people, but rather aims at general (universal) foolishness or baseness. Comedy therefore depicts types and typical weaknesses or vices that are laughed at by the audience.

We can only speculate as to what Aristotle had in mind concerning the effect of comedy on the audience, and it is rather doubtful whether he had earmarked specific emotions—like fear and pity in tragedy—that should be cleansed. But the aspect of the ridiculous is of greater consequence for the theory of comedy. Aristotle repeatedly stated in his *Rhetoric* that in comedy the sphere of action is the ridiculous and that the pleasure of comedy depends on it; the explanation and classifications of the ridiculous, however, are lost with the second book of the *Poetics*.[10] In the first book, there is only one utterance that became the starting point for all theories of the ridiculous: "The ridiculous consists in some defect or ugliness which is not painful or destructive."[11] This sentence found a cheerful reception among the Aristotelians up to the 18th century, especially since they could work on the classifications of the ridiculous. A case in point is Vincenzo Maggi's treatise *On the Ridiculous* (1550). He starts out by paraphrasing Aristotle's definition, "that the ridiculous is a fault and an ugliness and a kind of deformity that yet is without pain."[12] Maggi explains the term "without pain" and comes up with the novel distinction between the seriousness of life and the cheerfulness of comedy, if only in one example: "For if anyone saw a face distorted from convulsion, he would be moved not to laughter but to pity—unless indeed he is lacking in humanity."[13] What would offend or cause pity in real life can be ridiculed in comedy without harm, since the audience laughs not at a real person but at a character who typifies ugliness or baseness. The theatrical situation makes this "ridiculousness" bearable and the laughter is "without pain." Thus it follows that the ridiculous cannot (or better: should not) by itself produce laughter. Only when we are surprised, so goes Maggi's second argument, can ridiculous things trigger laughter. Laughter depends on wonder, and novelty is the cause of it. "Baseness that is capable of raising a laugh ought to be novel."[14] The novelty is either the ridiculous thing itself or the manner of expressing it. But when the surprise ceases, and the baseness continues, the laughter stops. The laughter of ridicule, which is cruel and offensive in real life, is tamed in comedy. Maggi's classifications of the ridiculous are as pedantic as might be expected, and it would not be worthwhile going into them any further if they did not contain a surprising utterance which has relevance for our topic. The ridiculous must be drawn from the ugliness or baseness of things which are "necessarily of the body, or of the mind, or of things happening extrinsically."[15] For the last group he gives examples such as: "To have base parents, to be born a pauper, to have unclean women at home—and to be of a perverse religion (like the Jews)."[16] Not only are the Jews singled out as a group in Maggi's classification, they are also considered ugly, debased, and perverse and are, as such, ridiculed. How this laughter can be "without pain" is not clear. Here, the age-old hatred of the

Jews distorts the theory of nondestructive laughter. The exception to the rule demonstrates Maggi's own lack of humanity when it comes to the Jewish religion.

The Aristotelian tradition extends far into the 18th century; in Germany, its influence only fades with the dawn of Idealism. For the German Enlightenment, Aristotle's *Poetics* was still the blueprint for literary theory, although his authority was used to legitimize new tendencies in literature that could have astonishingly contradictory results, as in the theories of comedy by Gottsched and Lessing. Johann Christoph Gottsched can rightly be called the reformer and schoolmaster of German literature. His magnum opus, *Versuch einer Critischen Dichtkunst vor die Deutschen,* published in 1730 and influential up to its fourth edition of 1751, was based on reason, rules, and respectability. "Vernünftigkeit" is a prerequisite of literature that imitates nature; the rules of his poetics are prescriptive and practical; they correspond to the decorum of polite society. The function of literature is defined by Horace's *prodesse et delectare;* literature becomes a useful tool to educate the bourgeois society. Nowhere is this more evident than in theater, which becomes a moral institution, and in the genre of comedy, which is used as a school of laughter. "Comedy is nothing but an imitation of wicked actions which amuse the audience with ridiculous things and which edify them at the same time."[17] This "Aristotelian" definition is remarkable for two things: first, not only does comedy entertain the audience, but its laughter has also to have a moral (or pedagogical) purpose; second, comedy combines the ridiculous with wickedness. According to the guidelines set up by Gottsched, the playwrights were to act like schoolmasters whose stern task it was to teach virtue. The effect of comedy—laughter—was used for the moral intent of ridiculing all those who deviate from the accepted ethical and social norms. Comedy became more satirical than ever. This is underscored by Gottsched's dissatisfaction with the Aristotelian ridiculous, "which does not cause pain" and which he felt had to be amplified by a vice (wickedness) that could be corrected. Although at one point he even suggests that comedy should expose and punish vices which escape the law, Gottsched's understanding of vice is better defined as a moral defect, lack of reason, or "universal foolishness." This type of comedy is strongly negative, since it exposes and humiliates the comic hero, at whom the audience laughs from a position of superiority. In German this kind of comedy is called "Verlachkomödie,"[18] "comedy of derision" or, simply, "satirical comedy."

Gottsched, a keen observer of the literary scene, was well aware of the changing literary taste of the times which strongly influenced the development of the comic genre. By the time he published the fourth, "improved," edition of his *Critische Dichtkunst* in 1751, the influence of the French *comédie larmoyante* on German theater was already noticeable. A new type of comedy emerged, which Gottsched polemically termed "virtuous comedy." He criticizes this "new form of comedy" because it is a comedy without satirical laughter and, more important, because it blurs the border between comedy and tragedy. When the audience takes pity on a comic hero, the tragic emotion endangers the comic effect. He

therefore proposes to call these "sad comedies" "bourgeois tragedies" or "tragi-comedies."[19] Gottsched was not far off the mark with his criticism and with his prediction. By his critical standards, the virtuous comedy was a rather doubtful proposition, and the *comédie larmoyante* branched out in three distinctive directions. It developed into the serious comedy (Diderot, Lessing) and the bourgeois tragedy; at the end of the century, it even degenerated into the *Rührstück* (Kotzebue, Iffland), which proved Gottsched's worst fears right.

The irritation of this dogmatist was more than understandable, for even before the middle of the century the traditional separation of tragedy and comedy was tampered with both in theory and in practice. In England, Richard Steel declared as early as 1723, in the preface to his *Conscious Lovers,* that the object of his comedy was "happiness and success," which "introduce a joy too exquisite for laughter."[20] His "sentimental comedies," which present virtuous *tableaux* in a family setting, reached Germany only indirectly via the moral weeklies, in which the bourgeoisie ascertained its virtues and propagated them. Comedy became a school of virtue where the bourgeoisie could cultivate its self-esteem and pamper its most precious sentiments. This tendency became even more obvious and influential in the French *comédie larmoyante* from Marivaux onward. For Gottsched this was a hard nut to crack, since he used the French theater as a model for the German stage and since Destouches, who was one of his favorite playwrights, used the new comic form with great success. As if that were not enough, the "weinerliche Komödie," as its enemies called it, was imitated in Germany and found an enthusiastic audience. Gellert, who was already the best-known playwright of the virtuous comedy, defended the new genre in his inaugural address at the University of Leipzig in 1751—under the very nose of Gottsched. Lessing, who was at that time himself experimenting with the old and the new forms of comedy, translated Gellert's Latin apology (*Pro comoedia commovente*) as well as Chassiron's attack on the old genre theory (*Réflexions sur le comique-larmoyante,* 1749) and published them together in his *Theatralische Bibliothek* in 1754.

The new comic genre was understood as an attack on the Aristotelian separation of genres by its critics, and as an innovative middle genre by its defenders. It clearly was a break with the age-old *Ständeklausel,* which postulated that only persons of noble birth and high station could qualify as tragic heroes and that only people from the lower or middle classes could be featured as comic characters. Gottsched affirms this separation reflecting the social order, defending it from the position of a loyal subject: "Although it cannot be denied that the nobles of this world can act foolishly or ridiculously, it would be contrary to the respect that we owe them to laugh at them."[21] He has to admit, however, that "if need be," barons, marquises, and dukes appear in comedies, too. Lessing soon conceptualized the change in dramatic theory. In 1754, in his introduction to the translations of Chassiron and Gellert, he writes that the innovation of the sentimental comedy is based on a more serious understanding of comedy. "It was assumed

that the world had laughed long enough in comedies and ridiculed tasteless vices; now someone had the idea that the world could finally also cry in comedies and should find a noble pleasure in quiet virtues."[22] If, with Lessing, we take into consideration that the standards of tragedy were lowered to allow for "heroes of the middle class" to arouse the pity of the audience, it is quite obvious that this poetic egalitarianism is only the aesthetic expression of bourgeois emancipation. The bourgeois becomes the virtuous hero of comedy as well as tragedy. The images of a simple and virtuous life, in which the bourgeoisie could recognize its own world, moved the spectators to tears; they no longer laughed at the vices of others, but wept about their own goodness. The roaring laughter of the old comedy was replaced by the subtle emotion (*Rührung*) of the new comedy. This effect of the sentimental comedy, which brings it dangerously close to the tears of pity in the old tragedy, is defended by Gellert through a reinterpretation of the dramatic affects. The sentimentality (*Rührung*) of comedy has nothing to do with the tragic sphere, he maintains, since the sentiments expressed in comedy have nothing in common with heroic affects, such as passion or despair, which arouse fear and pity. Tragedy deals with sublime emotions, sentimental comedy is satisfied with quiet, earnest sentiments that move the audience differently. The new comedy is the apt aesthetic expression of the age of sentimentality.

Although the new comedy seems at first sight only an inversion of the old form, where vice/baseness is replaced by virtue/goodness and laughter is silenced to a smile, it is in fact still a mixture of old and new devices. The virtues in private, everyday life had to be contrasted with vice, or virtue had at least to prove itself under duress; it is not enough to recommend virtue without at the same time exposing vice and folly in a humorous way. The danger of sentimental comedy is its one-sided presentation of goodness, which does not allow for contrast or conflict, and the effect could be sad, sweet—and boring. The audience leaves the theater with the sweet illusion of its own goodness. Lessing, who saw the promise and the shortcomings of the new genre, maintained that only those plays can be called true comedies "which present virtues as well as vices, goodness as well as inconsistencies, since only this mixture comes closest to the original, which is everyday life."[23] True comedy had to imitate life and to combine sentiment with laughter. As far as Lessing was concerned, the sentimental comedy was an interesting variation of the genre but not the model for the modern bourgeois comedy.

This level of comic achievement was reached with *Diderot's Theater,* which Lessing translated in 1760. Now comedy really became serious business, for Diderot propagated not only the "genre sérieux" but, as a sideline, also the "comédie sérieuse." Diderot was no longer satisfied with the comic battle of virtue versus vice nor with the satirical laughter which exposes one-dimensional characters. The old satirical comedy was for him too stilted and artificially removed from life. He therefore postulated characters who were formed by the conditions of their lives and placed in real life situations. The audience should be able to

recognize its own social reality on stage, where the characters act in accordance with the duties, inconveniences, and dangers of their social and professional conditions. The serious conflicts in a bourgeois setting arise not so much from within the characters but from external social conditions. The tragic ending, however, is avoided and the play ends happily in a tableau. The audience is moved to tears rather than laughter. If the new serious comedy needed a paradigm, Lessing's *Minna von Barnhelm* would be the best one. Tellheim is clearly a product of his social conditions. An officer who has been displaced and made useless through peace, he is without any means to support himself; he depends on the benevolence of the Prussian bureaucracy to restore his financial and social well-being; and he is a man whose honor has been tainted. That his serious situation does not deteriorate into tragedy, and his code of honor does not destroy his happiness, is the work of witty Minna who saves him for herself by restoring to him his autonomy. Tellheim's conflict finds happy resolution—without much laughter.

Lessing's own theory of comedy is indebted to the tradition which has been outlined so far. It developed further out of his theatrical experiences and his own experiments with the genre. Lessing's theory is as aphoristic as Aristotle's; nevertheless, it is the best summary of the form, intent, and effect of the new comedy.

Lessing, who used the ancient theory to legitimize new tendencies, started out with Aristotle's theory of the ridiculous. "Whoever has learned this lesson will try in his own behavior to avoid all forms of the ridiculous, and he will therefore become the most decent and well-mannered person."[24] In comparison with Lessing's thorough investigations of the emotional effects of tragedy in the same letter, his remarks on the comic genre are only an afterthought that he used to contrast tragedy and comedy. He ensures the usefulness of comedy in society by pointing out its preventative function of recognizing and avoiding the ridiculous. The school of laughter becomes a tool for society to increase the critical (and self-critical) faculties of the audience. (Likewise, it is the effect of tragedy to experience pity and to develop it into a useful social virtue.)

Even the famous letter to Friedrich Nicolai of November 1756 is no more than a rationalistic exercise to demonstrate the usefulness of comedy, and hence does not explain why the audience laughs. Although Lessing never developed a coherent theory of laughter or comedy, his *Hamburgische Dramaturgie* (1769) contains a few remarks which point toward the new comedy. If there is one tendency that runs through all these passages, it is his criticism of satirical laughter. "Where is it written," he asked, "that comedy should only laugh at moral faults, or only at unchangeable vices?"[25] If playwrights follow the Aristotelian tradition of laughter without pain, they should not ridicule natural defects or vices as such, but rather social habits or moral faults which can be cured or changed. But laughter and derision are far apart for Lessing, and the laughter at even one defect or one vice is distasteful for him. The one-dimensional characters of the old comedy violate the aspirations to reality of the new comedy. Although comedy prefers types to rounded characters, the comic character should nevertheless

have a mixture of personal qualities, where the dominant passion is in conflict with the others. Therefore, Lessing moves away from the stereotypical duality of comic objects and looks for new constellations which are comical: "Every incongruity, every contrast of reality and deficiency is laughable."[26] This remark is a clear break with the ridiculous nothingness of the Aristotelian tradition and anticipates future theories of laughter, including that of Freud. The comic laughter here arises from two inconsistencies: the incongruity of character and circumstances and the contrast between illusion and reality. Better yet, if the appearance of excellence is experienced as a defect in the same character. This is, once again, Tellheim's case, as his knightly code of honor becomes a displaced virtue, bringing him into conflict with reality and making him comical. His situation is quite serious, and yet, the contrast between his illusion of honor and his circumstances is comical: the audience is amused by this incongruity, but does not laugh at the character. Seriousness and laughter are so intertwined in this comedy that Minna has to defend herself with a paradox: "Can one not be very serious even when laughing?"[27]

Lessing does not further elaborate on the importance of incongruity for comedy, but the context of his utterance marks the same transition from laughing *at* to laughing *about* or *with*. "Comedy wants to improve [people] through laughter, but not through derision."[28] The new comedy achieves this by placing virtuous persons, who have our esteem, in comical situations. Comedy's "true, general use consists in laughter itself." The ridiculous and the laughter at it are from now on banished from the stage and replaced by sympathetic laughter. This "domestication of unruly laughter"[29] is not just a matter of style, but of morals. To ridicule others, strangers and outsiders, from the superior position of an insider was no longer tolerated. In serious comedy the laughter at the ridiculous is sublimated into the sympathetic comical laughter which enables the audience to laugh healthily at themselves.

II

If we now turn out attention to three comedies in which a Jew is a central character, this is no mere exercise to demonstrate how the theory of the new comedy works. Nor were the three comedies chosen as the easiest *exempla* to make my point about comedies without laughter. The matter is more complicated than that. The arrival of the new comedy around the middle of the 18th century, the suspension of satirical laughter, and the domestication of the ridiculous signify tendencies which can also be found in the moral and political philosophy of the times. The bourgeois audience no longer wanted to laugh about foolish or ridiculous characters, but rather at comical conflicts within its own sphere, and to laugh about the hero as if it were laughing about itself. The comedy of the Enlightenment was a school of laughter, criticizing the conditions that breed ignorance, intolerance, and prejudice; by means of laughter it intended to make society more

reasonable, self-critical, and tolerant. Alas, the silencing of satirical laughter at Jews in comedies did not mark an end to stupidity and prejudice in society—far from it—but it did signal a tendency, at least in literature, to understand and tolerate otherness.

When it comes to outsiders, the Age of Enlightenment is the age of tolerance. Nowhere was this more obvious than with regard to the "Jewish question," and what was termed the "civil improvement of the Jews" was nowhere advanced more forcefully than in the literary sphere. The extensive public debate on tolerance, in which two of Lessing's comedies played an important part, paved the way for reforms which slowly followed. The structural parallel between the theory of serious comedy, where the laughter at strangers and outsiders is suspended, and comedies in which a Jew is a central character is the enlightened concept of tolerance, the attempt at accepting and understanding otherness. The Jew on stage was the first test wherein the enlightenment principle of tolerance could prove its usefulness. We know how this sign of hope turned out to be an illusion later on, when tolerance was tested in reality or when Jewish emancipation became the issue; but that is quite another chapter, one belonging to the dialectics of Enlightenment.

"The subject to be discussed [first] is Shylock, Shakespeare's greatest error." Thus Gerald Friedländer begins his passionate defense of the Jew against Shakespeare's grotesque and horrific distortions. By the time he wrote it in 1921, the apologies of Shylock had long since run their course. As we have already mentioned, the shift in the reception of Shylock from a red-wigged monster to a sympathetic victim occurred at the beginning of the 19th century. This line of interpretation was carried to the extreme when the critic Godwin declared in 1875 that with Shylock's exit the play is virtually over: "The fifth act might very well be omitted in modern stage representation."[30] And symptomatic of today is the common error to think that Shylock is the Merchant of Venice, not Antonio. "The play has captured our imagination," observes Leslie Fiedler, "but Shylock has captured the play, turning, in the course of that conquest, from grotesque to pathetic, from utter alien to one of us."[31] It is against this backdrop that we must try to reconstruct the play's original meaning, if that is possible. Perhaps we have learned to be ashamed of Shakespeare's stereotypical presentation of Shylock, perhaps we are enlightened enough to see the ambivalence of the character, but lurking beneath our code of civility and official shame are archaic sentiments which are encrusted on the living. Uncovering them in *The Merchant of Venice* has a double function for our topic: first, Shakespeare's "lovely and perverse text" (Fiedler) can stand for the old comedy, which made its audience laugh at the social outcast of society; second, it demonstrates how the Jew was made into a comic character on which the audience could ritually release its age-old hatred.

The Merchant of Venice is undeniably a romantic comedy which revolves around money, love, and wiving, but it is also a play about a Jew. Daughters betray their fathers for love, youth wins out over old age, and three pairs of lovers

wander off to bed at Belmont in the end. As is customary for a comic plot, the lovers must overcome obstacles: Bassanio lacks the money to woo Portia; he has to solve the riddle of the three caskets to win her; and before he can marry her, he has to save his friend Antonio from a murderous Jew. But why does this comedy need a Jewish villain? A sinister Jew is by no means essential to the plot of the comedy; any other adversary could have fulfilled the same function of endangering the friendship, love, and bliss of the young. Not only is Shylock the exception in all of Shakespeare's plays, it is even doubtful that Shakespeare knew any Jews, since there were only a handful left in England after the expulsion of 1290, and most of these were Marranos. But there is good reason to believe that Shakespeare knew at least one Jew, Dr. Lopez, whose trial stirred the passion of the public in 1594. Dr. Lopez was a converted Jew from Portugal who became such a respected member of the medical profession in England that he was appointed court physician of Queen Elizabeth. Suffice it to say that Lopez became the victim of a courtly intrigue and was convicted of treason and attempted poisoning of the Queen. At his execution the enraged mob shouted: "He is a Jew and worse than Judas!" Here is the point where the fictitious world of comedy intersects the real world of Elizabethan England, and where the expectations of Shakespeare's audience come into play. Just one year later, Shakespeare gave the public what they wanted. Since they scarcely knew any Jews, he invented Shylock as a "symbolic scapegoat" (Fiedler) on whom they could vent their hatred. Christian legend gave us Judas and Ahasver archetypes of the treacherous Jew and the exiled Jew; to them, Shakespeare added Shylock, the avaricious Jew.

The very manner in which Shylock is introduced into the play makes him a monstrosity. "Three thousand ducats, well—For three months, well.—Antonio shall become bound, well." (I, 3). These three utterances characterize him for the rest of the play: he hates Antonio, "for he is a Christian" and, even more, "for he lends money out for gratis." Hatred of Christians and greed are the passions of this villain. Everything he thinks, feels, or does is permeated with his being a moneylender—even in his sleep he dreams of money bags. The money motif, usually a comic device (and, as such, also important in this romance), is clearly used by Shakespeare to typify the Jewish usurer and to amplify a Christian prejudice. Initially, Shylock's loan to Antonio seems to contradict these observations; instead of interest, he speaks only of a single bond, a pound of flesh to be taken from Antonio's body. What at first appears to be "a merry sport" is meant as a deadly bond. For Shylock hates Antonio so much that he wants revenge for all the humiliations and misfortunes he has suffered by him. His murderous vengeance makes Shylock "the very devil incarnate" in the eyes of the Christians. Hatred and revenge become synonymous with Judaism. As if this perverse projection of Christian hatred onto the Jew were not enough, Shakespeare goes one step further in the trial scene by presenting Shylock as a bloodthirsty monster. When Shylock whets his knife to cut a pound of flesh, all those horror stories of Jewish ritual murders of Christian children and virgins must

have come to mind in Shakespeare's audience; and they must have been relieved when Portia tricked him and the Duke expelled him from civil society.

Even if Shakespeare had intended to construct a Jewish monster out of deep-seated prejudices, he was too much a master of the stage to allow any one-sided and abstract presentation of wickedness. The dramatic economy of affects requires a rounder, more fully developed character to secure the intended effect on the audience. Therefore, Shakespeare permits Shylock a few utterances in which he can plead his own humanity, even allowing him moments of almost tragic dignity. What immediately comes to mind are verses such as, "For sufferance is the badge of all our tribe" (I, 3), part of a speech in which the outcast asserts himself as equal to the noble merchant Antonio; or Shylock's insistence on his otherness, "I will not eat with you, drink with you, nor pray with you" (I, 3), which makes him, in the eyes of the Christians, an obstinate Jew who cannot be converted; and, finally, those famous lines which are the delight of all actors since Kean: "If you prick us, do we not bleed? If you tickle us, do we not laugh? If you poison us, do we not die?" (III, 1). But all these wonderful statements of pride and dignity, which altered the reception of Shylock since the 19th century, have their own context that negates Shakespeare's "poetic justice." Let us take just one example, the famed "I am a Jew" speech, where Shylock seems to plead for anthropological equality. But it is by this very speech that he justifies his revenge: "And if you wrong us, shall we not revenge?" As if that were not enough, he continues: "The villainy you teach me I will execute." This is a plea not for humanity but for the equality of oppressors and murderers. Even Shylock's greatest triumph, his date in the Venetian court with Antonio which gives the Jew—at least on stage—legal equality, is tainted with ambiguity. Formal legality as exercised by Portia prevents the Jew from taking what is legally his—and rightly so, for it would be murderous revenge. Shakepeare's ambivalence toward the Jew, if it is not hidden partisanship against him, can still be exploited—as it was under the Nazis—and it should still irritate us today.

Shakespeare's Shylock seems to be a realistic character, yet he is more a caricature of a Jew: prejudices amplified by a genius. It has been proven many times how removed Shylock is from the world of Judaism and how the Christian playwright distorted his image. In Elizabethan England, a country without Jews, the commoners had no idea what a real Jew was like. Shakespeare gave his audience an archetypal figure on whom they could project their own darkest emotions. Shylock is a monstrosity constructed out of traditional prejudices: greed for money, hatred of the Christians, lust for revenge and for ritual murder; the fact that he is also a loner who hates music, company, and young love makes him even more sinister. A prophet-like figure from the past that threatens the well-being and happiness of the Christian community, he personifies the medieval myth of the Jews.

But how does this mythical figure of a terrible other fit into a comedy? What is there to be laughed at? Not only does Shylock interrupt the gay and romantic

action of the comedy, he can also disrupt the structure of the play so severely that the villain becomes the tragic hero, as the reception of the play shows. But at the Globe Theatre, the love-filled court of Belmont conquered the ghetto of Venice, swallowing up the Jewish tragedy and celebrating the victory of friendship and love over hatred and revenge. Venice and Christianity, state and church triumph over the dark forces of Judaism. Laughter defeats villainy: that is comedy. But the simplicity of the comic plot cannot completely explain the cruel laughter, for it has yet another dimension connected with the Jewish subplot. Already in Maggi's classification of ridiculous persons, the Jews were singled out as debased and perverse, and made the laughingstock of comedy. That is precisely what happens in Shakespeare's comedy. Since the audience cannot tease or scorn Shylock, the characters on stage do so for them vicariously. They all hate the Jew, and their language is full of anti-Jewish abuse. Even if Shakespeare's presentation of Shylock were ambiguous, the language which his characters use when speaking to or about Shylock is anything but ambiguous. With stereotypical monotony, they call him "dog" or "the dog Jew," and we all know what Shakespeare thought of dogs. If there were a pattern to these redundant obscenities, the leitmotif would be "dog" or "wolf," which can easily be associated with Lopez, and the climax, "devil." The vilification of Shylock makes it clear that he is a subhuman being. He can plead his own humanity as long as he wants, but they will thoughtlessly repeat over and over: "I am as like to call thee so again" (I, 3). Prejudice does not listen to reason. "It is this sense of a repetitiveness verging on obsession which remains with us—revealing finally how deep the roots of anti-Semitic horror go at all levels of society which Shakespeare portrays."[32] The laughter of the audience is the laughter of complicity, further degrading the person attacked. It is the exclusive laughter of derision and contempt that isolates otherness and laughs at it. The good and righteous Christians on stage and in the audience laugh at the outsider whom they neither understand nor wish to tolerate. There is no room for Jews, except when they cease to be Jews. Since Shylock is ridiculed, punished, ruined, and converted, the reconciliation is consummated in the love between Jessica and Lorenzo; baptized, she can marry him. The happiest Christian world would be a world without Jews. Or to conclude our discussion of Shakespeare on a more optimistic note by paraphrasing Hermann Sinsheimer: Shylock the Unwise is the witness of past enslavement of the Jews, Nathan the Wise is the witness of Jewish liberation.[33]

It would be a tedious exercise to enumerate all the comedies, carnival plays, and farces of the 17th and 18th centuries in which Jews were portrayed as comical villains or caricatures.[34] They behave on stage just as the commoners expected, just as they were seen on the street. As alien social outcasts who came into contact with the Christian community only when they left the ghetto to do business as peddlers, pawnbrokers, or moneylenders, they appeared on stage as comical types marked by their strange appearance and Yiddish speech. For our purposes, it is more important to mention the changes in the religious and intel-

lectual climate of the 17th and 18th centuries that gradually transformed the image of the Jew on stage. The tolerance debate, at least initially, had nothing to do with the "Jewish question"; it pertained only to the Christian minorities and sects that had broken away from the Catholic church, such as the Hussites, the Calvinists, the Huguenots, the Puritans, and the Quakers. After a full century of religious and civil wars, the longing for a lasting peace and religious tolerance could be felt all over Europe. The ensuing tolerance debate, too, slowly affected the relationship between Christians and Jews. In England, where Menasseh ben Israel had pleaded in 1655 for the return of the Jews to the Commonwealth, such figures as Locke and Toland argued for the naturalization of the Jews, leading to the short-lived "Jew Bill" of 1753. On the continent, it took a bit longer, as usual, and the first meager political success was the "Edict of Tolerance" issued by Joseph II in 1782. In the German-speaking countries the discussion belongs, by and large, to the literary sphere, and it is no surprise that the first cautious attempts at tolerating Jews are to be found in belles lettres. In 1747–48, Gellert published a novel, *The Swedish Countess,* containing portraits of "noble" Jews; in 1749, Lessing wrote a comedy, *The Jews,* in which for the first time in the history of German literature a Jew appeared on stage as a positive character. Lessing's play forms the bridge between Shylock and Nathan.

When Lessing wrote his play, prejudices against Jews were still treated almost as a matter of religious principle. For this reason, one cannot praise too highly the courage, tolerance, and talent of the twenty-year-old playwright. His comedy contributed to the nascent tolerance debate in Germany by using an exemplarily honest Jew to refute abstract prejudices against the Jews. This comedy was, as he later stated, "the result of a very earnest consideration of the despicable oppression to which the Jewish people must submit."[35]

The play is entitled *The Jews,* which may at first be somewhat misleading, as there is only one Jew, and he remains anonymous until the final scene. But the title reveals Lessing's intent to refute the prejudice against the Jews generally by means of the example set by one good Jew. It is a serious comedy about and against prejudices shared by the "Christian rabble" and the baron, who are both rendered laughable in their narrow-mindedness. The laughing matter is the comic nature of false generalizations and lack of reality in every prejudice.

One aspect of the dialectic of prejudice is that it is not merely stupid but dangerous as well—in the context of hatred of the Jews, even murderous. The threat to the Jews and the gravity of their situation surface repeatedly in spite of the comedy. Thus the baron's steward states that he would dearly love to poison all the Jews. This murderous stupidity remains merely latent in the play because fortunately—or rather, comically—the Jew remains incognito until the end. Prejudice is deaf to reason, as shown by the dialogue between the traveler and the steward, Martin Krumm (one of the robbers). When the traveler argues against the possibility that Jews were the robbers, since only a few are "tolerated" in the country and the robbers spoke the local dialect, Krumm offers this non sequitur:

"Yes, yes, I also believe that the Jews did it." He has good reason to blame Jews, for he must conceal his attempted robbery. His lengthy speech is an ideal paradigm for unraveling the intricate structure of prejudice as well. Prejudice is the ideology of a majority which has its roots in religious, political, or social myths; this false consciousness is a constant threat to the minority and can be activated whenever the Jews come into conflict with the material interests of the majority. Since prejudice is based on abstract generalizations, the commoner, who hardly knows anything about Jews, seems to know everything; in fact, he is satisfied with the lowest common denominator for the other: all Jews are "swindlers, thieves, and robbers." This is reason enough for Krumm to declare that if he were king, he would wipe out the Jews. Here, religious principle becomes aggressive, and religious resentments are ignited by Krumm's own precarious situation. Religious prejudices can then be used to justify any atrocity. As an example of this spontaneous aggressiveness latent in prejudice, Krumm cites the "disaster of Breslau," a pogrom which he blames on the Jews. The victim is, once again, made the aggressor who must be punished. But such atrocities also need a metaphysical justification, which in the case of anti-Semitism is easily at hand: God Himself condemns the Jews for what they did to Christ. The authoritarian personality, of which Krumm is a prime example, needs all the support he can get to bolster his weak ego and to project his weakness onto others; Krumm therefore quotes the pastor and the baron as authorities who are of the same opinion when it comes to Jews.

If the traveler thinks that this is only the language of the "Christian rabble," and that the educated baron is free of prejudice, he will soon hear more of the same, the only difference being that the baron has a scientific method to recognize all Jews. An expert in physiognomy, he claims he can immediately read all "malice, treachery, and egotism" in a Jew's face. The baron may be older and better educated than the commoner, but his anti-Jewish sentiments are as deeply ingrained. Neither the baron nor the rabble become wiser, not even at the end when the virtuous traveler identifies himself as a Jew. The first reaction of the baron is surprise: "A Jew? Cruel misfortune!" And his next utterance is as comical as it is logical: "So, there are times when heaven itself prevents us from being grateful." For *gratia dei* and according to the laws of the land, any marriages between Christians and Jews are forbidden. The perplexed reaction of the servant of the nameless traveler who blurts out, "There are after all Jews who aren't Jews," is more ambiguous, since it points out the crux of the play. For the sake of the final surprise, the Jew has to appear without distinctive features of his religion or nation. If the baron has learned anything at all, it is merely that he has met *one* noble Jew: "Oh, how commendable the Jews would be, if they were all like you." His use of the subjunctive, however, suggests that this Jew is only an exception and that the baron is still prejudiced against Jews. This is underscored by the Jew's ironic rejoinder: "And how worthy of love the Christians, if they all possessed your qualities." It is a rather dry ending for a com-

edy, and the serious moral stifles the laughter. Even if the characters on stage haven't learned much, the audience should leave the theater wiser and more tolerant. This is a learning play, and its message is part of the plot structure, articulated by the traveler who at the end asks the baron "to judge my people in the future more leniently and with fewer generalizations." This is not a first step toward Jewish emancipation in Germany, as Walter Hinck has suggested, but an earnest plea for tolerance which was met with skepticism, if not outright disapproval.[36]

In one of the first reviews of the play, Professor Michaelis of Göttingen praises Lessing's noble intention of criticizing the foolishness of hatred and contempt with which the Christians confront the Jews in everyday life, but he then raises two objections. First, the traveler is so noble, moral, and ready to help that, although it may not be impossible to find him among the Jews, it certainly would be improbable. Second, this improbability detracts from the pleasure of the comedy. If we disregard for the moment the hidden anti-Jewish sentiments, Michaelis' criticism has some validity. The virtuous Jew is simply too good to be true for a prejudiced audience, too improbable on a stage where the Jew was traditionally a comical and ridiculous type to be laughed at. Who is there, in Lessing's comedy, to laugh at? Certainly not *The Jews,* who are the invention of prejudice and who are absent from the play; certainly not the traveler, whose identity is revealed only at the end to contradict common prejudice. If the audience laughed at all, it would be about the narrow-mindedness and stupidity of false generalizations by the Christians on stage—i.e., about themselves. But that is a tall order indeed. Frankly, there is not much laughter in this play. It is the first serious comedy in Germany, and also the first learning play.

In the late 18th century, the old comedy of types is slowly replaced by the sentimental comedy and the serious comedy. The subject matter of these new comedies is no longer a typical defect, vice, or wickedness of a character which is ridiculed and laughed at, but instead more serious social problems which are presented in a comical light. The comic plot confronts the audience with misperceptions, false generalizations, and common prejudices within their own society rendered laughable in their incongruity. The satirical laughter of exclusion is replaced by critical laughter of inclusion. The audience laughs with the comic protagonists, whose foibles it shares; viewers learn how to laugh about themselves and to avoid the mistakes they have seen on stage. In his comic learning play *The Jews,* Lessing succeeds in frustrating the expectations of the audience and in inverting the old comedy. If the audience expected a comical farce about Jews that would ritually reaffirm their prejudices by satirical laughter, it was to be deeply disappointed; the abstract generalizations and stereotypical behavior that went along with the old comedy are refuted here by the example of one noble Jew. But this is also the crux of Lessing's comedy, for at bottom Lessing is basing his argument on an exception. The Jewish traveler has to admit that sympathy for him and tolerance toward him as a Jew do not change the general attitude of the Christians against his nation. The good Jew, as an exception, is simply

better than the rest of them. Lessing's model suffers from the one-sidedness of his criticism: conventional prejudice is defeated by one concrete example, but this triumph for the sake of the idea of tolerance also exacts its price. To make his point, Lessing, too, falls into the trap of abstraction. The good Jew, whom nobody recognizes as such, distinguishes himself by virtue of his general humanity, education, and wealth—that is to say, by bourgeois attributes. Only under these conditions is it possible for the noble Jew to be assimilated by Christian society. "The bourgeois Shylock is postulated as the task of individual emancipation," Hans Mayer concludes laconically.[37] The concrete historical manifestation of this type of emancipation was to be found in the court Jew of the 18th century. It was certainly not enough to base tolerance on the discovery of one honest Jew, be it as an exception or a model. This kind of tolerance can only offend the individual tolerated, since it is at best a weak gesture of good will with a troubled conscience. The Christians who have all the rights and who are righteous, tolerate the religious minority, the outsider, and the other as if this were an act of grace. In a condescending or sentimental manner, they grant tolerance to one exceptional Jew while still clinging to deep-seated prejudice against *the* Jews (as demonstrated by the baron in Lessing's play). More than this simpleminded solution was required to overcome the horror of prejudice.

A promising change in the attitude toward the Jew can be detected during the second phase of the tolerance debate in the late 18th century, when theologians, philosophers, and poets discovered the moral value of natural religion and the ancient history of Judaism. Historical thinking, which was still working with the simple model of three phases in the education of mankind, ranked Judaism as the first important step in this educational process. The introduction of monotheism and the Mosaic Law were interpreted as great religious as well as cultural achievements. The Old Testament is viewed as the first book of enlightenment for mankind. Although it seemed to be easier for Enlightenment philosophers to deal with the "Jewish question" in the past, the debate about natural religion paved the way for religious tolerance in their present-day society. They further argued that if all religions are based on one natural religion, of which the fundamental law is universal morality, then it would follow that all religions should tolerate each other, and that Jews should even be permitted to integrate into society. Lessing's *Nathan the Wise* summarized these debates: all religions are equal before God, and their members have to prove the worthiness of their belief by practical morality and unprejudiced love.

Lessing's last drama grew out of the debates about natural religion; specifically, it is the result of his dispute with the Protestant pastor Goeze about the toleration of the deists. In his eleven *Anti-Goeze* letters, he openly polemicized against the dogmatism and intolerance of the pastor. When he was censored by the Duke of Brunswick in 1778, Lessing decided to write his 12th *Anti-Goeze* as a dramatic parable, in order to test the limits of enlightened despotism, to see "whether he would be permitted to use his old pulpit, the theater, to preach"

the gospel of tolerance.[38] When his friends heard about his plan to continue his polemical debate with Goeze on stage, they worried that a satire of his opponent would hurt his cause even more. But he calmed them down by promising the "most sentimental play" that he had ever written,[39] and the reaction of one of the first readers bespeaks exactly that sentiment: "We often had to laugh in order not to cry."[40]

As a probable setting for his fictive plot, Lessing chose Jerusalem during the time of the truce after the Third Crusade. Muslims, Christians, and Jews live there together under precarious conditions, and Nathan in particular has to move especially cautiously between the two hostile camps. His existence is threatened more by the irrational behavior of the Christians than by the financial distress of the Sultan. The potential conflicts in the religious war and the underlying possibility that all the tensions will be directed at the Jew lend this comedy the seriousness necessary for its message of religious tolerance. Nathan's wisdom and virtue overcome the murderous Jew-hatred of the Christian patriarch, the religious narrow-mindedness of the servant Daja, and even the shrewdness of the Sultan. Under his influence, all characters learn how to understand and respect one another. The advice of the prudent judge in Nathan's parable of the three rings sums it all up: "Well then, let each aspire to emulate his father's pure un-prejudiced love. Let each strive to match the rest in bringing to the fore the magic of the opal in his ring. Assist that power with all humility, with benefaction, hearty peacefulness, and with profound submission to God's will" (III, 7). This is the center of the learning play, but the idea of tolerance also runs as a leitmotif through all major scenes of the drama. Typical of Lessing's dramatic art, these scenes are long disputations, all ending in emotional promises of friendship that guarantee, at least on a personal basis, the enduring effect of tolerance. In the final tableau, all the main characters, who have fast become friends, discover that they also are members of one family—all except for Nathan, the one who arranged this utopian image of universal love. *Nathan the Wise* is indisputably the greatest statement of enlightened humanism. But can this serious drama of tolerance also be read as a comedy?

The subtitle says "a dramatic poem," a rather general characterization of the genre. Indeed, it is one of the first "poetic" dramas in German literature written in blank verse; but more importantly, drama was not just a generic term in the late 18th century, it could also have the French meaning of *drame,* which was Diderot's middle genre between tragedy and comedy, the *genre sérieux.* In the same theoretical context as discussed at the outset, *Nathan the Wise* can be understood as a serious comedy which—according to Diderot—demonstrates the virtues and duties of the characters. The first critic to discover the comic quality of the play was none other than Schiller. In a footnote to his essay *On Naive and Sentimental Poetry* (1795), Schiller observes that Lessing knew he had not written a tragedy, and it would have required major changes to do so, "but with small, random changes it might have been a good comedy." Using Schiller's

arrangement and under Goethe's direction, *Nathan* was staged at Weimar in 1801—and ever since it has been one of the most popular plays on stage.

Only recently have the comic aspects of the play been rediscovered in literary criticism as well as on stage;[41] laughter is permitted again and is not out of place. It is, to be sure, a quiet laughter which does not distract from the seriousness of the message. The reaction of the first reader, who laughed so as not to cry, may be even more appropriate today than it was then. This paradox is the secret of the serious comedy. If we leave aside for a moment the dominant idea of the play and concentrate on the plot structure instead, we may be surprised at how simple it is. The drama is a sentimental family play that fully corresponds to Diderot's theory of the serious comedy. In the course of the action, Nathan discovers that the Templar who saved his daughter Recha from the burning house is actually her brother. Both are, as we learn in the end, children of Saladin's missing brother. In the final tableau, the Muslim Sultan, the Christian knight, and the adoptive daughter of a Jew embrace each other as members of one family—the utopian image of a peaceful family of mankind. Within this theoretical framework, even Northrop Frye's list of typical comic characters can be applied:[42] Nathan is the old father who does not want to lose his naive daughter to a passionate young man. Daja, the servant and confidante, and Saladin, the benevolent ruler, complete the cast of the sentimental comedy. But, according to this theory of comedy, the play has two shortcomings: first, it does not end in marriage although the utopian vision of a better and more tolerant future is clearly expressed; second, the historical figure of Saladin threatens to disrupt the fictive plot of the comedy. Nathan, the fictitious Jew, not Saladin, the conqueror of Jerusalem, is the hero of the play. Lessing mastered this cliff by downplaying Saladin's historical and heroic greatness and by integrating him into the family plot. The war rests; the Sultan is concerned with private rather than public matters. In the play he is "the hero who would rather be the gardener of God," and he is presented as the paterfamilias, a "hero in slippers" (Demetz) who worries about family affairs more than about the affairs of state.

As is typical for the *comédie larmoyante,* the comical is grafted onto the serious theme, and the episodic or minor characters provide for comic relief.[43] Al Hafi, for instance, who is Nathan's chess partner and friend, finds himself in a comical conflict of interest right from the start: as a hermit he has become a "creature of the state," the treasurer of Saladin, and as such he visits his rich friend to use Nathan's capital to replenish Saladin's empty coffer. Al Hafi's existence as a monk contradicts his new role at the court, and his friendship with Nathan is endangered by his office as treasurer. He neither measures up to his official function nor does he want to rob his friend, so he runs away before the conflict breaks open in order not to lose his humanity. The other episodic character, the Patriarch, may appear today more murderous than comical. The role is clearly invented as a literary satire of Goeze's intolerance and dogmatism which should be laughed at. The parallels between Lessing's disputation with Goeze and the

inquisition of the Templar by the Patriarch can be clearly delineated in content and rhetoric. These parallels must have been far more obvious to Lessing's audience than they are today, but we shiver when the Patriarch monotonously repeats his verdict, "The Jew must be burnt." Here hatred disrupts the atmosphere of the comedy, and this caricature of a Christian bishop seems no longer comical. That this murderous fanaticism has no consequences for Nathan has to do with the structural function of the episode and with the role of the Friar in the play. Similar to the Dervish, the Friar—with the telling name of *Bonafides*—is not up to the task of being a spy for the Patriarch, as this contradicts his nature. As an obedient monk, he follows the orders of his superior, but as a simpleminded person he acts against the intentions of the Patriarch by warning the victim. That is his humane side; his comical one is that he is naive to the point of not even noticing his own narrow-mindedness. When he discovers to his surprise that Nathan behaves "like a Christian," Nathan corrects his hidden prejudices with the ironic reply: "Indeed, the very thing that makes me seem a Christian to you, makes you a Jew to me"—yet another aphorism of tolerance.

Lessing followed Diderot's theory of serious comedy even in that the virtuous hero is defined by his social conditions, which make him more probable and realistic. Nathan is a merchant, and money is the condition of his bourgeois existence. The title of the play could have been *The Merchant of Jerusalem*,[44] for Nathan is not only wise and virtuous but also very rich, and he knows how to use the power of money wisely. There is no other German drama where money is as important a part of the dramatic plot and dialogue. He is introduced as a merchant who comes back from one of his business trips on which he also collected debts. His caravan of "twenty heavily loaded camels" is described by Daja, and in the fourth act Nathan's "bags" (of gold or money) are piled up on the floor of Saladin's palace. Nathan uses his money freely to buy the silence of Daja, to reward the Templar, to get information from the Friar, and to support the bankrupt Sultan. In no other classical drama is the language of the play as permeated with financial terminology and metaphors of money; even in his monologue of contemplation before he delivers his parable of the three rings, Nathan plays with the allusion that the truth can be coined as if it were money.

What for Saladin is merely "the smallest of petty matters"—"fatal, cursed money"—is for Nathan the condition of his material existence. The sultan has at best an irrational relation to money; he suffers from lack of it, but somehow he hopes to fix the deficit sooner or later. He represents the crisis of feudalism, whereas Nathan, the merchant, has the financial power to help the ruler with advice —and money. Let us not forget that the whole discourse about tolerance, too, centers around money. It is Saladin's lack of money which leads to the central scene between him and Nathan, and their encounter was planned by Sittah, Saladin's sister, as a trap to hold the rich Jew's money hostage for the truth. Nathan anticipates what they are up to when he contemplates that they want the truth, "as if the truth were cash." He is skating on fairly thin ice, and he can only

hope to save himself with a "fairy tale." Even the famous ring parable, which is first and foremost a theological discourse, speaks of change: the old order is based on the privilege of one ring which makes its possessor "lord of the house," and after the "tyranny of the one ring" is broken, a new order emerges, based on equality, competition, and tolerance. The three brothers have an equal opportunity to prove, in free competition, the worth of their rings before God and the world. It does not seem too farfetched when critic Paul Hernadi attributes these values to the emergence of bourgeois society: the old privilege is replaced by the new work ethic. It is no surprise that Nathan, the merchant, is the prophet of this new ethos, since members of his profession were considered the most useful people of the commonwealth in the 18th century, for "they knit mankind together in mutual intercourse" of trade.[45] Nathan's profession as a merchant and his wise use of money distinguish him from Shylock, the usurer. This shift also makes it possible to change the attitude of the audience toward the Jew from prejudice to tolerance, from ridicule to respectability. Nathan is not only rich, as prejudice would have it, he is also respected because of his wisdom and his virtue. In short, he behaves almost as respectably as the bourgeoisie in the audience, which permits them to identify with him.

For the sake of the universal idea of tolerance, Lessing sacrificed the original ending of the comedy. In the first sketch, the play had a conventional happy ending with a double marriage: after the discovery of his real identity, Curd von Staufen (the Templar) marries Sittah, and Sittah "leads Rahel (Recha) to her brother." These interreligious marriages truly promise a happy future of love, peace, and tolerance. As the end stands in the final version, the Templar and Recha are surprised, if not shocked to find out that they are siblings and that they have to tame their passion into brotherly/sisterly love. The audience must be disappointed, too, and the allegorical arrangement of the end is a weak substitute for the joy of love, marriage, and the promise of rejuvenation of society. Even the final tableau of a family of mankind has a flaw, is a utopia tinged with mourning: all main characters are members of one family—except Nathan. He who arranged the reconciliation stands aside; he does not belong to this happy family.[46] A rather sad and provocative ending for a comedy. And yet, Lessing's ending is also realistic since it reflects the contradictions of his times, when tolerance could be postulated, but equality was still denied to the Jews.

Nathan is a rich merchant; he is as virtuous as Thorowgood (his English counterpart) from Lillo's *The London Merchant*—and, third, he is also a Jew. But Lessing plays down Nathan's Jewish identity to such an extent that some critics have even remarked that he is scarcely a Jew any longer.[47] Nathan's short narration about the pogrom in which he lost his wife and seven sons links his fate to the sufferings of his people, but he limits his Jewishness to his faith. In the idiom of tolerance, Nathan puts it thus: "We have not chosen a nation for ourselves. Are we our nation? What then is a nation? Are Christian and Jew first that before they are human beings?" Belonging to a people no longer matters

to Nathan, and the chance of birth has to be overcome by universal tolerance. Apart from his religion, Nathan's identity as a Jew is not marked by any specific Jewish manners or customs; he is not surrounded by a Jewish community, nor has he educated Recha according to the teaching of Judaism. "What, after all, is Jewish about Nathan?" asks George Mosse, and his surprising answer is that "to most Jews it was his *Bildung*—his wisdom and tolerance—which counted." Perhaps this is also the secret of *Nathan*'s success. Nathan the Good, as Saladin calls him at the end of the first sketch, who distinguishes himself not very much by his Jewish attributes, but rather by virtue of his *Bildung,* general humanity, and wealth, became the prophet of German Enlightenment. What he proclaimed on stage was the credo of natural religion, which matured into the religion of humanity during German Idealism. Everyone could identify with Nathan, the Christians as well as the Jews. For the Christians this drama was the poetic edict of tolerance, and for the Jews it became what Mosse has termed the "Magna Charta of German Jewry."[48]

The seriousness of this message has prevailed over the comic qualities of the play. Especially in the productions immediately after the defeat of Nazism, the solemn atmosphere of the performances did not allow for comic relief. Even if Lessing intended *Nathan the Wise* to be a serious comedy, the Holocaust overshadowed the reception of the play, and it has truly become a comedy without laughter. But we should not overlook the paradox offered by this serious comedy: namely, that sometimes we have to laugh in order not to cry. Or, to give the last word to witty Minna: "Can't one be very serious, even while laughing?"

Notes

1 Helmut Arntzen, *Die ernste Komödie: Das deutsche Lustspiel von Lessing bis Kleist* (Munich, 1968). The convincing interpretations of the book are based on the premise that "the few German comedies are, on closer scrutiny, in truth tragedies or tragicomedies or dramas which are (generically) undetermined"(p. 9). Arntzen fails to mention Diderot's theory of the *comédie sérieuse* and its influence on the comic genre in the second half of the 18th century. He leaves the reader with the impression that the "serious comedy" is his invention. This essay is a theoretical correction and supplement to his book.
2 Etienne Souriau, "Le risible et le comique," *Journal de psychologie normale et pathologique* 41 (1948). See also H. R. Jauss's discussion of this article, "Das lebensweltliche und das fiktionale Komische," in *Das Komische,* ed. W. Preisendanz and W. Warning (Munich, 1976), pp. 361ff.
3 See Manfred Fuhrmann, *Einführung in die antiken Dichtungstheorien* (Darmstadt, 1973), p. 63.
4 Ibid., p. 65.
5 Aristotle, *Poetics,* in *Theories of Comedy,* ed. Paul Lauter (New York, 1964), p. 10.
6 Ibid., p. 11.
7 Gerald F. Else, *Aristotle's Poetics: The Argument* (Cambridge, 1957), p. 74.
8 Aristotle, *Poetics,* p. 13f.
9 Ibid., p. 19.

10 Fuhrmann, *Einführung*, pp. 61f.
11 Aristotle, *Poetics*, p. 14.
12 Vincenzo Maggi, "On the Ridiculous," in *Theories of Comedy*, p. 65.
13 Ibid.
14 Ibid., p. 73.
15 Ibid., p. 69.
16 Ibid., p. 66.
17 Johann Christoph Gottsched, *Versuch einer Critischen Dichtkunst vor die Deutschen* (Leipzig, 4th ed., 1751), p. 643.
18 Horst Steinmetz, *Die Komödie der Aufklärung* (Stuttgart, 1966), p. 20.
19 Gottsched, *Versuch einer Critischen Dichtkunst*, pp. 644, 650.
20 Quoted from Alberto Martino, *Geschichte der dramatischen Theorien in Deutschland im 18. Jahrhundert* (Tübingen, 1972), p. 377.
21 Gottsched, *Versuch einer Critischen Dichtkunst*, p. 647.
22 Gotthold Ephraim Lessing, *Gesammelte Werke*, ed. Paul Rilla, 2d ed. (Berlin, 1968) 3:601.
23 Ibid., p. 642.
24 Ibid. 9:78.
25 Ibid. 6:149.
26 Ibid.
27 Lessing, *Minna von Barnhelm* (IV, 6) in his *Gesammelte Werke* 2:208.
28 Ibid. 6:149.
29 Joachim Ritter, "Das Lächerliche," in *Historisches Wörterbuch der Philosophie*, ed. J. Ritter, 4:3.
30 Gerald Friedländer, *Shakespeare and the Jew* (New York, 1921). As quoted in *William Shakespeare: The Merchant of Venice*, ed. W. Moelwyn Merchant (New York, 1967), p. 48.
31 Leslie A. Fiedler, *The Stranger in Shakespeare* (New York, 1972), p. 97.
32 Ibid., p. 109.
33 Hermann Sinsheimer, *Shylock: The History of a Character or The Myth of the Jew* (London, 1947), p. 144.
34 Elisabeth Frenzel, *Judengestalten auf der deutschen Bühne* (Munich, 1940), pp. 23, 31. It should be noted that this dissertation of 1938 is tainted by the anti-Semitism of the Nazi period; indeed, the book can be read as a paradigm of Nazi *Germanistik*. Only the bibliography of primary sources is still useful. A major revision is Helmut Jenzsch's dissertation, *Jüdische Figuren in deutschen Bühnentexten des 18. Jahrhunderts* (Hamburg, 1971), which tries to prove the rise of the "noble Jew" in German drama.
35 Lessing, *Gesammelte Werke* 3:676.
36 Walter Hinck, *Das deutsche Lustspiel des 17. und 18. Jahrhunderts und die italienische Komödie* (Stuttgart, 1965), p. 283.
37 Hans Mayer, *Außenseiter* (Frankfurt, 1975), p. 339.
38 Lessing's letter to Elise Reimarus, September 6, 1778.
39 Lessing's letter to Karl Lessing, October 20, 1778.
40 Elise Reimarus' letter to Lessing, May 18, 1779.
41 Still the best interpretation of *Nathan the Wise* as a comedy is Peter Demetz's essay "Lessings 'Nathan der Weise': Wirklichkeiten und Wirklichkeit," in *Lessing: Nathan der Weise: Dichtung und Wirklichkeit* (Berlin, 1966), pp. 121–58; also in *Lessings "Nathan der Weise,"* ed. Klaus Bohnen (Darmstadt, 1984), pp. 168ff.
42 Northrop Frye, *Analyse der Literaturkritik* (Munich, 1964), pp. 165–87.
43 A comparison with *Minna von Barnhelm* would show how Lessing uses this technique of comic relief in both comedies. See Demetz, pp. 126ff.
44 This aspect invites interesting comparisons with Shakespeare's and Lillo's merchant dramas.
45 Joseph Addison, *Spectator* 69 (May 19, 1711). Quoted in Paul Hernadi, "Nathan der Bürger: Lessings Mythos vom aufgeklärten Kaufmann," in *Lessings "Nathan der Weise,"* p. 348.
46 An anecdote may underscore this point. In 1933, when the Jews were excluded from Germany's cultural life, they founded the *Jüdischer Kulturbund*. Its first theater production was *Nathan the Wise*, and it ended as it never had before. As George Mosse tells it: "Nathan stayed behind, proud and lonely at the front of the stage as the curtain fell." See George Mosse, *Germans and Jews beyond Judaism* (Cincinnati, 1985), p. 16.
47 Demetz, "Lessings 'Nathan der Weise,'" p. 122.
48 Mosse, *Germans and Jews*, p. 15.

Satire Prohibited:
Laughter, Satire, and Irony
in Thomas Mann's Oeuvre

BURGHARD DEDNER

I

The *Betrachtungen eines Unpolitischen,* Thomas Mann's long and elaborate account of why, between 1914 and 1918, he supported Germany's conduct of the war, including the declaration of war and the assault on Belgium, contains a chapter entitled "Einiges über Menschlichkeit," in which, among other things, the author describes how one day he was struck by the sight of a one-armed man leading a blind man through the streets of Munich. Both wore uniforms; both were evidently war cripples (I use this drastic and unsentimental term on purpose). The author says that this sight initially provoked in him "human" emotions; that he reacted with pity and fury, with the thought of "never again will we allow this to happen," with the gesture of "j'accuse" directed against the war mongers of all nations. "Euch haben sie zugerichtet! dachte ich. Nein, es ist ungeheuerlich, Wahnsinn, Verbrechen und Schande. Nie darf und nie wird es wieder sein" (*GW* 12:471).[1]

He approached the two cripples, knowing that, seen close up, life is "schlichter, bescheidener, unrhetorischer, kaum je ohne humoristischen Einschlag, und kurzum viel menschlicher ist es dann gleich" (ibid.). Sure enough, the observer's anger diminished as soon as he came closer. It was a nice spring day; the two cripples seemed to be enjoying the weather and even the attention they were getting from the public; they were talking about trivial concerns such as lunch or digestion; one of them started laughing; they were using the guttural sounds of the Bavarian dialect: "Der Einarmige sah sich manchmal die Menschen an, der Blinde konnte sie nicht sehen, er stierte künstlich geradeaus; aber er wußte ja, wie sie meistens aussahen, und sehr viel hatte er nicht daran verloren. Das Wetter war schön, wie gesagt. Sie gingen und atmeten die angenehm herbe, nach welkem Laub duftende Luft, und die Sonne schien ihnen auf die Nase" (*GW* 12:472).

The observer's anger diminishes even more when he imagines what these two men must have experienced in the last months. Obviously, they had been wounded and had suffered badly up to the point when medical attention alleviated

most of their pain. They soon enjoyed the coziness of their beds, the warmth and comfort of a hospital, the camaraderie of their fellow sufferers. One of the men, to be sure, had lost his arm; yet couldn't a one-armed man still get an adequate job on, say, a farm or in a factory? And the other one, the blind man? Thomas Mann confesses that blindness had once seemed to him to be a fate worse than death until he had been told that deafness, not blindness, was the real curse. Blind men, he assures us, are remarkably happy; in fact, they can be so jolly that they throw their glass eyes at each other in their hospital wards.

We all would agree, I assume, that this text is an extraordinary display not of human but of barbarian feelings; that it shows an author who is obviously determined to be blasé and to ridicule those who refuse to share his petty cynicism. Yet one may ask what bearing this anecdote has on my topic. To be sure, it could provide us with sufficient material to write a satire on Thomas Mann. But does it in itself contain elements of satire? Does it show traces of irony? I shall try to demonstrate that it does both.

Satire, according to the easiest and most pragmatic definition, is "aesthetically socialized aggression."[2] Satire can—if the object of attack carries little weight—be "jesting," or—if the object of attack is important—it can be "pathetic."[3] Jesting satire achieves its goal by arousing laughter; pathetic satire arouses emotions such as indignation or hatred. Translated into everyday situations, a politician or a district attorney who portrays his opponents in such a way as to arouse our hatred uses the means of "pathetic" satire; a student who, with the intent of arousing the laughter of his peers, mimics his teacher's mannerisms, makes use of "jesting satire."

If we follow these distinctions, we can easily conclude that Thomas Mann, at the beginning of his anecdote, strikes a satirical note. Indeed, he approaches his subject as if he intended to write a pathetic satire on wartime politics. He gives a vivid description of two men mutilated in war, then directs our attention to the causes of their suffering, and, with the help of the initial image, he arouses emotions such as anger and fury. In this respect, the beginning of the anecdote resembles some of the best prints by George Grosz or paintings by Otto Dix, works of art in which we are confronted with both the victims of gas and trench warfare and with the people who, through their words, their actions, or just their indifference, helped to send them there.

How about the second part of the anecdote? My assumption that pity and fury are the normal and, indeed, the only possible reactions to war cripples is—according to Thomas Mann—based on an error. Reality consists of the two opposite spheres of *Leben* and *Geist*—a pair of opposites so genuinely German that I shall not try to translate these terms. By his very profession, the *homme de lettres* is necessarily a partisan of *Geist*. As long as he does not reflect the partiality of his position, he will, therefore, support the claims of *Geist* against *Leben;* he will attack reality in the name of ideals.[4] To sum up this argument: Thomas Mann's first reaction to the sight of war cripples was not natural; it only proved him to be a partisan of *Geist,* a victim of his profession.

An author who has overcome such shortcomings will try to steer a middle course between the claims of *Leben* and *Geist,* or—according to the definition given in the *Betrachtungen*—he will react ironically. An ironic writer will do justice to the demands of his opponent, those of *Leben;* he will lovingly embrace everything that is not "reason and art," that is "unschuldig, gesund, anständig-unproblematisch" (*GW* 12:91): he will—to come back to our example—accept the brutal facts of *Leben.* Thomas Mann's second and final reaction, then, was ironic. The ironic writer renounces the demands of *Geist,* which told him that all wars had to be stopped; he exchanges the position of attack for the more subservient one of the faithful observer; he listens to the voices of life and finds that they are reassuring, harmless, "human," and that, contrary to what the satirist might think, life is capable of healing all wounds.

It is in a later chapter with the title "Ästhetizistische Politik" that Thomas Mann sums up such observations in order to launch an attack on satirical writing in general. The attack is specifically directed against works by both Heinrich Mann and the new Expressionist generation, against writers who publicly opposed the war. The title of the chapter already hints at Thomas Mann's major and most serious argument against such antiwar satires. He tries to convince his readers that the authors are, and always were, aestheticists who have temporarily changed their field of operation. They claim to be politicized; yet their interest in politics is an aesthetic one, and they pursue political goals in order to satisfy their aesthetic needs. In more general terms, the satirical writer is the aestheticist's brother; like him, he is more concerned with art than with reality; like him, he has no true knowledge of the real world, which he keeps at a safe distance (*GW* 12:537–67). The anecdote of the two war cripples is told in such a way as to prove this point. In the initial phase of satirical attack, the observer kept his distance; as soon as he came closer, his anger disappeared. Satire—in this respect, the structural equivalent to aestheticism—is a product of distance; irony is a product of close observation.

II

In her book on satire and humor, Georgina Baum has argued that to the same degree that 19th-century German authors were making peace with society, they considered satire an inferior or marginal literary genre. According to Baum, this development was triggered by the failure of the 1848 revolution.[5] Yet if we want to find early traces of literary theories that argue against satire and in favor of either irony or humor, we can go back to the works of Friedrich Schlegel and Hegel. These writers were bitterly opposed to each other; both, however, were reacting to the experience of the French Revolution. We should use this referential point as well, if we want to understand both Thomas Mann's aversion to satire and his use of the terms *Leben* and *Geist.*

Geist, of course, is the key word for the Enlightenment and its practical consequence, the French Revolution; the term *Leben* is dear above all to the Post-

and Neo-Romantics. It had been one of the programmatic claims of the Enlighten-
ment that all traditions, i.e., the political and social status quo, submit to the
judgment of "reason," or—to quote Schiller's definition of satire—that reality
be compared with the ideal. In the view of Romantic and later conservatives,[6]
this procedure meant that the enlightened proponents of *Geist* arrogated to
themselves the authority to change *Leben,* alias a political system based on feudal
privileges and the power of the not always enlightened despots, according to their
principles. The result of this arrogance was then demonstrated by the supposed
failure of the French Revolution which, again from the conservative perspective,
proved that *Leben* was of a higher value than the claims of reason.

 This basic opposition is again characteristic of some of the literary and political
controversies during World War I. Many German intellectuals who publicly and
through satirical writings opposed German war policies placed themselves in the
traditions of both the Enlightenment and the French Revolution; in this respect,
the author of the *Betrachtungen* was certainly right in calling literary satire a
weapon of *Geist* against *Leben.*

 In the same manner, Thomas Mann's second observation, the supposed struc-
tural identity of satire and aestheticism, can be understood best if one considers
the downward path which led from 18th-century idealism to *fin de siècle*
aestheticism. At the time of the French Revolution, Schiller was certainly justified
in thinking that the enlightened writer could proclaim ideals common to mankind;
that these ideals stood above the concerns of disputing parties; and that literary
satire was a nonpartisan institution. Hence, the unmitigated pathos of some of
his dramatic heroes—a pathos which possibly sounded convincing in the 1790s
but which would have sounded hollow around 1900. By then, the once revolu-
tionary class had forsaken its "ideals" in favor of "real" values such as finan-
cial and political power, while the most ardent critics of bourgeois society, the
socialists, regarded ideals as part of a superstructure the material basis of which
was located elsewhere. In this situation, only two major options remained to the
middle-class oppositional writer. He could—in the manner of Flaubert[7]—choose
indirect means of attack, distinguish between esoteric and exoteric levels of mean-
ing, and hide his satirical indignation behind a mask of irony; or he could—in
the manner of Stefan George—substitute aesthetic ideals for the former moral
and political ones. At a time when values such as justice, freedom, and reason
might have seemed tarnished by decades of inhumane politics conducted in their
name, to attack ugliness in the name of beauty appeared a possible way of preserv-
ing the dignity and pathos of satirical writing.

 Thomas Mann preferred the ironic option. He did not think highly of aestheti-
cism;[8] he thought even less of the newly acquired political creed of some former
aestheticists and, in general, of the political turn German literature was taking
before and during World War I. These facts can be explained—although not justi-
fied—by such historical experiences. Weren't Heinrich Mann and the Expres-
sionists, Thomas Mann could ask, falling back behind the lessons of history; were

they not arrogating for themselves a status of naiveté forbidden to the 20th-century writer?[9] Had not 19th-century history been the story of illusions lost? The argument was hard to counter. When Heinrich Mann—in his essays "Geist und Tat" (1910) and "Zola" (1915)—upholds the banner of political idealism, he resembles a self-conscious Don Quixote who confronts the disillusioning lessons of history with indefatigable heroism, with an emphatic "and yet," "and even though." In his view, July 14, 1790, the first celebration of the fall of the Bastille, had proved once and for all that mankind was capable of forming a universe of brotherly love, and that the utopian ideal could become real.[10] In the light of such bliss, all later disappointments lost their importance. Similarly, Heinrich Mann celebrated Emile Zola's precarious victory in the Dreyfus affair as a clear sign that *Geist* will prevail. For Thomas Mann, however, the Dreyfus scandal only illustrated the high degree of corruption possible in a society supposedly founded upon the principles of equal rights and justice for all.[11] In this same manner, he relentlessly exposed the inner contradictions of those oppositional writers who pretended to oppose the war for humanitarian or pacifistic reasons when, in reality, they were partisans of the Western allies, and he had nothing but ironic comments for Wilson's rhetoric about making the world "safe for democracy."[12]

Besides the opposition of "illusions kept" and "illusions lost," the opposition of "closeness" and "distance"—a factor common to aestheticism and political satire—was, as we have seen, a second parameter in the debate concerning the respective values of irony and satire. It is in this respect, I think, that Thomas Mann's position is totally wrong.

Let us first consider the supposed connection between distance and aestheticism, and then the relationship between distance and satire. The best example may be the novella *Tristan* (*GW* 8:216–62). Its hero, an aestheticist by name of Spinell, shows his contempt of the burghers with their plain appetites, who are so "wirklichkeitsgierig," or greedy for reality, that they always approach women as closely as possible and stare into their faces. Spinell casts only furtive glances at them, barely enough to feed his mind with a few impressions which he will then embellish to the point of ideal beauty. Any close look at reality would, of course, deprive him of such imaginary ideals. Thus, not only is the ideal unreal, but the very distinction central to the aesthete's thinking, that between beauty and ugliness, has no basis in reality. It is a product of the imagination. Reality is a mixed bag; it lacks such clear opposites as beauty and ugliness, and it also lacks the distinctions basic to idealistic satire, such as good and evil, just and unjust, moral and immoral. At worst, such distinctions are lies; at best, they are a product of distance. Why did Heinrich Mann, this ardent admirer of French political and literary traditions, never visit Paris in order to verify his opinions? He has avoided Paris, we are told, because he knows that only he can keep faith in his ideals who does not test them.[13]

Thomas Mann may be right in pointing out that 20th-century idealistic satire owes much to its distant, quasi-aestheticist perspective. Yet what he calls the

perspective of "life" is the school of emotional barbarity for the very reason that what he calls "life" is even more abstract than the constructs of reason. It is, after all, not life but human beings who are responsible for the atrocities of war. In sum, both Thomas Mann's close observations and his imagination concur in shielding him from the experience of suffering, which might seem to prove that pathos or irony are not necessarily products of either distance or closeness. Perhaps we should even say that satirical pathos is most likely a function of the closest possible perspective.

In Georg Büchner's drama *Dantons Tod,* the deputy Lacroix—until then a member of the ruling party, now incarcerated and soon to be executed for high treason—marvels at the number and at the miserable state of the prisoners around him. His fellow prisoner Mercier, who has already spent a year in jail, answers him by quoting bits of political rhetoric, adding: "Geht einmal euren Phrasen nach, bis zu dem Punkt wo sie verkörpert werden. Blickt um euch, das Alles habt ihr gesprochen, es ist eine mimische Übersetzung eurer Worte."[14] Karl Kraus, one of the most eminent German satirical writers of this century, quoted these sentences in order to show how antiwar satires might be written.[15] The satirist—it follows from this example—must pursue the path which leads from the abstract to the real, from the distance of the intellect to the closeness of life, from the political slogan, purposefully or thoughtlessly coined and repeated, to the victims of gas and trench warfare. Satire does not rely upon abstract ideals but on the suffering imprinted on the faces and bodies of peace- and wartime victims and on the cruelty and indifference of those who keep alive these machineries of destruction and profit from them. Such satires are written not in the name of *Geist* but in the name of *Leben,* of suffering life, and their pathos, far from being a function of distance, is based on the artist's refusal to repress or to minimize that which he has seen.

III

It was between the completion of *Buddenbrooks* (1900) and the appearance of *Tonio Kröger* (1903) that Thomas Mann first raised objections to the satirical mode of literature. To do justice to our topic we therefore have to widen our scope of observation beyond the political and literary debates of World War I. At the same time, we should refrain from focusing our attention only on literary satire; rather, we should also have a look at Thomas Mann's portrayal of everyday satirical situations, situations which are part of our daily lives.

Here again, the distinction between "jesting" and "pathetic" satire applies. Let me give an example. In the first part of *Buddenbrooks,* ten- or twelve-year-old Christian Buddenbrook tells his family how his religion teacher had publicly scolded one of the pupils with the sentence: "Äußerlich, mein gutes Kind, äußerlich bist du glatt und geleckt, ja, aber innerlich, mein gutes Kind, da bist du schwarz . . ." (*GW* 1:17). I suggest interpreting this scene as an example

of everyday pathetic satire. Christian, in an attempt to arouse his audience's laughter, imitates the teacher's gestures and words and thus exposes him to "jesting" satire, although in a very mild form.

It is for two reasons that I draw attention to such scenes of everyday satire, or—as we may also say—of derision and contempt. First, it seems to me that such scenes, i.e., the traumatizing experience of being the possible object of ridicule, provided young Thomas Mann with his most basic and most central incentives for writing. And second, if we look at such scenes, the former assumption that satire is a weapon used by the representatives of *Geist* against the forces of *Leben* has to be qualified. Thomas Mann's early writings demonstrate that, in his experience, derision was one of the weapons used by the social insiders of his time, by those who represent *Leben;* if the representatives of *Geist* make use of satirical means as well, they use them as a weapon of defense.

The author who, in *Betrachtungen,* seems almost incapable of taking other people's sufferings seriously had, fifteen years earlier, spoken of suicidal plans, or "Selbstabschaffungspläne," as he called them.[16] It is not surprising, therefore, that his early works are, above all, an expression of suffering. Time and again, the author presents in them scenes of laughter directed against his heroes. Such scenes may occur, as in the early novella *Der Wille zum Glück,* on the first day of school, when the hero looks through moist eyes at the mocking crowd of his peers with their grinning faces (*GW* 8:43). They also occur in later school years, where derision is used as a weapon by teachers and students alike. Tonio Kröger is the victim of laughter when, in one of his dancing lessons, he crosses the barrier of the sexes and joins the girls (*GW* 8:285f.). When Prince Klaus Heinrich, the hero of *Königliche Hoheit,* speaks to his fellow high school students, he is always greeted by the sound of "Hoho," a sound of laughter precariously on the verge of derision (*GW* 2:92f.); and those attending the citizens' ball, a group of young people closely resembling a Dionysian crowd, treat him like a carnival fool (*GW* 2:103f.). When the Bajazzo, the hero of an early novella, trying to approach a young lady, meets her testing glances and her companion's grin, he suddenly becomes aware of the fadedness of his clothes and, more generally, of the fact that he has become an outcast of the social class to which his family had once belonged (*GW* 8:136f.). Derision is an important feature of the pivotal scenes in *Der Tod in Venedig* and of the closing scenes of such stories as *Der kleine Herr Friedemann, Tristan, Luischen, Der Weg zum Friedhof, Gladius Dei.* In these cases, laughter often accompanies the hero's death.

Only a strong personal trauma can explain the frequency and central position of such scenes. Nor are the reasons for this trauma hard to find. Young Thomas Mann was the—obviously inept—descendant of an important merchant family. He was a catastrophic high school student, aroused further suspicion by his haughtiness, and was an outsider because of his latent homosexual preferences. Away from Lübeck, in Munich, he retained this outsider position, being a North German among Bavarians, a patrician among rebels, a conservative among saloon

anarchists. As late as 1910, the eminent critic Alfred Kerr and the philosopher Theodor Lessing wrote satirical reviews about Thomas Mann's works and personality.[17]

The short form of the novella does not allow much more than a presentation of scenes; the author of a novel can explain the historical conditions under which derision can thrive as a prominent form of social interaction. *Buddenbrooks* gives such explanations by contrasting the atmosphere of bourgeois life at the beginning and at the end of the 19th century. The scenes already referred to—the teacher's scolding words and Christian's mockery—are totally lacking in seriousness. The teacher's pathetic satire strikes no real wounds, and Christian's jesting satire merely adds to the amenities of life.

The last parts of *Buddenbrooks* show the atmospheric changes brought about by Lübeck's integration into Prussia, by Prussian militarism, the politics of imperialism, and the political and economic modernization of the country leading to new and tougher forms of competition. Satirical exposure, under such circumstances, assumes the meaning which the philosopher Hobbes, familiar with 17th-century despotism and the emergence of the modern state, ascribed to it.[18] It is a weapon with which the subjects of such states fight their wars of competition.

How can the victim of derision and humiliation counteract the attacks directed against him? First of all, he must hide his feelings. This holds true both for normal social life and for the writing of literature. In everyday life, any open display of weakness will only increase the aggressors' pleasure. In the literary sphere, the direct, undisguised expression of an author's warm heart and sincere emotions is the trademark of the dilettante. It would provoke embarrassment and laughter both in middle-class social circles, where such frankness is considered tactless, and among professional writers, for whom art is a matter of form, not of content. Seen from this perspective, literature depends heavily on techniques of concealment, on the art of expressing one's own situation—as Thomas Mann did—through the portrayal of old beggars and hunchbacks, of clowns and ridiculous outsiders.[19] More than anything else, such techniques contribute to the ironic texture of his early writings. Irony at this stage was not an ambivalent affirmation of "life"—as it is defined in the *Betrachtungen*—but rather a reaction to a literary and social taboo.

Besides concealment and irony, there is a second possible means of reacting to the fear of derision. The author can counter it with his own laughter. Shortly before the dance master François Knaak makes him the target of derision, Tonio Kröger had, on the private stage of his imagination, ridiculed his teacher:

> Er schritt—und niemand schritt wie er, elastisch, wogend, wiegend, königlich— auf die Herrin des Hauses zu, verbeugte sich und wartete, daß man ihm die Hand reiche. Erhielt er sie, so dankte er mit leiser Stimme dafür, trat federnd zurück, wandte sich auf dem linken Fuße, schnellte den rechten mit niedergedrückter Spitze seitwärts vom Boden ab und schritt mit bebenden Hüften davon . . . Was für ein unbegreiflicher Affe, dachte Tonio Kröger in seinem Sinn. (*GW* 8:283f.)

In the same way, Hanno Buddenbrook and his friend set up an imaginary satirical cabaret in which the "Anstalt," the institution of learning, resembles a mental institution where the *Lehrkörper*, the "faculty body," takes on a monstrous shape and where the head master figures as a tyrannical god (*GW* 1:722f.).

Such scenes, literary satires in embryonic form, are one possible answer to the threats of degradation and derision; in this respect, the heroes certainly stand for the author. One should remember that, in 1902, a district attorney cited *Buddenbrooks* as an example of libelous satire; that the burghers of Lübeck exchanged keys revealing the "real identity" of the persons mentioned in the novel; and that, as late as 1955 when Thomas Mann was to be named an honorary citizen of his home town, the CDU members of the city council abstained from casting a vote because they still had not forgiven the author for the less than flattering portraits of their honorable ancestors. To be sure, *Buddenbrooks* is much more than a small town satire; still, the satirical mode is one of its features.

Thomas Mann reacted to the district attorney's reading of *Buddenbrooks* by declaring publicly that, in his writings, he had never meant to expose any human being other than himself and that, far from being satires, his writings were indeed autobiographical confessions.[20] This interpretation is untenable; all it shows is the author's intention to switch sides and to make his peace with society. Four years earlier, in 1902, he had already written a story entitled *Die Hungernden,* in which he explicitly and programmatically rejected the weapon of satire. It deals with a writer named Detlef who has visited an opera ball, and tried to make friends with a young lady, Lili, and her companion, but has been rejected. While leaving the ball, he imagines the relief this couple must feel upon his departure; he depicts to himself their tacit and smiling understanding that he is but a queer character. At the same time, however, he is aware that his writing talents—or, more specifically, his satirical talents—can give him power over those who reject his overtures:

> Ihr seid dennoch mein, empfand er, und ich bin über euch! Durchschaue ich nicht lächelnd eure einfachen Seelen? Merke und bewahre ich nicht mit spöttischer Liebe jede naive Regung eurer Körper? Spannen sich nicht angesichts eures unbewußten Treibens in mir die Kräfte des Wortes und der Ironie, daß mir das Herz pocht vor Begier und lustvollem Machtgefühl, euch spielend nachzubilden und im Lichte meiner Kunst euer törichtes Glück der Rührung der Welt preiszugeben? (*GW* 8:266f.)

Undoubtedly, the author is preparing to write a satire on those who have rejected his pleas for friendship.

Outside the opera house, however, Detlef confronts a beggar who takes him in from top to toe and lets out a contemptuous snort, which makes the hero realize his error. Lili, Detlef, and the beggar all are involved in an eternal power struggle. This struggle, in which contempt, laughter, grinning, and satire count among the weapons, is based on nothing but a misunderstanding of the human condition. Essentially, man is suffering; he is in need of love and "hungry" for affection,

an insight the author draws from both Schopenhauer and the New Testament. The story ends with the sentence: "Und während er daheim unter seinen Büchern, Bildern und still schauenden Büsten saß, bewegte ihn dies milde Wort: 'Kindlein, liebet einander . . .' " (*GW* 8:270).

In a letter to a friend, Thomas Mann dismissed this closing sentence as "bis zur Trivialität unbeträchtlich,"[21] and we should certainly respect his critical judgment. In its emblematic character, the story nevertheless deserves attention. Derision, we are told, is a weapon of everyday life; satire, in its full literary development, is a form of revenge which perpetuates a useless struggle that ought to be replaced by universal compassion. This, at least, is the suggestion on which the story ends—a suggestion both morally impeccable and practically useless in a society based on competition, and heading toward war. The solution suggested in *Tonio Kröger* and repeated in *Betrachtungen* is, in this respect, not much better. Here, the potential satirist is instructed to take an ironical stand, which is defined as the willingness of the mind to accept and even love the behavior of mindless "life"; this benevolence is based on the tacit assumption that the representatives of "life" are harmless, good-natured, even lovable. *Buddenbrooks* and most of the early novellas, works which seemed to be founded on the author's firsthand experiences and insights, had shown the opposite.

Reinterpreting his own satirical texts as autobiographical studies was Thomas Mann's first act of submission to society; in a second such act, he ascribed the satirical vein to the supposed foes of both life and culture. Thomas Mann's second novel, *Königliche Hoheit,* a text which is more strongly influenced by social and political theories of a decidedly conservative nature, points in this direction. In the closing chapters of *Buddenbrooks,* derision had developed into a weapon used by the powerful; literary satire was a potential counterweapon. In *Königliche Hoheit,* it is a coalition of *Geist* and the modern form of capitalism which wields the weapon of satire against "life," that is, against the political and cultural status quo of the German empire.

In the German provincial town which is the scene of the novel, the "people," *Volk,* treat their monarch with the respect owed to a father; both the journalists and the young members of the middle classes, on the other hand, try to make the hero the target of their laughter and criticism. In addition, the reader is told that under the more advanced social conditions of New York City the *Volk* has been transformed into a mob that persecutes the modern version of kings—the owners of industrial wealth, with their laughter, their hatred, and their murderous feelings (*GW* 8:232, 263). Derision and public persecution are weapons used in the class struggles of modern society. In Thomas Mann's thinking, however, the parties involved in this struggle are not the rich and the poor, the exploiters and the exploited, but rather the representatives of *Kultur,* on the one hand, and the forces of barbarianism, on the other. In Nietzsche's *Geburt der Tragödie,* the likely model for this thought, the hordes of Dionysus had embattled Apollo's temples in a similar way.

At the time of his *Betrachtungen,* Thomas Mann radicalized these thoughts and, thereby, practically reversed the analysis given in *Buddenbrooks.* The forces of life incarnated in the German empire, which once had haunted Hanno Buddenbrook, must now guarantee the survival of culture, while pro-Western intellectuals, the authors of satires, constitute the real danger. Thomas Mann now sides with those who laugh against those who write satires. One should not, however, overlook the political versatility of this basic structure which still prevails in the novella *Mario und der Zauberer.* Here, in Thomas Mann's first portrayal of fascism, the seduction of the masses relies partly upon the show master's ability to turn the audience's laughter and contempt against his opponents and victims, and, once again, it is a member of the *Volk* who succeeds in breaking the spell. The author, in commenting upon his story, could not quite make up his mind whether or not it should be read as a satire on Italian fascism.[22]

IV

Scenes of derision, public exposure with the intent of arousing laughter and contempt, jesting satire: all these connected phenomena can be weapons of the powerless. They can be expressions of discontent and enactments of a social struggle, and Thomas Mann may have been right in giving them a major role in his descriptions of 20th-century society. One should remember, though, that the role of derision is limited. It may be directed against representatives of values and power, but it is not a weapon which the hungry will use against the well-fed, or the mutilated against their tormentors and butchers. Charlie Chaplin's movie *The Great Dictator* would be a convincing example of jesting satire if Hitler had endangered nothing but the cultural life of Europe. In matters of life and death, wherever material, physical needs are under attack, only pathetic satire is allowed. Thomas Mann's conspicuous barbarity in the anecdote from his *Betrachtungen* was caused by the very refusal to make this distinction, by an attempt to treat serious matters lightly and to switch—in the face of war cripples—from pathetic satire to irony. Let me finish with the question why Thomas Mann refused to make this distinction, or—to be more precise—why he tried to reverse various kinds of physical and cultural suffering.

A brief look at the story *Die Hungernden* can yield a first hint. In this story we are given an extensive inside view of Detlef's psychic sufferings; in contrast, the beggar who appears at the end of the story is but a symbolic figure, an incarnation of the contemptuous and aggressive drives which pose a possible threat to social stability. The title *Die Hungernden* allows the author to compare the writer and the beggar under the heading of "hunger." The emphasis, however, lies on the hunger of the soul; the hunger of the stomach is outside Thomas Mann's range of concern. In an afterthought to the cripple episode, the author of *Betrachtungen* compares various kinds of suffering. Those who decry the pains inflicted by warfare are reminded that peacetime capitalism had produced slums,

cripples, starvation, and that—infinitely more important—it had produced psychic
traumata, had struck wounds of the soul which life does not heal:

> Nicht das pittoreske und blutig-augenfällige Elend ist das tiefste und eigentlich
> entsetzlichste auf Erden; es gibt Leiden und Qualen, Entwürdigungen der Seele, bei
> denen dem Menschen die Lust vergeht, mit Glasaugen zu werfen, Wunden, die keine
> Menschenhand betreut und um die keine öffentliche Karitas sich kümmert, innere
> Verstümmelungen, ohne Ehre, Eisenkreuz und Heldentum, die nicht zur erbaulichen
> Erschütterung der Mitwelt in der Herbstsonne spazierengeführt werden und von denen
> diese Welt voll sein wird, auch wenn wir die Segnungen des ewigen demokratischen
> Völkerfriedens genießen. (*GW* 12:475f.)

In speaking of such psychic sufferings, the author is of course referring to his
own experiences, experiences of suffering the expression of which forms the
esoteric meaning of Thomas Mann's early work—a meaning hidden behind the
surface of grotesque masks and shapes. Since in his society psychic suffering
was a possible source not of pity but of laughter, embarrassment, and indigna-
tion, it needed to remain silent and, in this respect, may have seemed less privileged
than the "picturesque" forms of misery. In his earliest novellas, the author Thomas
Mann circumvented the taboo of psychic exhibitionism by translating psycho-
logical suffering into the physical pains and deformities of his fictional heroes—
an ironical procedure. This procedure, combined with a typical middle-class lack
of experience, may have contributed to his insensitivity toward physical suffer-
ing. It may also explain how Thomas Mann could conceive the idea that satirical
pathos in view of war cripples was of a metaphorical nature; that it was a func-
tion of aestheticism and distance; that the pains of the mutilated counted little
in comparison to those of the peacetime psyche.

 Another aspect of this distortion needs considering. Since for Thomas Mann
physical suffering is of metaphorical value only, it does not count as a legitimate
stimulus for political action. Consequently, when he analyzes political movements,
mass actions, revolts, and revolutions, he does not think of them in material terms
as attempts at redistributing social wealth and alleviating hunger, poverty, or other
causes of degradation and despair, but instead always analyzes them in terms of
anticultural movements, as Dionysian assaults upon Apollonian culture. This dis-
torted perspective—which, by the way, has been a central feature of the middle-
class trauma of revolutions since the Enlightenment—also accounts for the im-
portance of derisory scenes in Thomas Mann's works. Derision is one of the first
signs of an assault directed against the fragile fortress of culture; the young author
might have considered satire a legitimate weapon of defense. In *Königliche Hoheit,*
oppositional journalists direct their satirical attacks against the cultural represen-
tative, the novel's hero; in *Betrachtungen eines Unpolitischen,* satire is definitely
considered a weapon with which the *homme de lettres* seeks to promote Western
civilization at the expense of German culture. The satirist has become the useful
idiot of Dionysian "barbarianism."[23] All this makes sense only within a frame-

work of cultural analysis, not of social analysis—let alone a framework of pains caused and suffered.

I know of only a few examples in Thomas Mann's works where scenes of derision assume a positive quality. The most important one may be a chapter in the last part of the *Joseph* novels where Pharaoh's lieutenant Joseph succeeds both in feeding the hungry people of Egypt and in serving his lord by depriving the Egyptian landlords of their wealth and their power. Joseph avoids open conflicts; he relies solely upon his cunning, upon his ability to outwit his dumb opponents—nature, on the one hand, the country's feudal relics, on the other. Joseph's cunning arouses the merriment of the people. At the same time, the losers of this social change, the landlords, become the laughingstock of the populace:

> Tatsächlich wurde im Volke viel gelacht—und zwar bewundernd gelacht—darüber, wie Joseph, unter gelassener Ausnutzung der Preislage im Umgange mit den Großen und Reichen, für seinen Herrn, den Hor im Palast sorgte . . . (*GW* 5:1759)

In retelling the biblical story, Thomas Mann deliberately uses an older version in which this event approaches the genre of *Schwank*. The narrator draws attention to

> gewisse derbe Wendungen von ausgesprochen komischer Prägung, die wie stehengebliebene Reste einer volkstümlichen Farce wirken und durch die der Charakter des Urgeschehens hindurchschimmert. So, wenn die Darbenden vor Joseph schreien: 'Her mit Brot für uns! Sollen wir etwa sterben vor dir? Geld ist alle!'—eine sehr tiefstehende Redensart, die im ganzen Bereich der Fünf Bücher sonst nicht vorkommt. Joseph aber antwortete darauf in demselben Stile, nämlich mit den Worten: 'Los! Her mit eurem Vieh! Dafür will ich euch geben.' In diesem Ton haben die Bedürftigen und Pharaos großer Markthalter selbstverständlich nicht verhandelt. Aber die Ausdrucksweise kommt einer Erinnerung daran gleich, in welcher Gesinnung das Volk die Vorgänge erlebte—einer komödienhaften Gesinnung, die moralischer Wehleidigkeit ganz entbehrte. (*GW* 5:1760)

There are two reasons why the laughter of the people is now seen as a legitimate reaction. In his sociopolitical reforms, Joseph acts as the servant of a monarch whose major concerns are religious discoveries and cultural improvements; the masses are, therefore, not unleashed but carefully tied to higher concerns.[24] At the same time, however, the author, who by then has lived through most of the Nazi period and has seen the success of the New Deal, has learned that hunger and physical suffering are not minor matters, let alone metaphors, and that laughter directed against oppressors and exploiters can be justified even if it comes from below.

Notes

1 Thomas Mann is quoted from his *Gesammelte Werke in zwölf Bänden* (Frankfurt, 1960) according to volume and page numbers.
2 "Satire ist ästhetisch sozialisierte Aggression (eine Satire ist ein Werk, das ganz davon geprägt ist)." Thus Jürgen Brummack, "Zu Begriff und Theorie der Satire," *Deutsche Vierteljahrsschrift für Literaturwissenschaft und Geistesgeschichte* 45 (1971), Sonderheft Forschungsberichte, p. 282.
3 I am using this ambiguous term on purpose. Pathos is the mode of speech reserved for *serious* matters and thus the opposite of jest.
4 According to Schiller's famous definition: "In der Satyre wird die Wirklichkeit als Mangel, dem Ideal als der höchsten Realität gegenüber gestellt." *Schillers Werke: Nationalausgabe* (Weimar, 1962) 20:442.
5 Georgina Baum, *Humor und Satire in der bürgerlichen Ästhetik: Zur Kritik ihres apologetischen Charakters* (Berlin, 1959). Perhaps one should slightly correct this thesis. Since such writers as Jean Paul and Heinrich Heine considered themselves humorists, and since the young Friedrich Schlegel and Heine spoke in favor of irony, the rule which equates irony and humor with conservatism must allow for exceptions.
6 This is still the major thesis suggested by Reinhart Koselleck, *Kritik und Krise: Ein Beitrag zur Pathogenese der bürgerlichen Welt* (Frankfurt, 1967).
7 Cf. Heinrich Mann's analysis of Flaubert's literary strategies in his 1905 essay *Eine Freundschaft: Gustave Flaubert und George Sand,* ed. Renate Werner (Munich and Vienna, 1976), p. 20.
8 Cf. his attacks on aestheticism in *Tristan* und *Tonio Kröger* (*GW* 8).
9 A mental disposition which Thomas Mann characterizes with the term of *Velleität* borrowed from Nietzsche.
10 Heinrich Mann, *Zwischen den Rassen,* in his *Gesammelte Werke in Einzelausgaben* (Düsseldorf, 1975) 14:137.
11 "Meinen Sie nicht, daß Handlungen, wie die Freisprechung eines offenbar fälschlich Verurteilten . . . recht leise, bescheiden und in verschämter Stille geschehen sollten, statt mit moralischen Posaunenstößen . . . verkündigt zu werden?" (*GW* 12:180).
12 Cf. *GW* 12:462.
13 "Das aber tut der deutsche belles-lettres-Politiker. *Er hütet sich,* von der französischen Wirklichkeit Kenntnis zu nehmen, sei es literarisch oder gar durch den Augenschein. . . . Für ihn ist Frankreich keine Wirklichkeit, sondern eine Idee" (*GW* 12:561).
14 Georg Büchner, *Dantons Tod,* in his *Sämtliche Werke und Briefe,* ed. Werner R. Lehmann (Munich, 1974) 1:52.
15 *Die Fackel* 474–83 (1918): 19.
16 In a letter to Heinrich Mann (February 13, 1901).
17 For Thomas Mann's quarrels with Theodor Lessing, see the elaborate account in Peter de Mendelssohn, *Der Zauberer* (Frankfurt, 1975) 1:821–34.
18 Thomas Hobbes, *Leviathan,* pt. 1, chap. 6.
19 Cf. Heinrich Mann on Flaubert in his *Eine Freundschaft,* p. 20.
20 "Bilse und ich" (1906), in *GW* 10:11–22.
21 Letter to Carl and Paul Ehrenberg (October 22, 1902), in *Dichter über ihre Dichtungen: Thomas Mann,* p. 1, ed. Hans Wysling (Munich, 1975), p. 175.
22 Cf. Hans Rudolf Vaget, *Thomas Mann Kommentar zu sämtlichen Erzählungen* (Munich, 1984), pp. 223–26.
23 Cf. the similar interpretation of the Socratic spirit given in Nietzsche's *Geburt der Tragödie,* chap. 19.
24 Cf. my forthcoming article on "Lachritual und Mitleidsethik," in Proceedings of the Thomas Mann Symposium, March 1988; *Thomas Mann Studien,* vol. 9.

Thalia in Austria

EGON SCHWARZ

"The 19th century seems to leave room for play," Johan Huizinga writes in his book *Homo ludens: A Study of the Play-Element in Culture.* [1] One should amend this title with the phrase *homo animal ridens,* for play and laughter go hand in hand and are in that combination characteristic of human beings. Both faculties enable us to rise above ourselves, to see things in a less serious light, to poke fun at reality—but, most of all, at ourselves. In short, and paraphrasing Nietzsche, laughter and play make the bad world bearable as an aesthetic phenomenon. Laughter is play, freedom from restrictions (including those of neurotic origin), liberation of the inevitability of the given; it frees us from civilization and for civilization. I shall not dally in discussion of the mechanics of laughter. Not only does its psychophysiological nature remain largely unexplained, but it is also dependent on temperament and subjectivity; indeed, it swells and ebbs in one and the same individual according to external circumstances, erupting less readily in solitude than in the company of others, for, as Freud has recognized, "it is one of the highly contagious psychic utterances." [2] Instead, I shall focus on its playful-comical aspect, which can be documented in literary texts. A similarity in names is perhaps symptomatic of the fact that the aesthetic, the playful, and the comical are derived from a common root: Thalía is one of the three Graces, Thalīa the Muse of Comedy.

Yet where were these two cousins in the 19th century? Rumor has it that they disliked dwelling in the north and have, therefore, always maintained a summer cottage in Austria. They are said to have visited Germany only rarely during the staid 19th century; instead, they are reputed to have shared a townhouse with their sisters Aglaia and Euphrosyne in Vienna, for the imperial city was always highly receptive and productive in the matter of entertainment—and that is, after all, their *métier.* Just why the gracious ladies felt so at home in this land of operettas, and why they retreated there during bad times, is difficult to say. Perhaps it was because of a certain lack of seriousness exhibited by the inhabitants, a forced youthfulness, indeed an almost pathological childishness. Franz Grillparzer, who was well acquainted with such matters, believed that compared to "Old Man Germany" Austria was an "apple-cheeked youth," [3] and it is this youthfulness which provokes the rational-didactic tendency also harbored by Thalia, for in her best moments she defines her task as *ridendo dicere verum.* At any rate, much that Sigmund Freud, a neighbor and close acquaintance of the cousins, had to

41

say of the phenomena wit, humor, and comicality also applies to many Austrians, their intellectual life in general, and literature in particular: infantility, scurrility, an abhorrence of strenuous thought processes, a delight in nonsense and mischief, a childish imagination, and skillfulness in any sort of wordplay or language manipulation.

These colorful attitudes, which exist in such abundance in Vienna, will be introduced by way of several examples chosen from the rich supply of Austrian farces, the first being Ferdinand Raimund's masterpiece of comic literature, *The King of the Alps and the Misanthrope (Der Alpenkönig und der Menschenfeind).*[4] To whatever extent Shakespeare's Timon and Molière's Alceste may have served as absolutely essential models, the extraordinary comic effects could have been achieved only by means of the magic mechanisms of the popular Austrian fairy tale play. That the king of the Alps, Astragalus, appears as Rappelkopf, and that Rappelkopf is in turn personified as his brother-in-law Silberkern; that the misanthrope is forced to confront himself, and that he must acknowledge his own abhorrent manner with growing distaste; that he is able to comment on his behavior and thus distance himself more and more from it: these strategies owe their existence to the fantastic transformations possible in 19th-century Viennese popular theater. The scenes in which Rappelkopf is forced to confront his own ego are not only irresistibly comical, they also stage his recovery and conversion so convincingly and believably as nowhere else in the history of stage conversions. The audience experiences them, is carried along, and deems them not only plausible, but practically demands them as the logical outcome of the conflicts.

The hilarity here is not a result of questionable jokes and wordplays—which are, of course, not lacking—but stems from the separation of consciousness and behavior, a separation only achievable in this type of theater. What is usually possible only as a thought process, the humorous distancing of reason from the subconscious psychic compulsions, the separation of the ego from the id: in these stage scenes, it becomes visible, is near tangible reality.

In the beginning scenes of the second act, this separation is still relatively simple. It is a result of the irreconcilable back and forth movement between Rappelkopf's own feelings and the role he must play as his brother-in-law. At once, the audience is hopelessly drawn into the conflict, for what it faces is nothing less than the daily see-saw between inner feelings and outer conventions, a conflict with which the viewers are well acquainted from their own experience. *Ridendo dicere verum!* While the protagonist greets his wife, toward whom he feels a paranoid aversion, with hypocritical hugs as he meets her in the persona of her brother, he utters aside as Rappelkopf: "Awful! This viper lies at my breast" ("Entsetzlich! Diese Natter liegt an meiner Brust"); but as the brother-in-law, Silberkern, he must wax friendly: "At last I see you again, dear sister" ("Endlich sehe ich dich wieder, liebe Schwester"). *Aside:* "I can't stand to look at her" ("Ich kann s' nicht anschaun"). Friendly again: "How are you, dear sister?"

("Wie geht's dir denn, du liebe Schwester du?" [383]). The same scene is repeated with all persons of his acquaintance: for example, his daughter's fiancé whom he despises, and the servant whom he suspects of murder; and by and by he has to revise his opinion of all of them. He feels compelled to say of his wife: "She is not so bad after all" ("Sie ist doch nicht gar so schlecht" [385]). And now he considers August, whom he learns to accept as his future son-in-law, a "passable human being" ("passable Mensch") whom he "almost misjudged" ("beinahe verkannt" [399]); and he realizes that simple Habakuk is "too feeble-minded to be a murderer" ("für einen Mörder . . . zu dumm" [390]).

What is so sophisticated about this conversion is its duality which enables us to take it seriously and to smile at it at a higher level. In such places, it becomes obvious that the playful character of the comical makes it nonbinding. When Rappelkopf, overcome by his own fatherly feelings toward his daughter Malchen, finds himself hugging and kissing her, whereas only a few minutes before he was willing to disinherit her because of her love for August (387), he comments: "O shame! Here I am a misanthrope and now I am engaged in a kissing game with no end in sight" ("O Schande! Ich bin ein Menschenfeind und komm da in eine Küsserei hinein, die gar kein End nimmt" [388]). If one could imagine the slight dialect coloration absent from such remarks one would understand why the simple folksy tone is an indispensable prerequisite of this type of comedy. Language, form, and content create a harmonic, comic unit. This stepping out of one's role, this strangely direct turning to the audience does by no means harm the conversion process; on the contrary, it only shows the hypothetical character of the play and at the same time provides the impression of a sublime escape from an otherwise intractable reality.

All this is comical enough, but the entrance of the king of the Alps increases the humor. The king's attitude is a faithful copy of the misanthrope's behavior, and thus the misanthrope can identify with it emotionally, but he is also able to disassociate himself from it when he sees it personified. The drama of this transformation with all its lapses and progressions is perfectly orchestrated in Rappelkopf-Silberkern's rapid exchange of reactions to Astragalus-Rappelkopf's rude behavior. In the beginning he still expresses pride and agreement: "That's me—I'm not in a good mood, but that's the way it is" ("Ich bins—Aufgelegt bin ich nicht gut, aber das kann nicht anders sein" [393]). "Everyone is so afraid of me: it's a real pleasure" ("Eine Angst hat alles vor mir, daß es eine Freude ist" [394]). "Well said, I like that" ("Das ist wieder gut gesprochen, das gefällt mir"), "Bravo," "Bravissimo" (337). But soon admiration is mixed with doubt: "I do think that there is something repulsive in my behavior" ("Ich find doch, daß ich etwas Abstoßendes in meinem Betragen habe" [396]). "I am really a raging fiend. I'm beginning to detest myself. . . . And how he screams! . . . By the time this is over he will have ruined my lungs" ("Ich bin ja ein rasender Mensch. Ich fang mir ordentlich an selbst zuwider zu werden. . . . Und wie er schreit!

. . . Bis die Gschicht ein Ende hat, ruiniert er mir noch die ganze Brust'' [397]).
The more disagreeable the one grows, the more reasonable and pleasant toward
his fellow human beings becomes the other. Finally, there is a confrontation be-
tween the one and the other ego and the climax is reached when the two opponents,
indistinguishable doubles in the eyes of the audience, face each other with their
weapons drawn for a duel. And when the prince from the spirit world throws
himself into the river, he drowns, visibly, the sick side of Rappelkopf's psyche
in the waves. In the end, the exhausted convert exclaims, with the full backing
of the audience: ''Heaven help me, once a misanthrope and never again'' (''Der
Himmel steh mir bei, dasmal ein Menschenfeind, in meinem Leben nimmermehr''
[408]). The highly comical effect of this caricature amounts to the exposure of
a pathology typical of the epoch.[5] Because of space restrictions, it could be in-
dicated here only cursorily. Our admiration grows, however, when we consider
the fact that we are dealing with a self-portrait of Raimund with whose aid the
author attempted to rid himself of that very paranoia. Although his attempt was
in vain, it nevertheless shows us that laughter is equally represented in both realms:
in art as well as in life.

Whereas Raimund's misanthropic drama must be seen as a psychological com-
edy, Johann Nestroy's *Talisman* (1840),[6] exhibits predominantly sociosatirical
traits. In spite of his growing recognition, this author has never found total
acceptance in Germany. He is basically still seen as a local poet of the sort of
Ernst Niebergall in Darmstadt. In reality, however, what one of the scholars best
acquainted with his work has said of him is true: namely, that he is ''the greatest
German comedy writer,'' ''for whom comedy is not a sideline but his trade, life,
and propelling force as it was for a Goldoni or a Molière. Nestroy, with his pro-
found humor and bold nonchalance, his carefree transition from folksy fun to
philosophical insight, surpasses the authors of single brilliant comedies and in-
tentionally didactic plays—Lessing, Kleist . . . Brecht.''[7]

There is no lack of popular comedy, even slapstick, in the *Talisman*. There
is an explosion of insinuations and innuendoes, covert references, wordplays,
and complete, ready-made quotes, as for instance the famous aphorism that reality
is the surest sign of possibility, and the malicious but humorous saw about women:
''Nerves of spiderwebs, hearts of wax, and heads of iron: that is the foundation
of the feminine structure'' (''Die Nerven von Spinnengeweb', d' Herzen von
Wachs und d' Kopferl von Eisen, das is ja der Grundriß der weiblichen Struktur''
[293]). This verbal net is so closely woven that one could see the linguistic tissue
of the drama as a complete, clever cloth of speeches and ripostes. Nor is there
any lack of profoundly comic situations with disguises, mix-ups, and other con-
fusing events. But all of this serves a higher purpose, the uncovering of hidden
desires and vanities, the exposure of a superficial, hierarchically constructed
society.

The social strata are also linguistically demarcated: for instance, in such a
way that the social climber Titus changes his speech pattern according to the sphere

in which he is currently trying his luck. He sweet-talks the mistress in charge of the garden, who has just hired him: "Whether you call me a helper or a gardener or—it's all the same; even—let's just suppose—if I should succeed as a gardener to raise feelings in your heart . . . and if you should make me the sole ruler of this plantation . . . even then I would always be your servant" ("Ob Sie mich Gehilfe nennen oder Gärtner oder—das is alles eins; selbst—ich setz' nur den Fall—wenn es mir als Gärtner gelingen sollte, Gefühle in Ihr Herz zu pflanzen . . . und Sie mich zum unbeschränkten Beherrscher dieser Plantage ernennen sollten . . . selbst dann würde ich immer nur Ihr Knecht sein" [293]). But once admitted to the social circle of the castle owner, who fancies herself a writer, Titus uses a consciously intellectual manner of speech which is worthwhile reproducing verbatim because of the satirical intent with which Nestroy has charged it. When asked by the lady (who, incidentally, hopes that there is more to his sexual capabilities than to his secretarial ones) what sort of "literary education" he has had, he provides this answer:

> A sort of millefleurs education. I know a little of geography, have an inkling of history, an idea of philosophy, a smidgen of jurisprudence, am acquainted with surgery, and have had a taste of medicine.

> (Eine Art Mille-fleurs-Bildung. Ich besitze einen Anflug von Geographie, einen Schimmer von Geschichte, eine Ahndung von Philosophie, einen Schein von Jurisprudenz, einen Anstrich von Chirurgie und einen Vorgeschmack von Medizin [317]).

And in the course of a soirée during which the chatelaine would like to see her secretary sparkle with intelligence, there evolves a dialogue, directly alluding to Nestroy's own literary trade, with a guest maliciously named Herr von Platt (which basically means "shallow"):

HERR VON PLATT: For my part, I would love to write a comedy.
TITUS (*to Herr von Platt*): Why don't you then?
HERR VON PLATT: My sense of humor is not in a state to state something funny with it.
TITUS: So write a sad comedy. On a dark background even the weakest joke looks pretty good, just as the faintest embroidery is still visible on black velvet.
HERR VON PLATT: But can you call something sad a comedy?
TITUS: No! If there are three jokes in a play and otherwise nothing but corpses, dying and dead people, graves and gravediggers, then you call it a genre picture.

(HERR VON PLATT: Ich für mein Teil hätte eine Leidenschaft, eine Posse zu schreiben.
TITUS [*zu Herrn von Platt*]: Warum tun Sie's dann nicht?
HERR VON PLATT: Mein Witz ist nicht in der Verfassung, um etwas Lustiges damit zu verfassen.
TITUS: So schreiben Sie eine traurige Posse. Auf einem düstern Stoff nimmt sich der matteste Witz noch recht gut aus, so wie auf einem schwarzen Samt die matteste Stickerei noch effektuiert.

HERR VON PLATT: Aber was Trauriges kann man doch keine Posse heißen?
TITUS: Nein! Wenn in einem Stück drei G'spaß und sonst nichts als Tote, Sterbende,
 Verstorbene, Gräber und Totengräber vorkommen, das heißt man jetzt ein
 Lebensbild [326]).

The talisman, which gives the work its title, is a hairpiece the purpose of which is to cover the central figure's red hair. This "blemish" has become a liability, arousing the usual prejudice with far-reaching consequences for the protagonist, condemning him to unemployment, starvation, and vagabondage. This red hair may be replaced by any other characteristic deviating from the norm, be it a different skin color, an exotic slant of the eyes, nose, or lips, the wrong religion, or having been born on the wrong side of the tracks. In other words, the arbitrariness of the offending characteristic and its exchangeability indicate that in the *Talisman* we have before us the prototype of comedy as allegory.

To begin with, there are the crassly descriptive names. The red-haired hero's name is Fire Fox (Feuerfuchs); the gardener is called Flora Trecutter (Flora Baumscheer), the rich uncle, a beer hall owner, Tap (Spund). Another feature of allegorical satire is the deviation from commonplace realism, a cavalier treatment of the conventions (already observed in Raimund's peep show stage). The numerous asides, the many interruptions of the action by couplets, sung by selected actors at the stage apron for the purpose of casting comic aspersions on the plot, the surprising, barely motivated changes in the hero's circumstances, intended to illustrate the fickle fortunes of the world with its ups and downs, the constant stepping out of character and telling tales out of school—all this belongs to the epic-panoramic theater and is much more reminiscent of Brecht than of the classic-mimetic drama.

The irony of the situation is enhanced by the fact that those discriminated against do not respond in psychologically identical ways to their particular circumstances: Salome, the red-haired shepherdess, who occupies the lowest rung on the social ladder of the village, reacts in a shy and resigned manner; Titus Feuerfuchs, on the other hand, exhibits a dynamic, almost demonic defiance. Of course, the satirical effect of the comedy is increased when it turns out that Titus—even after ridding himself of his red hair through a series of black, blond, and grey wigs (which, by the way, cause most hilarious mix-ups)—does not owe his social success to his mental faculties, but instead to his physical attractiveness and to the fact that three merry widows have caught on to his bachelor status.

The blatant and totally implausible automatism of success, failure, and final happy ending as well as the impudent manipulation of the individual by society become, openly displayed as they are, an enticement to laughter. In short, of Nestroy's nearly one hundred comedies, the *Talisman* is one of the best (Kierkegaard is counted among its early admirers). It is an indication of the haughty disdain shown to "folk literature," especially when suffused with Austrian dialect, that this comedy has not only been considered unworthy but is almost totally neglected by leading scholars of German literature.

From the 19th century we shall now step into the 20th, from Raimund and

Nestroy to Fritz von Herzmanovsky-Orlando, from the psychological and sociocritical to the historical comedy, which nevertheless owes a great deal to, and would not be in existence without, its forerunners. The postmortem of the Hapsburg Monarchy was one of the main concerns of the First Austrian Republic. No one has indulged in it with greater gusto, and no writer has pronounced his diagnosis of "absurd" with more aplomb than Herzmanovsky-Orlando. Following the principle of *similia similibus monstrantur,* he makes use of the preposterous for the mainspring of his satire, and his imagination proves to be inexhaustible in the production of absurdities; unceasingly, it spews forth the most monstrous ideas. Under these circumstances, it is not surprising that the literary historian facing a style fairly bursting with nonsense must remain pitifully inadequate in his attempt to describe its techniques. Still, I shall try to illustrate Herzmanovsky-Orlando's talent by way of the farce *Emperor Joseph and the Station Master's Daughter (Kaiser Joseph und die Bahnwärterstochter),*[8] first performed in 1957. One can start anyplace, even with the list of the *dramatis personae,* which contains three dozen names, not counting the valets, ladies in waiting, pages, lavender sellers, and other unnamed persons as well as a number of stuffed yet animated creatures "from the realm of hallucinations." A number of the characters listed are affixed with a star indicating, in a footnote, a "silent role" which need not be filled. Among those left, there are ten with the first name Franz. Their last names are Zwölfaxinger, Piffrader, Trummruckinger, etc.—highly suggestive but untranslatable, for all this takes place in a fictitious Austrian mountain village named Wuzelwang on the Wuzel. Most of those named Franz are employed by the railroad, e.g., Franz Teuxelsieder, whose exact title is "imperial patrimonial assistant adjutant stoker candidate substitute apprentice without portfolio" ("kaiserlich erbländischer Hilfsheizerstellvertretersanwärtersubstitutengehilfe ohne Gebühren"). The main figure is Innocentia Zwölfaxinger, nicknamed Nozerl. The aristocracy is represented by the Countess Primitiva de Tomato (Primitiva von Paradeyser), Count Orpheus Wumpsbrandt, Lord Onophrius Maw of the Forest (Lord Onophrius von Laab im Walde), Lady Ignazette von Zirm, née Scare-the-Guest (Scheuchengast), of the House of Scheuchengast-Scheuchengast, erroneously also referred to as Little One-Ear (Eynöhrl), and so on. The author's skill is beyond comparison when it comes to inventing strange but, seemingly, intrinsically Austrian names. Indeed, the author's own name, a mixture of German, Slavic, and Italian elements, sounds like one of his inventions.

The action of the play takes place in 1786, during the reign of Emperor Joseph II, nearly half a century before the advent of the railroad. Herzmanovsky-Orlando is not stingy with anachronisms. At one point, he quotes a character from Hofmannsthal's *Rosenkavalier,* only to correct himself at once with the remark: "Oh no, that's not till later" ("Ah na, dös kummt ja erscht später" [17]). In order to exploit the railroad anachronism to its utmost comical extent, at the end of the little drama the author calls for the appearance of His Excellency the Imperial British Ambassador Lord Percy Fairfax Fitzroy Hobgoblin who announces that the beater Stephenson, hurt during a recent hunt, has received as restitution

permission from the Prince of Wales to sire a son who will invent the railroad in 1829. At the same time, it is ordered "that until then all such inventions are forbidden and any possibly already in existence must be invalidated" ("daß bis dahin alle derartigen Erfindungen zu unterbleiben haben und alle etwa schon gemachten Erfindungen ungültig sind"). This edict causes understandable consternation among the assembled passengers and officials of the Austrian railroad. But the Emperor quickly regains his composure. His comment, "Well, let's just let the beefeaters have it. The railroad is nothing but trouble anyhow" ("Na ja. Lassen wir's halt den Rostbeefischen. Mit der Eisenbahn hat ma eh nix wie Scherereien" [45]), dissolves the embarrassing silence. Among general applause, everybody lines up for the final curtain call, and to the tune of "O du mein Österreich," a national anthem, the assembled chorus of participants entones resignedly:

> That the railroad had been long invented
> in our country, that we always knew.
> Yet this is knowledge not for the world intended,
> But that is our country, Austria, too!
>
> (Daß die Eisenbahnen längst erfunden waren
> Hier bei uns, das wußten wir ja gleich.
> Doch die Welt wird leider nie davon erfahren—
> Ja so geht es schon einmal mit Österreich! [45])

And with the engine whistling sadly in the background and blowing a few puffs of steam, the curtain falls.

Of course, the comedy has no coherent action. A rational structure of this kind would contradict the whole idea. Such incongruity is strictly adhered to in all of Herzmanovsky-Orlando's works, the dramatic as well as the narrative ones—a practice for which this magician of the incoherent has been unfairly criticized. Instead, the grotesque characters and scenes are lined up like pearls on a string, barely held together by the railroad theme. The railroad officials, kept only moderately busy by the rare appearance of a train, blacken their faces, glue on beards, and go poaching in the woods. In the manner of the Parcae, three shabbily dressed characters appear as "officially installed train-arrival-prophetesses" ("behördlich konzessionierte Zugs-Ankunfts-Wahrsagerinnen"). Furious barking by the stuffed dog Waldmann also announces the arrival of trains, which, additionally and needlessly, are preceded by a rider: all this serves to prevent unpleasant surprises. A corpulent widow named Cacklesmith Leopoldin (Gackermaier Leopoldin) is forced to buy a so-called "Zuwaagkarte" ("overweight ticket") for 3 guilders and 27 farthings, as is prescribed in the "transportation rules for fat people and unaccompanied uglies" ("Beförderungsbedingungen für dicke Leut und Mißgeburten ohne Begleitpersonen" [32]). Emperor Joseph, traveling incognito as a "man of means," descends from a "yellow railroad car with one window, a car like a sedan chair, adorned atop with a plume of ostrich

feathers and decorated with trumpet-blowing and drum-beating angels'' (''ein gelber, einfenstriger, sänfteartiger Wagen, über dem ein Straußenfedernbusch wippt und der mit trompetenblasenden und paukenschlagenden Putten verziert ist'' [20]). While drinking milk and eating hot dogs from the engine's hot water tank, the gentleman jokes and flirts with Nozerl, the naive mountain girl, who is in service as ''Imperial patrimonial assistant railroad subemployee'' (''kaiserlich erbländisches Hilfsbahn-Unterorgan''). Meanwhile her father, the station master, is pursuing the illegal hunt of mountain game. Indeed, a dead chamois finally crashes from a rock onto the stage populated by a group of travelers and courtiers, who have arrived unexpectedly. Nozerl faints into the Emperor's arms, thereby causing a fit of jealousy on the part of her betrothed, who threatens to attack his sovereign with a knife.

> TEUXELSIEDER: Ah, is that how it is? Is it? (*In despair*) I'll drown myself . . . I'll throw myself in the creek. . . . But before that . . . *Threateningly:* Before that I'll cut out the guy's guts! *He draws his knife.*
>
> ZWÖLFAXINGER (*stepping between them with patriarchal authority*): Teuxelsieder— don't do that! We're not murderers. Don't you dare! The guts stay where they are!
>
> (TEUXELSIEDER: Ah, sooo is dees? Sooo? *Verzweifelt* I geh ins Wasser . . . i stürz mi in'n Gießbach. . . . Aber zuvörderscht . . . *Gräßlich* . . . zuvörderscht laß i dem Herrn da die Darm außa! *Er zieht das Messer.*
>
> ZWÖLFAXINGER [*tritt mit patriarchalischer Wucht dazwischen*]: Teuxelsieder—dös tuast net! Mörder san mir koane . . . Untersteh dich! Die Darm bleiben drinnert! [34])

This is a perfect parody of the melodramatic folk play. At this critical moment, the robber Rinaldo Rinaldini appears on stage and, imitating closely the German gobbledygook of the Italian intrigant Valzacchi from the *Rosenkavalier,* also draws his knife against the monarch. Now, whether it is the objection of his superior or an inner impulse, patriotic loyalty for the existing order conquers the feelings of jealous revenge in Franz Teuxelsieder's heart and he throws Rinaldini into the abyss, for which deed he and Nozerl are knighted immediately by the Emperor and endowed with the titles of Baron Franciscus Xaverius of and on Teuxelsieder and Baroness Innocentia Zwellefaxinger (43).

Only the literal quotation of the dialogues can give an idea, albeit remote, of their scurrility. While cleaning his gun, Zwölfaxinger calls his subordinate and future son-in-law a ''stupid idiot,'' to which Teuxelsieder objects agitatedly:

> TEUXELSIEDER: What? A stupid idiot? You are calling me a stupid idiot? And me having finished stoker school?
>
> ZWÖLFAXINGER (*condescendingly, while he continues cleaning his gun*): And what did you learn in that there stoker school?
>
> TEUXELSIEDER: We learned all about rusting, the whole year! But not right away. At first, we learned how to get breakfast, and then how to stomp june bugs. And elective was distance spitting . . .

(TEUXELSIEDER: Wos? Bleeder Kerl? Mi heißen S' an bleeden Kerl? Wo i d'Hoazer-
schul absolviert hab?

ZWÖLFAXINGER [*geringschätzig, während er die Reinigungsarbeit wieder aufnimmt*]:
Was hast denn schon g'lernt in dera Hoazerschul . . .

TEUXELSIEDER: 's Verrosten ham mir g'lernt, ein ganzes Jahr lang! Aber net sofort.
In der erschten Klass' ham mir's Fruhstuckholen g'lernt und in der zweiten's
Maikäfer Zsammtreten. Und als Freigegenstand's Weitspucken . . .)

As with all dialect-speaking figures in the Austrian comedy, their barely mastered
standard German serves Herzmanovsky-Orlando as a means of expressing
hypocrisy or subservience toward authority. The following exchange, which pokes
fun at the lack of education in rural areas, takes place between Zwölfaxinger and
his daughter:

ZWÖLFAXINGER (*sings*):Chamois have their crossing,
 The railroad, it does too,
 And when I go ahunting,
 The train can go choo-choo,
 Yoohoo, yoohoo,
 The train can go choo-choo!

NOZERL: Papa, Papa! How can you say sich a thing! When the railroad is our most
highest pride! When our enshineers have done invented the railroad! Of course
only when His Matchesty and the Holy Father said it's okay. The chief forester
told me all about it . . . How the Emperor Joseppf—

ZWÖLFAXINGER (*interrupts, reprimanding her*): Joseppf! Joseppf! If you call our
Majesty Joseppf one more time I'll . . . ! Didn't I tell you when you were learn-
ing to write that the Emperor is soft in the rear . . . Josefff . . .

NOZERL (*contrite*): I'll never do it again, Father . . . So then when the Emperor
Joo-seff . . . installed the office of dustmaster—the one with the inscription
"Emperor Joo-seff in favor of the fair distribution of dust"—they told him: if
he would build the railroad it wouldn't ever be dusty in Austria nevermore
. . . and that's why they invented the railroad.

(ZWÖLFAXINGER [*singt*]:D' Gams hoan an Wechsel
 Und auch's Bahngleis hat an,
 Und wann i auf d'Gamserl geh,
 Pfeif i auf d'Bahn!
 Juhu, juhu,
 Dann pfeif i auf d'Bahn!

NOZERL: Vatter, Vatter! Wie kann man soliches sagen! Wo die Bahn unser höxter
Stolz is! Wo doch unsere Inschiniere die Bahn derfunden ham! Natürlich mit
Bewilligung von Seiner Majöstött und vom Hl. Vater. Der Herr Oberförster hat
mir alles erzählt . . . Wie damals der Kaiser Joseppf—

ZWÖLFAXINGER [*unterbricht tadelnd*]: Joseppf! Joseppf! Wannst unsere Majestät
noch einmal Joseppf aussprechen tust, nachher . . . ! Hab ich dir nicht beim
Schreibenlernen g'sagt, daß der Kaiser hinten weich ist . . . Josefff . . .

NOZERL [*beschämt*]: Ich will's gewiß nie wieder tun, Herr Vater . . . Alsdann, wie

also der Kaiser Joo-seff . . . das Staubmeisteramt gegründet hat—das mit der Aufschrift: "Kaiser Joo-seff für die gerechte Verteilung des Staubes"—, da haben s' eahm g'sagt: wenn er die Eisenbahn bauet, so tat's überhaupt nimmer stauben in Österreich . . . und dessentwegen ist die Eisenbahn erfunden worden.)

Indeed, Nozerl is the main comic character, a fact which is even evident in her monologues:

> NOZERL: He could be such a good papa for me if his chamois didn't always lure him away. Well. I guess he is more a person than a station master. No wonder. The railroad isn't really established in the Imperial countries, and that little bit of train traffic can give no satisfaction to nobody's life. A person needs a diversion. And I'd rather he is out in nature than that he should go down to Samuel Dogsbones, to the pub in Rogues Valley, and dishcusses bolidics . . . If only they don't catch him . . . I fear the worst . . . right, Waldmann? You too?
> *(The dachshund makes strange whining noises.)*
> 'cause, if'n they catch him it's all over. Then they'll sell him to Fenice, on a slave ship . . . *Sobs* I can see him rowing, our Papa, . . . and because of his black face they think he's a Moor . . . Zwölfaxinger, the Moor of Fenice . . .

(NOZERL: So viel ein guater Vatter könnt er mir sein, wann eahm net allweil die Gamserln verlocken täten. No ja. Er is halt mehr Mensch als Stationsvorstand. Is ja auch kein Wunder. Die Eisenbahn hat sich noch nicht richtig durchgesetzt in den Kaiserlichen Erblanden, und dös bisserl Zugsverkehr kann einem Menschen keinen Lebensinhalt nicht abgeben. Da muß er sich halt nach einer Abwechslung umschaun. Und 's is mir no allweil lieber, er bleibt in der frischen Natur, als wie daß er zum Hundsknochinger Samiel hinuntergingert, in die Bahnhofswirtschaft von Schurkental, und über Bolidik dischkutiert . . . Wann s'eahm nur net derwischen . . . Mir schwanet Übeles . . . gelt, Waldmann? Dir auch?
[*Der Dackel gibt sonderbar weinerliche Töne von sich.*]
Weil, wann's eahm derwischen tun, dann is aus. Dann verkaufen s' eahm nach Fenedig, auf die Galeere . . . *Schluchzt* I siech ihm schon rudern, in Herrn Vattern . . . und wegen sein schwarzen G'sicht halten s' ihm für an Mohren . . . Zwölfaxinger, der Mohr von Fenedig . . . [*17–18*])

And now the initial dialogue between Innocentia and the Emperor, whom she has not recognized:

> GENTLEMAN: I'm thirsty. Do you have any milk, dear girl?
> Nozerl *makes a frightened, defensive gesture.)*
> GENTLEMAN: Do you have any milk? A glass of milk?
> NOZERL: Oh, I see—in a glass. At once, if you please.
> *(While the Servants discreetly busy themselves around the elegant gentleman, Nozerl runs inside and returns with a glass of milk which she hands over with a curtsy. The Gentleman drinks in small, elegant sips.)*
> GENTLEMAN: That quenches the thirst and refreshes. Thank you, my child, who are you?
> NOZERL: I'm minding the railroad and the sheep there, too!

GENTLEMAN: So young and so much on your tender shoulders? Well, well! And what's your name?

NOZERL: Nozerl, if you please.

GENTLEMAN: Nozerl? That is no Christian name. How did the reverend Father baptize you?

NOZERL: Innocentia Walpurga Maria-Taferl Zell und am Gestade, Sir. But now you must excuse me. I have work to do.

(HERR: Mich dürstet. Hast du Milch, liebes Mädchen?
[*Nozerl macht eine erschrocken abwehrende Geste.*]

HERR: Ob du Milch hast? Ein Glas Milch?

NOZERL: Ah so—im Glas. Sofort, bitte.
[*Während die Lakaien sich diskret um den vornehmen Herrn zu schaffen machen, läuft Nozerl ins Haus und kommt mit einem Glas Milch zurück, das sie mit einem Knicks überreicht. Der Herr trinkt in kleinen, vornehmen Schlucken.*]

HERR: Das kühlt und labt. Ich danke dir, mein Kind. Wer bist du?

NOZERL: Ich tu die Bahn da hüten, und auch die Lämmlein hüte ich!

HERR: So jung und schon so viel auf deinen zarten Schultern? Ei, ei! Und heißen tust du?

NOZERL: Nozerl, zu dienen.

HERR: Nozerl? Das ist kein Name christlichen Bekenntnisses. Wie taufte dich der hochwürdige Herr Pfarrer?

NOZERL: Innocentia Walpurga Maria-Taferl Zell und am Gestade, Herr. Aber jetzt muß der Herr mich entschuldigen. Ich habe Dienst [20–21]).

At the very end, the buffo-opera character of the comedy is fully established, the assemblage breaks out in a chorus, and now, after all, something akin to a moral of the story is offered:

GENTLEMAN: I do not want to spare you my own kindness,
 I'll spread it fully with imperial hands.
 But you will never know the name behind this,
 Surely it's known in all my lands.

CHORUS: Surely it's known in all his lands.

GENTLEMAN: And if we wait a hundred years into the future,
 It is, and always was, the Austrian lot,
 That no one should be capable or willing
 To give a name to who is who and what is what.

CHORUS: Let no one give a name to who is who and what is what!

GENTLEMAN: Yet secretly we know and are quite certain,
 Of who did what and where there is a fire,
 But from the name we'll never lift the curtain,
 For nothing but a mishmash could transpire.

CHORUS: Oh, what an awful story could transpire.

GENTLEMAN: Let others vie for the attention—
 Humility is our element!

And if of name and place there is no mention,
It's sure an Austrian in the end . . .
CHORUS: Yes, it's an Austrian in the end.

(HERR: Mit Beweisen meiner Huld will ich nicht sparen,
Streu sie aus mit volle kaiserliche Händ.
Meinen Namen aber sollt ihr nie erfahren—
Ich verlaß mich drauf, daß ihn ein jeder kennt.
CHOR: Er verlaßt sich drauf, daß ihn ein jeder kennt.
HERR: Noch von heut in vielen hundert Jahren
Bleibt's ein österreichisches Patent,
Niemals nicht um Gottes willen zu erfahren,
Wie man wen und wie man was beim Namen nennt.
CHOR: Daß nur niemand nichts beim rechten Namen nennt!
HERR: Insgeheim ist man sich zwar im klaren,
Wer was ang'stellt hat und wo es brennt,
Doch den Namen wird man trotzdem nie erfahren,
Weil sonst eine Mischkulanz entstehen könnt.
CHOR: Eine fürchterliche G'schicht entstehen könnt.
HERR: Mögen andere die Blicke auf sich zahren—
Die Bescheidenheit ist unser Element!
Kann man wo von wem den Namen nicht erfahren,
Ist's zumeist ein Österreicher dann am End . . .
CHOR: Ja, ein Österreicher ist es dann am End.)

The message is clear enough, and it is cleverly presented. But the ultimate comic effect in Herzmanovsky-Orlando's work is achieved by employing many elements, not only the relatively simple one which is derived from the scurrility of a culture when observed from a distance, especially that of time. In addition to the grotesque capriciousness evident in every line, there is the admirable artistry of his parody, with which he strikingly imitates all styles and genres; the biting caricature depicting, with brilliant clarity, typical figures and institutions of the Austro-Hungarian monarchy; and, above all, the language, reproduced in the most laughable detail, of the different professional groups, ethnic minorities, and social strata, as if a soliloquist were at work who knew all the nuances of dialects and social linguistics.

But this sequence does not end with Herzmanovsky-Orlando. Helmut Qualtinger and his collaborator Carl Merz present us with a work worthy of our attention, *Der Herr Karl.*[9] The protean Karl is less robustly comical than his dramatic forerunner Travnicek,[10] into whom Qualtinger convincingly incorporated the various aspects of a widespread social ill. With the aid of clever dialogue, in which wordplay and other humoristic means assume the main role, the prejudiced personality of the Viennese petty bourgeois is brought to the fore, and the mutual demasking of milieu and protagonist is carried out.

Still, the masterpiece of such self-criticism is undeniably *Der Herr Karl*. This creation represents an apex in postwar literature, a literary cleansing, the culmination of "coming to grips with the past," enacted in the Austrian way. It does not take supernatural powers to recognize this hair-raising monologue as an X-ray portrait of mob behavior. The play's success lies in the skillful combination of an obviously sociohistorical pathology with the inexorable historicity of an environment that brought it forth. This petty bourgeois type becomes the successor of the "Austrian face" in the drama *The Last Days of Mankind* (*Die letzten Tage der Menschheit*) by Karl Kraus, without doubt one of the great scions of Austrian tragicomedy in his capacity as author and also as actor. Qualtinger's Herr Karl is more than this, however; that is, he is the epitome of the apolitical, vacuous all-European fellow traveler. Moral indifference, exploitation of women, deviousness, laziness, sexual voyeurism, a touch of pyromania, an aestheticizing antihumanism, political prostitution, opportunism—all these combine to form the portrait of modern mass man, whose features are hardly comical anymore.[11]

Qualtinger is equal to his forerunners on all counts, but the level of comedy has been lowered. His humor illuminates the darkened landscape only in the form of a subtle glimmer of insight. In Raimund's comedy, society seemed still to be more or less intact, with only its edges beginning to unravel. It was rather the rebellious individual, the rabid outsider, who was ridiculed for his misanthropic distrust. Having been forced to recognize his hatred as unfounded, he was reintegrated into society; peace and order were restored.

In Nestroy's play, society is more closely scrutinized; its collective desires, vanities, and prejudices are made accountable; its hierarchical structure, with injustice and deprivation at its core, is criticized. Still, confidence in the individual has not yet eroded. It is shown that an enlightened mind can bring light to the hidden corners of the social building and drive away the shadows. Although self-centeredness cannot be erased, for it is the driving impulse behind the individual, its ill effects can be lessened. The Enlightenment has not yet entirely lost its power. When society is ridiculed, the ensuing laughter forces it to acknowledge diligence and uprightness without regard to a person's social position. Granted, the happy ending is sheer coincidence; but like the deus ex machina of classical drama, it guarantees the world's intactness. It is not an afterthought: it is, instead, a just reward.

Herzmanovsky-Orlando relinquishes this hope. The individual no longer possesses a sense of destiny, nor does society as a whole. Neither can sustain or lift up the other. Irrationalism rules, reason is without power, all of mankind is senile. This very fact gives rise to an irresistibly grotesque humor. But it is black humor. We are shown a vanished world, together with the reasons for its demise. All of society, without exception, is the butt of such ridicule.

Qualtinger attempts to come to terms with the dark era that followed the dissolution of the monarchy. His bitter satire is the only means adequate to lay bare the horrifying consequences of the loss of reason and responsibility. He

manages to combine the psychological, sociological, and historic approaches of his forerunners. His comprehension of the driving forces, his convincing portrait of the fellow-traveler mentality, his exposure of the pathological instincts seething in the masses compel the witness of this dramatic unveiling to recognize the facts: That's the way it was, that's the way it is—a prerequisite for the experience of the hilarious, the potentially comical. Its complete breakthrough is, however, prevented by the murderous background, the absurdity which—still relatively harmless in Herzmanovsky-Orlando's work—has now become deadly. The realization that sinister changes have put a stop to progress gained through enlightenment and emancipation places a heavy burden on Qualtinger's work. And this weight stifles his laughter. Nor is he the only one thus affected.

Of course, the complete story cannot be understood solely on the basis of a few strategically selected comedies. One would need to look at other works these authors have produced. What is more, no mention has been made of Schnitzler, Hofmannsthal, or other masters of comedy. But the connection has become visible. And rumor has it that once again Thalia is looking for a home.

Notes

1 Johan Huizinga, *Homo Ludens: A Study of the Play-Element in Culture,* trans. R. F. C. Hull (Boston, 1964), p. 191.

2 Sigmund Freud, *Gesammelte Werke,* vol. 6: *Der Witz und seine Beziehung zum Unbewußten* (1905) (London, 1940), p. 194 (my translation).

3 Franz Grillparzer, *Sämtliche Werke,* vol. 1: *König Ottokars Glück und Ende* (Munich, n.d.), p. 1037 (my translation).

4 *Sämtliche Werke* (Darmstadt, 1971). Page numbers follow the quotes in the text. All translations, unless otherwise indicated, are my own.

5 See Heinz Politzer, "Zauberspiegel und Seelenkranker: Ferdinand Raimunds *Der Alpenkönig und der Menschenfeind,*" in his *Das Schweigen der Sirenen* (Stuttgart, 1968), pp. 185–205.

6 Johann Nestroy, *Komödien,* ed. Franz H. Mautner, vol. 6 (Frankfurt, 1979). Page numbers in the text.

7 Mautner in Nestroy, *Komödien* 1:iv. A complete interpretation of the *Talisman* by Mautner can be found in Benno von Wiese, ed., *Das Deutsche Drama,* vol. 2 (Düsseldorf, 1958).

8 *Gesammelte Werke,* ed. Friedrich Torberg, (Munich/Vienna, 1957) 3:7–45. Page numbers in the text.

9 *Qualtinger's beste Satiren: Vom Travnicek zum Herrn Karl.* With texts by Helmut Qualtinger, Gerhard Bronner, and Carl Merz. Ed. with a commentary by Brigitte Erbacher (Munich/Vienna, 1973), pp. 298–316.

10 "Der Travnicek," ibid., pp. 95–128.

11 See Egon Schwarz, "Was ist österreichische Literatur? Das Beispiel H. C. Artmanns und Helmut Qualtingers," in *Für und wider eine österreichische Literatur,* ed. Karl Bartsch, Dietmar Goltschnigg, and Gerhard Melzer (Königstein/Ts., 1982), pp. 130–51; English version, "What Is Austrian Literature? The Example of H. C. Artmann and Helmut Qualtinger," in *From Kafka and Dada to Brecht and Beyond.* Ed. Reinhold Grimm, Peter Spycher, and Richard A. Zipser (Madison, 1982), pp. 63–83.

The Politics of Laughter:
Problems of Humor and Satire in the FRG Today

FRIEDEMANN WEIDAUER, ALAN LAREAU, AND HELEN MORRIS-KEITEL

Laughter is the best medicine, they say. But just as there are many kinds of medicine, so are there many types of laughter. Laughter can help us hide from the symptoms of a diseased world or persuade us of the seriousness of its disorder. This "serious laughter" is the force behind political satire. Its possibilities and problems in modern West German society are the focus of this study.

The comic is a *structural principle* underlying actions and acts of communication. All definitions of the comic can be reduced to the notion of the conflict between what is and what should be. It is the representation of a subject's actions as determined from outside without the subject's knowledge. Two conflicting texts are present in the same action: one being the text according to which the subject thinks to be acting; the other, the text actually determining the action by imposing itself from outside. In most cases, the supposed text is that of lofty ideals which subsequently becomes subjected to the dictate of harsh realities.[1]

Humor is a *pose or attitude* adopted toward the comic. It resigns itself to this eternal and irreconcilable conflict between ideal and reality. It is best to smile or laugh about the ugliness of the world as an aberration from the ideal. Humor works on a level of solidarity and empathy with the perspective of the humorous subject, allowing one to recline and overlook the contradictions of everyday life. Such an attitude became prevalent in the literature after the abortive German Revolution of 1848, when the discrepancy between prerevolutionary ideals and postrevolutionary *Realpolitik* made many progressive-minded people turn away from everyday politics.[2]

The satirical *technique* actively works against this complacent behavior and exposes "das schlechthin Menschliche" as "das herbeigeführte Unmenschliche."[3] Satire exaggerates and analyzes the conflict between the ideal and reality, making this discrepancy appear unbearable, also hinting at possibilities for change. Schiller's classic definition set up satire as an aesthetic category:

> In der Satire wird die Wirklichkeit als Mangel dem Ideal als der höchsten Realität gegenübergestellt; es ist übrigens gar nicht nötig, daß das letztere ausgesprochen werde, wenn der Dichter es nur im Gemüte zu erwecken weiß.[4]

Marx emphasizes the use of satire as a political weapon:

Man muß den wirklichen Druck noch drückender machen, indem man ihm das Bewußtsein des Drucks hinzufügt, die Schmach noch schmachvoller, indem man sie publiziert.[5]

In aesthetic form, satire transforms indignation or hatred into something useful for society.[6]

Our investigation will comprise three case studies of contemporary satirical texts. The first part defines how satire exposes and analyzes the conflict between the ideal and reality in the context of contemporary West German society. Examples from political cabaret of the last decade demonstrate satirical techniques and call attention to the special relation of author, audience, and satirical object. The next section explores satires of the Christian-Democratic government that came to power in the "Wende" or "change of course" in 1982. Lampoons of Chancellor Helmut Kohl exemplify satirical strategies directed at politicians as symbols of the political system. In the final section, the *Volk* is used as the object to demonstrate the discrepancy between political ideal and reality. The effectiveness of the satirical *Volksstück* to attract and stimulate critical analysis among this milieu will be examined. In conclusion, we shall reflect on the ambivalence which can compromise the critical and progressive potential of the satirical method.

Satire and the Schizophrenia of Life and Politics

While class interests and a society based on the exchange of goods regulate the relations of the individuals in this society, the ideals of the Enlightenment such as humanity, freedom, equality, and tolerance still serve, on the one hand, as the legitimation of official policy and, on the other, as the paradigm for the self-realization of the individual. It is this discrepancy between the Enlightenment ideals and the reality of capitalist society which political satire has as the central point of an attack directed against the hypocrisy of politicians and politics in the public sphere. In the private sphere, social satire attacks what Herbert Marcuse called "die verstohlene Gemeinheit des Spießbürgers."[7] The sublime, free, bourgeois individual imagines him- or herself to be acting according to free will, but in reality life is determined by economic laws and the necessities of the market society. Satire unmasks this incongruity.

Because there is no place for the realization of the bourgeois concept of identity in real life, its full expression has been assigned to the cultural sphere. Similarly, the ideals of the Enlightenment remain abstract concepts that are either transferred to the "higher" level of culture or to the sphere of inner qualities of the "soul." The individual internalizes these ideals and seeks their fulfillment in private life, since there is no room for them in the public sphere. At the beginning of this process of internalization stands Kant's *Categorical Imperative*. The free development of personality and humanity becomes everybody's personal responsibility in a society that counteracts it on every level. In contrast to the

ideal, society defines the person next to oneself primarily as a rival. As Marcuse put it:

> Es gehört eine jahrhundertelange Erziehung dazu, um jenen großen und alltäglich reproduzierten Schock erträglich zu machen: auf der einen Seite die dauernde Predigt von der unabdingbaren Freiheit, Größe und Würde der Person, von der Herrlichkeit und Autonomie der Vernunft, von der Güte der Humanität und der unterschiedlosen Menschenliebe und Gerechtigkeit—und auf der anderen Seite die allgemeine Erniedrigung des größten Teils der Menschheit, die Vernunftlosigkeit des gesellschaftlichen Lebensprozesses, der Sieg des Arbeitsmarkts über die Humanität, des Profits über die Menschenliebe.[8]

Satire reverses this educational process and reconstructs the initial shock.

Satire of those in power contrasts that which the politicians claim to be doing with what is actually being done. Satire of the average citizens can blame its objects for their schizophrenic behavior and hidden philistine shabbiness, and suggest that the conflict can be resolved if the individual would "behave right." But it can also serve to analyze the conflict, demonstrate that it is an inherently antagonistic conflict, and thereby point at alternatives which lie beyond the system that reproduces it.

On this level, satire works against the ubiquitous "common sense" or "public opinion" that offers easy wholesale explanations which save the individual mental activity and guarantee a feeling of safety by knowing that one thinks as the majority thinks. Public opinion and common sense express the prevalent mentality of the time, the unreflected forming of the individual's cognition through its environment. Satire acts as *Ideologiekritik* by attacking this mentality on its various levels of expression, such as strength proven by numbers, irresponsibility for social processes, suggestibility of and easy identification with offered values, one-dimensional thinking, opportunism, negation of one's own social status, and assumed moral superiority.[9]

In and through language, satire can make visible what is wrong with the whole. Language in its deformed state makes visible the deformed state of society. Satire, therefore, begins and ends by quoting. Language is not only the vehicle for conveying the subject matter, it is part of the subject matter itself. By quoting, one quotes the *Zeitgeist*, "public opinion," and "common sense" present in advertisements, political speeches, songs, and the language of everyday life.[10]

A first example taken from American popular culture pulls most of these notions together into a concise form. Woody Guthrie's song "This land is your land, this land is my land" suggests that we all can be our own little Benjamin Franklins, stake our claims, and live as free individuals happily ever after. Satire quotes the first line of this song, defamiliarizes it by adding a different emphasis, and right away we can see the conflict between ideal and reality: *That* land is *your* land, and *this* land is *my* land—with a fence in between and a watchdog on each side. Through this manipulation, we are reminded that our freedom ends

where our neighbor's property begins, and that the word "private" as in "private property" comes from the Latin word *privare* ("to deprive, rob"). The essentials of life are scarce, be it private property, jobs, or money. We define our neighbor as a competitor in the fight for them, but we are not allowed to say this.

Our first sample of scenes from various cabaret shows could have the title "*Humankind* in the Age of Mechanical Reproduction"—in this case, of its own reproduction. Progress made in the field of organ transplants and DNA engineering further weakens the already shaky concept of individual identity, another step toward the reification of the human body beyond the already existing exploitation in the workplace and elsewhere. This development corresponds to the policies of a welfare state that measures the need of its citizens in percentage points of bodily damage to the cripples it produces through wars, work-related accidents, and environmental catastrophes. This forms a recurrent theme in contemporary political cabaret. Quoting article 1 of the *Grundgesetz* of the Federal Republic— "the dignity of man shall be inviolable"—Martin Buchholz in his show *Lacht auf, Verdummte dieser Erde* goes on to ask: Yes, the dignity—maybe, but what about his body?[11]

The role of the welfare state in the process of reification is illustrated in a scene from Gerhard Polt's record *Deutelmoser,* entitled "Der Organspender" ("The Organ Donor").[12] After a visit to a state agency which promised him an income at subsistence level, a veteran of World War II can expect the following income: in addition to social security and the pension he receives as an invalid who suffered a bullet wound in Russia, he will now receive 2000 marks in cash for his body accepted by a hospital as a trade-in. He is proud of the deal because he did not mention the loss of two teeth and "several other organs" as a prisoner of war in Russia. If he had left his spleen, too, at the banks of the Dnjepr, he would have an additional 37.80 marks per month.

In a scene treating the same topic, the Münchner Lach- und Schießgesellschaft[13] employs one of the basic techniques of political cabaret: a naive person unfamiliar with the absurdities of modern life seeks advice from an "expert." Here, an average citizen received an offer from the hospital of 438.50 marks for his heart, liver, and kidneys, plus additional money for other body parts. He asks a marketing expert: "What are they going to do with them?" Some of the organs will go to a transplant bank, another to the pharmaceutical industry, the rest to a crematory where the heat produced is being used to heat public buildings. As a form of recycling, this utilization of the human body is good for the environment, saves space in the cemeteries, and the children in the public schools will be thankful for the "human warmth."

The Drei Tornados, in a scene entitled "Soldat 2000,"[14] use another common satirical technique: the fictitious characters put themselves in the shoes of the logic dominating the reality of official policy and technology, thus exposing its illogical and inhumane character.[15] By pushing the dialectic of the enlighten-

ment to its negative pole, satire shows what lies ahead if instrumental rationality has its way. An army officer explains: despite the efforts of disarmament and the various "zero solutions," we have the potential to kill every human being sixty times. The fact that every human being can be killed only once does not suggest that we have too many missiles but too few potential victims for them. Using a human clone developed by Daimler-Benz for use as factory workers, gene technology can crank out fifty-three battalions of the new "Soldier 2000" per year to make up for this gap. The fact that the material of these clones can be recycled as protein-rich food cuts down the cost of mass graves and ensures that the next army can eat its way all the way to Moscow. The prototype has recently been tested in the Gulf War.

Even when operating with what at present seems to be an extreme form of exaggeration, satire has a hard time keeping up with the development of technology and the progressive reification of every aspect of life. Three decades ago Hans Magnus Enzensberger pointed out that reality is quickly catching up with the nightmare described in the satire.[16] The shock is evoked by the proximity of satire to reality. Therefore satire should develop a technique to represent this minimal discrepancy. "Nur durch die Genauigkeit fühlt sich eine Wirklichkeit, die aller Beschreibung spottet, noch betroffen"[17]—or as Werner Schneyder put it, "realist satire is when you laugh your head off about some politician and actually lose it in the process."[18]

The possibility of mechanical reproduction of the human being itself has added a new quality to the problem of individual identity in bourgeois society. Satire as a mirror of social processes may have a greater sensibility for where they might take us. Thus, by presenting future nightmares as reality, it can have a warning function.

Satire can never be the direct result of a text; it always involves interpretation in the act of reception. When the satirists are making fun of or condemning some other person, they put themselves in the position of a social authority, for which they need the approval of others—in this case, of the audience, which endorses it with its laughter.[19] Laughter establishes direct control over the reception. At the same time, it has the function of forming groups. It defines the group one belongs to and establishes the borders where other groups begin. Hence it is a social gesture[20] that requires a group consensus. If the satirists go beyond this consensus, they might lose the collaboration of their audience.

Satire always requires intellectual superiority toward its victim. Therefore the authors have to take into account the level of consciousness of the audience. They have to work with what they assume the audience to know, a knowledge the audience in turn uses to judge what is being presented.[21]

Clearly, the knowledge and level of consciousness of the audience is determined by social and historical factors. Thus satire is a function of the historically defined moment of reception.

The satirists are left with three possibilities. They can work with the knowledge of the audience as it is, and bring out new aspects in old facts through techniques of defamiliarization. Then, they can play with this knowledge by getting at the breaks, taboos, stereotypes, and unreflected ideas contained in it. Or, finally, they can go through the trouble of supplying new information, thus providing the audience with a new perspective.

A scene by the Münchner Lach- und Schießgesellschaft illustrates this technique. The beginning of the scene provides new factual information by doing some basic arithmetic. The state takes in 2.86 marks in taxes for each pack of cigarettes. Based on a consumption of 128 billion cigarettes per year, this adds up to 22 billion in tax money. The state spends about 40 billion marks on "defense." Thus smokers pay for almost half of the defense budget. The scene goes on to use this information in order to cast some light on the dubious budget policies of the state. On the one hand, the state cannot afford to give up this source of income just for the sake of saving some of its citizens from lung cancer; on the other, the *Grundgesetz* demands: "Everyone shall have the right to life and to inviolability of his person" (article 2, paragraph 2), which the state should be there to protect. But the money is needed to defend the "free world"—or rather, to satisfy the demands of the lobbyists of the military-industrial complex. Satire, in an act of playfully blaming the victim, turns the situation around: those who are against smoking are against military expenditures and undermine the defense efforts of the free West, thus nonsmokers are communists. Only the cigarette industry recognizes children as full citizens by letting them smoke and thus partake in the fight against communism. Those who refer to the constitution and to the laws for the protection of children turn out to be enemies of the state.[22] A quote from Degenhardt's "Questioning of a Conscientious Objector" draws the conclusion of this perverted logic: "You always refer to the *Grundgesetz*. Say, are you a communist?"[23]

In their pose of intellectual superiority, the satirists often forget about the ambiguous character the ideals of the Enlightenment have taken on in modern society. Thus, in the true vein of the Enlightenment, they often suggest that sufficient intelligence on the part of politicians would solve most problems, would help us out of our "selbstverschuldete Unmündigkeit." Werner Schneyder is an example of this disregard for the dialectical nature of intelligence. He sings the song "For my taste, they [the politicians] are not intelligent enough," and it comes as no surprise when later on he says resignedly: "We cannot depose them anymore, we can only despise them."[24] This is what Walter Benjamin referred to as "linke Melancholie,"[25] which comes about through the futile attempt to turn back the wheel of history of the bourgeois state to an ideal condition in which it never was.[26] Unless satire has as its foil ideals that go beyond the ideals of the bourgeois state, it is bound to get caught up in the attempt at solving antagonistic contradictions as if they were temporary symptoms.

"Die Zeit schreit nach Satire": Satire and the "Wende"

Wie ist es möglich, daß an die 80 Prozent des Fernsehvolkes sich an "politischen" Kabarettsendungen ergötzen und die Wahlen regelmäßig das Gegenteil dessen zeitigen, was die Kabarettisten, wenn auch nur noch in feinster Sublimierung, moralisch-pädagogisch anstreben? Liegt es an der Ohnmacht der Satire oder an der Bewußtlosigkeit des Publikums?

Cabaret historian Klaus Budzinski, *Die öffentlichen Spaßmacher*, 1966

After the Second World War, satire became an important tool for dealing critically with the contemporary situation in Germany. With the prosperity and restorative policies of the 1950s, progressive humorists tried to educate their audience and act as their advocate in the struggle for democracy by exposing the discrepancies and contradictions in their society.[27] Yet, by the 1960s, deep mistrust had arisen around the function and effectiveness of satire in West Germany. The satire which laughed at the folly of the politicians had fallen to the level of a mere court jester who could say anything, but was never taken seriously. Many critics feared that, instead of offering true critical opposition, satire only provided an alibi with which the government could demonstrate how tolerant it was. Others felt that, instead of provoking its audience to change the situation, satire only provided a release valve for feelings of dissatisfaction, diffusing resistance into noncommittal laughter.

When the Social Democrats came to power in the late 1960s, a split developed in the satirical camp. On the one hand, progressive satirists who sympathized with the SPD were confronted with a dilemma. The values they had been battling no longer ruled, at least in name. Reluctant to attack the framework of the system, these satirists found themselves in a dead end, playing the role of topical entertainers. On the other hand, more radical satirists in the wake of the extraparliamentary opposition and the student movement opted for a satire which took a standpoint outside the party framework. Looking beyond surface phenomena, this satire tried to make a radical critique of the system itself. In order to avoid the pitfalls of conventional satire, these critics adopted a shock strategy, aggressively confronting and provoking the audience without giving them the opportunity to shake off the attack with laughter and applause. This satire became agitation instead of culinary entertainment.

When the conservative Christian-Democratic Union came to power in 1982 under the chancellorship of Helmut Kohl, one could well expect a revival of satire. Once again, even the less radical satirists found themselves in the opposition and had ground under their feet from which to attack. Political themes and scandals abounded: the Flick party contribution affair, the arms race and SDI, nuclear power, unemployment, educational policy, guest workers, the environment. The contradictions of the Bonn system are painfully apparent as the Kohl government talks of great ideals while betraying those very ideals in its actions. And indeed,

at first glance, it would appear that satire has blossomed since the "Wende." Books of Kohl jokes, political caricatures, cartoons, and humor seem more prominent than ever. As Kurt Tucholsky said in 1929: "Die Zeit schreit nach Satire." Chancellor Helmut Kohl, the most popular target for satirists of the "Wende," has become a symbol of all that is wrong with the CDU government. Let us look at three satirical strategies directed at Kohl as representative of the new regime: satire as a gag, satire as a personal attack, and satire as a cultural critique.

Model 1: The Topical Gag. In these satires, although they use political themes, the emphasis lies so heavily on the comic technique that laughter is an end in itself, and no political analysis takes place.

The mere abundance of Kohl jokes would seem to signal a new trend toward public dissent and critical thinking. For example, one joke attacks the employment policy of the regime:

> Kohl will einen arbeitslosen Architekten trösten. "Wenn ich nicht Bundeskanzler wäre, würde ich auch Häuser bauen." Der Architekt: "Wenn Sie nicht Bundeskanzler wären, würde ich das auch tun."[28]

The joke exposes the government's hypocritical rhetoric as Kohl expresses admiration for the little man but at the same time makes policies which favor the industrialists and do nothing for those in whose interest he pretends to act. Another joke unmasks the government's inhumanity and lack of concern for the elderly.

> Der Bundeskanzler fragt Lambsdorffs Nachfolger, wie er sich denn eine vernünftige Rentenreform vorstellt. "Die realistischste, die mir eingefallen ist, sieht so aus, daß 1985 die Rentner bei Rot über die Straße gehen dürfen und ab 1986 müssen."[29]

Here the satire points up the discrepancy between the professed social service of the pension reform and the brutal economic interest behind the government, which always comes first. Both of these jokes do have a strong satirical effect. Yet if one looks at a volume of Kohl jokes as published by the Eichborn Verlag in 1984, one finds only a few that are truly political. Most just mock Kohl's stupidity:

> Kohl läßt sich nach einem anstrengenden Tag nach Hause chauffieren. Doch unterwegs bremst der Fahrer vorsichtig das Fahrzeug ab. "Ich glaube, das ist ein Platte[r]." Sie steigen aus und besehen sich den Schaden. Kohl meint tröstend zu seinem Chauffeur: "Da haben wir aber noch mal Glück gehabt, der Reifen ist ja nur unten platt."[30]

The effect depends only on recognition of the punchline. One could substitute any name here; these jokes are interchangeable with your average *Ostfriesenwitz* and are not specifically linked to the politician Kohl or his government. Similarly, the many political caricatures which have appeared in anthologies on the book market seldom offer real critique.[31] For the most part, they are merely puzzles: one has to figure out the allegory, the reference to a recent political event.

Figure 1. Walter Hanel, Kohl caricature from *Kölner Stadtanzeiger,* in Pepsch Gottscheber (et al.), *Die geistig-moralische Wende. Eine satirische Bilanz* (Frankfurt: Fischer, 1986), n.p. Used by kind permission of Walter Hanel, Bergisch-Gladbach.

A cartoon of Kohl sitting on a chair that is really an hourglass, with the sand slowly draining out from under him, is a funny idea but does nothing to tell us why Kohl's time is running out or what is wrong with his politics (fig 1).

Model 2: The Privatizing Attack. Concentrating on the personal Kohl, these satires attempt to destroy respect for Kohl by making him ridiculous as an individual outside of his official context.

The figure of "Birne," the pear-headed caricature of Helmut Kohl, has boomed among satirists. The *Birne* iconography goes back to a popular French caricature tradition of the 1830s, portraying the "Bürgerkönig" Louis Philippe as a pear (in French, a "fathead"). It would seem to be the ideal parallel, evoking a time of great disillusionment with a new government which appeared so promising to many but beneath the surface was rotten to the core—as one described it, "auf politischem Gebiete wesenlose Formeln, auf wirtschaftlichem Gebiete

Figure 2. Daumier, "The lawgiving machine of constitutional monarchy, its three main elements and all the accompanying accessories": the pear on the throne, a ministerial harlequin balancing an enema syringe on his nose, the dynastic mummy, and the symbols of the money-box, swords and chains, the executioner's block, and again the enema syringe. *Le Charivari,* July 21, 1834.

die nackte Selbstsucht der freien Konkurrenz, verbrämt mit schönklingenden Phrasen, die in bewußte Lüge ausarteten"[32] (fig. 2).

Burkhard Fritsche's cartoon of Wilhelm Tell today shows Helmut Kohl holding an apple as Tell asks whether he should shoot the apple or the pear (fig. 3). Whereas the French cartoons satirize Louis Philippe in his official capacity, showing his abuses of the monarchy and the corruption of the court, the *Birne* cartoons only malign Helmut Kohl the individual. In Peter Knorr and Hans Traxler's volume *Birne: Das Buch zum Kanzler,* Kohl appears laughable not as a politician but as a naive, muddleheaded philistine (for example, in the bedroom with his wife, Hannelore, fig. 4). Mocking Kohl on the most private level is intended to question his authority in his role as statesman. A Traxler flip book cartoon entitled *Birne zaubert: Eine hochkarätige Performance aus dieser unserer Bananenrepublik* shows Birne the magician doff his hat and cape, as a giant banana grows out of his fly, swells and retreats again, at which Birne bows and is bestowed with cheers and thousand-mark bills.[33] Focusing on the personal, the satirist chooses to ignore the chancellor's political significance. The issue becomes Helmut Kohl's personality rather than the system itself.

Wilhelm Tells Meisterschuß !

Figure 3. Burkhard Fritsche, *Im Land des Lächelns. Knallharte Geschichten + abenteuerliche Gestalten. Vom Leben selbst gezeichnet* (Hamburg: VSA, 1984), n.p.

Model 3: The Cultural Critique. Picking up on his misuse of language, his prostitution of the classical heritage, and his artificial heroism, these satirists see Kohl not as a political figure, but as a symptom of the miserable intellectual level of modern society.

An especially popular topic for attack by today's satirists is the ridiculous, overinflated language of the conservative politicians. Emotionally charged but vague concepts, such as *geistig-moralische Wende, Aufschwung, Heimat, Freiheit, Zukunft,* or *Erneuerung,* give the government the appearance of being on a great humanitarian mission, but say nothing. In a piece entitled "Das große Kohl-Worträtsel," Dieter Höss offers a two-page list of disjointed words: "Histo-rische—Stunde—dies—nicht—Zukunftsperspektive—breiter—Chichten—ist—nicht—bei—Gänse—der—Sprache—wir—sprechen—mit—Stil—Würde—Ernst—in—allem—Hohen—Hause—die—Deutlichkeit—nicht—selbstverständlich—wir—

Figure 4. Hans Traxler and Peter Knorr, *Birne: Das Buch zum Kanzler. Eine Fibel für das junge Gemüse und die sauberen Früchtchen in diesem unserem Lande* (Frankfurt: Zweitausenddeins, 1983), 8–9. Copyright 1983 by Zweitausendeins, D-6000 Frankfurt am Main 61, Postfach.

wollen—Stil—Würde—Erneuerung" . . . *ad nauseam.* Below, the "directions" for the puzzle explain: "Die obenstehenden Wörter ergeben, richtig zusammengesetzt, eine richtige Kohl-Rede."[34] Kohl's syntax and metaphors are notoriously bad, and pearls of wisdom such as "Das blanke Ich muß wieder aufgehen im Wir des Volkes"[35] betray that his politics have become more talk than meaning.

Eckhard Henscheid's semifictional biography *Helmut Kohl: Biographie einer Jugend* picks up on this theme of the new conservative abuse of language. Imitating Kohl's speech style, this biographer clumsily attempts to juggle overblown concepts into convincing sentences. It is no coincidence that the chapter on "Kohls Ethik" is a fragment: after tripping over syntax and becoming hopelessly entangled in a net of verbal nonsense, the author breaks off the attempt "wegen Unqualifiziertheit und Unsäglichkeit."[36] An attempt at finding the "ethics" beneath the surface results in gibberish:

Seht, Freunde, in der Politik und auch und gerade damals, als Kohl sich schon den Ministerpräsidenten ausbedungen und abgerungen hatte (allerlei Geschäfte riefen ihn da dann immer wieder von Mainz nach Tilsit), auch noch in der Zeit, als Kohl schon

als Kanzleramtsinhaber die 'natürliche Autorität' (Kohl am 13.5.85 über Kurt Gor-
batschow) wieder wider Adornos "Ohne-Leitbild"-Standpunkt und gegen Marcuses
"Ohnemichel"-Ideologie systemüberwindend oder jedenfalls mindestens systemwen-
dend sich nicht entwinden konnte, in seine oder ihre alte Rechte einzuschmettern,
selbst da noch zwickte.[37]

—whereupon the frustrated author abandons his unfinished monstrous sentence
to try again. Similarly, in the final pages, the tale turns into utter lunacy, running
in circles like a mad dog chasing its own tail:

> Gegner Kohls—und ihrer sind boing viele—verweisen in diesem Zusammenhang im-
> mer wieder nachhaltig und lauthals auf die ebenso ektoplasmisch wie zombiespastisch
> obergärige Spitzenwürfigkeit dessen, was quoggl ab 1982 "Wende" quasseln sollte
> quark. Gewiß, da ist was dran schrumm. Kelch und Pneuma.[38]

Language runs riot; freed by Kohl's abuses, the words metamorphose and invent
themselves, a new intellectual cancer.

Following the recent CDU strategy of self-legitimation by constantly refer-
ring to cultural figures and literary heroes, Henscheid's fictional biographer loads
his tale with references to Brahms, Goethe, Eichendorff, Hugo Wolf, Verdi, and
many others as he tries to stylize the chancellor into a lofty intellectual. He pulls
parallels out of nowhere just to drop impressive names. For example, Kohl moved
to the Marbacher Straße, which ties him to Schiller, who grew up in the town
of Marbach.[39] Quotes from all possible sources are drawn into the narrative out
of context, and Latin and English catchwords decorate the text to give it an air
of pompous authority (ironically highlighting the much-ridiculed fact that Kohl
knows no foreign languages). This narrator has set himself the task of making
Helmut Kohl into a hero; no distortion, no lie is too great. Every event in Kohl's
life is overdramatized with ridiculous metaphors and pompous archaisms. Primar-
ily a parody of modern biographies and journalists, this book is also an attack
on the Kohl cult, but it is hardly a critique of Helmut Kohl or the government.

Instead of analyzing and unmasking Kohl and his party, Henscheid heaps
scorn on him. Ultimately, Henscheid is reduced to describing Kohl as an "Umpf":

> Der Umpf ist ein Primat und durchsetzt die gesamte Biosphäre mit einem . . . Schwall
> an Virulenz und Orschgreed. Eines der erregendsten Abenteuer der Genesis, ja viel-
> leicht ihr televisionäres Telos (Zielprojektion) ist der Umpf . . .: der Höhepunkt der
> Schöpfung selber. . . . Das Symbol des . . . Umpf ist folglich . . . der sogenannte
> Krampf. Nämlich im Kopf des Umpf rumpumpelt stets ein starker Scherbelhaufen
> aus Wurst und Wusch und Schleim, der alles sogleich . . . überschwemmt und
> überschwuchtelt . . .[40]

Such passages of acid indignation hardly help to clarify or expose the chancellor.
Large sections of the book attempt to "soil" Kohl through disrespectful sexual
allusions. The tale is interspersed with Kohl's affairs with various women, and
his sex life with his wife makes for juicy passages of gutter humor. Kohl's political

career emerges here merely as sublimation of his uncontrollable urge to masturbate.[41] The power structures, class interests, and economic machinations which underlie current policies go unmentioned.

Assessment. We have seen here three satirical strategies toward the current government, all of which appear to miss the mark as political critiques. We have first the jokester persona which is primarily concerned with an original punchline or comic technique. The mere topicality of these satires, and even their apparent oppositional character, cannot make up for a lack of political reflection and analysis. Then we have the personal lampoon, which all too often resorts to mockery of the individual and loses sight of the system this individual represents. Though they assume and foster contempt toward the chancellor, they do not channel the critical energy anywhere. Finally, we have the enraged intellectual who sees Kohl no longer as a political phenomenon but as the symptom of cultural barbarism. These satires do effectively expose the hypocrisy of the "geistig-moralische Wende," which despite all surface appearances is neither intellectual nor moral but merely greedy for power and money. And yet, all these critiques fail to go beneath the surface, for they work almost solely by means of aesthetic critiques: Kohl is unattractive, he is not an eloquent speaker, he has a silly smile, he has a pear-shaped head. The satirists seem to argue for a leader who is handsome, charismatic, and intelligent. But what values the leader should have, and how the system the chancellor leads should look: these questions are beyond the realm of this mockery. These works lack a clear perspective, a political value system from which the attack is directed, and as such they fail as critiques. In effect, these pieces are deadeningly negative, rejecting all political values.

It may seem that a socially and intellectually regressive period would provoke satire as protest. Today there is so much to satirize, yet we look for that satire in vain. The 1980s are a time of disillusionment and apathy. Kohl *is* a satire, people will tell you. Look at his policies and his speeches. Even his perpetual, vacuous smile says it all. How can the satirist top such unbelievable remarks as Kohl referring to the GDR as a concentration camp, his Gorbachev-Goebbels parallel, or the so-called black-out during his testimony on the Flick affair—or Geißler's line that pacifism was responsible for Auschwitz? Who can laugh about Bitburg? When the populace grows accustomed to such scandals, shock and provocation become virtually impossible.

Laughter is a two-edged sword. In the 1940s, the caricaturist Thomas Theodor Heine questioned his own attempts at fighting Hitler through laughter when he related that "our caricatures were very popular. But they helped to make the people we caricatured popular. And so it was that we fought in vain."[42] These Kohl satires run the same danger of making Kohl appear ridiculous, harmless, and even involuntarily sympathetic. In response to the *Birne* book, a critic wrote: "An sich kann sich Birne freuen: Wer so rangenommen wird, hat doch irgendeine Bedeutung."[43] Rather than having an enlightening effect, these works, which use satirical techniques merely to humorous ends, may even tend to reinforce the

status quo by reconciling the reader with the crazy world of politics, soothing us with laughing resignation.

Politics, they seem to be saying, is not worth taking seriously, even in jest.

The Satirical *Volksstück:* Attempts at Alienating Entertainment

The object of political satire can, as we have seen, be those most obviously associated with politics—that is, the professional politicians. Is there a feasible means of locating political satire among the "masses"? Two writers, Gerhard Polt and Siegfried Zimmerschied, appropriate a *Volksstück* format for this purpose. The varying results these authors have had in their adaptations are the focus of the following section.

The concept *Volksstück* is a catch-all category for a theater of and for the people (*das Volk*). *Volksstücke* vary from regional, dialect-bound, popular pieces, such as those of Nestroy and Raimund, to the critical realism of such 20th-century authors as Ödön von Horváth and Bertolt Brecht. Whatever the intention of the *Volksstück,* simple diversion or organ of criticism, it is a reflection of the everyday life of the people in which entertainment has a central function in making reality attractive to the public. The challenge to the modern *Volksstück* writer is to recognize, as Brecht put it, that "dem Volk aufs Maul schauen ist etwas ganz anderes als dem Volk nach dem Mund reden."[44] The foils of reality and entertainment as elements of the satirical *Volksstück* are not ends in and of themselves but ultimately serve the goal of didactic criticism.

Gerhard Polt, together with Hans Christian Müller, has produced a number of works including television programs, theater pieces, a film, recordings, and many books. Both men began their careers in the Munich cabaret scene. Such titles as *Wirtshausgespräche oder Die schweigende Mehrheit erzählt*[45] and *Fast wia im richtigen Leben*[46] hint at a focus on the everyday or the experience of the "little man." And, indeed, the larger works concern themselves with the perceptions and concerns of this social strata. The audience is given access to conversations within the "private" sphere. The intended effect is to force the audience into reflecting on similar situations within their own private sphere, from which they normally cannot gain any critical distance.

Wirtshausgespräche is a collection of three progressively apolitical conversations taking place in a local bar, which are to be performed on a single evening. In the first sketch, subtitled "Veteran und Reservist," Polt attempts to show the relationship of the *Spießbürger* to politics. The characters as the scene opens are: the waitress Anna and the bartender Otto, a penniless bum, Herr Crott, a veteran (of World War II) and recently released member of the Bundeswehr. In an early statement by Anna, the stage is set for the two main political topics of the evening, unemployment and war:

Anna [referring to the *Penner* who cannot afford to pay his 2 DM bill] Wenn man solchene Leute sieht, ma verstehst ma direkt, warums diese Neutronenwaffe baun,

so Leut wie der san ja total unrentabel, solchene Parasiten.
The Veteran responds: Des hatt zu meiner Zeit net gebn. Da hat ma solchene Subjekte eingesammelt. A Schaufel in d Hand, a Tritt in Arsch und ab in Steinbruch.[47]

Here, Polt uses both exaggeration and understatement to question the "solutions" offered by the present and past political systems. He exaggerates the ineffectiveness of the present system to deal with the problem of unemployment by implying that only war can lower the growing number of such "social misfits." The "alternative" offered by the veteran is discredited by its unstated but implicit coupling with Hitler and fascism. Anna, looking then to the future, sarcastically offers another possibility. She tells of a new plan whereby citizens will have an option between paying taxes and the sponsorship of a particular *Beamter,* civil servant. This raises the question of how unemployment will be funded if no or very few taxes are collected. Anna's reply: "Mei dei werden in Beamtenstand erhoben, dann ham mir die Arbeitslosigkeit praktisch glei au beseitigt."[48] The ability of all three plans to deal effectively with the problem of unemployment is questioned; the "solutions" offered merely work to eliminate the symptoms of unemployment by "eliminating" this class of people either directly, through a bomb or forced labor, or indirectly, by renaming them. However, the viewing audience is not granted time, nor are sufficient causal relationships exposed, to allow them to question the acceptance of unemployment by the system as a given, or to reflect on the possibility that the system itself is the cause of this problem. Even the open-endedness of the conversation, which could stimulate reflection, is abruptly cut off by Mr. Crott falling from his stool and having to be sent home in a taxi.

After Mr. Crott's departure the attention of the audience is refocused on the topic of war—and, in particular, on atomic and neutron weapons. The young reserve officer responds to Otto's fears of a total annihilation:

Was habt s' es gega de Neutronenwaffe? De is ethisch betrachtet wertvoller, weis die Sachwerte nicht antastet. . . . Wenn einer in am Atomkrieg stirbt, na is er meisten selber mitschuld. Unser Bevölkerung is ja in erschreckendem Maße uninformiert.[49]

A choice between no information and misinformation is no choice. There is more "hope" in Otto's total fear of any kind of modern war than in the reserve officer's misguided thoughts on the ethics and survivability of such a war. The emptiness of the dialogue is underscored when it becomes apparent that this "knowledge" is merely a reflection of military brainwashing. "Wissen Sie zum Beispiel wie ma sich verhält, wenn a Nuklearschlag kimmt? . . . Da schaun s', i habs schriftlich."[50] Upon which he reads aloud and enacts the provisions to be followed: jumping behind the counter, zipping up his jacket, putting up his hood, putting on his gloves and sunglasses, and wrapping himself in aluminum foil. Otto flips on the television, and the ludicrous futility of these actions is punctuated by a film report about the effects of atomic bombs, neutron weapons, and Cruise missiles. Polt succeeds in isolating an accepted part of society, war, which needs to be critically examined, but again fails to provide enough information

to bring it into a larger context or spur a motivated counterresponse to the notions presented.

Polt is aware of the cancerous symptoms prevalent in modern West German society but fails to reach the level of true political satire. Why does he refuse to expose any causal relationships? Why does he avoid or divert from didactic moments—reverting to a mere *Unterhaltungsform?* An answer is the audience, and, in this case in particular, the television audience. As Manfred Bosch states in his article analyzing the use of the *Volksstück* in modern television:

> . . . nicht in kritischer und solidarischer Sicht soll das Publikum mit eigenen Verhaltensweisen konfrontiert werden, denn dies würde die Frage nach deren Ursachen implizieren, sondern in Form einer Komik, die die Deformation der dargestellten Figuren und ihrer Entsprechungen in der Realität den Betroffenen selber anlastet. Die apolitische Fassade und die bewußte Ausblendung der gesellschaftlichen und ökonomischen Rahmenbedingungen menschlichen Handelns und Verhaltens gehören freilich zu den Gesetzen des Volkstheaters im Fernsehen.[51]

The ambivalence of position, which is necessary to guarantee a large audience, undermines the sharpness of the possible satire. Those who are politically educated—whatever their leaning—will be able to fill in the necessary contexts and fulfill the goal of the satire. Those in the viewing audience limited in their political thinking and merely seeking distraction will remain captive of the humoristic deformations.

How then does Siegfried Zimmerschied's attempt at a satirical *Volksstück* compare with Polt's? While Polt must adapt to the framework of national television, Zimmerschied chooses to remain on a local level—appearing in cabarets and small *Volkstheater.* Passau is the center of his activity, although he has traveled widely throughout West Germany.

In his piece *Für Frieden und Freiheit—Ein Holzweg in vierzehn Stationen,* Zimmerschied combines the personal and the political within the family sphere. This piece tells the story of Wick Wimmer, Hausmeister, his wife Irmgard, and their daughter Regina, who get caught in the Passau political game. Between the nagging of his wife, whose biggest desire is to have a family member at least mentioned (perhaps with picture) in the society column of the local newspaper, and the chiding of his antiestablishment daughter to enter the system and make a difference, Wick decides to enter the game. As he says:

> Des is a Schpui, Regina, mid ganz feste Regeln und wer de kennt, der kann oisse werd'n. Do schau d'as a. . . . I kann musizian, i kann singa, i kann Schprich reißn, i kenn vui Leid, i bin a Original—des is mei Kapital. Aushängeschuit'l, Alibiwurzelsepp, der d'Leid a'ziagt, des is mei Kapital, vaschtähst. Jede Partei braucht ihr'n Luis Trenker.[52]

Then they enlist Gerold Hinterreiter, the bland son of an influential local politician, who in turn sees this as an opportunity to woo Regina. However, Wick learns that knowing the rules does not always mean being able to control them.

The characters are well developed in their roles as agents and victims of a "politically" controlled society. Through their relationships with one another, the rules of the game become clear. The greatest "enthusiasts" are also the object of the most pointed satirical scenes. Irmgard, who is so concerned about appearances, forces her daughter into a dirndl and her husband into wearing the "folksiest," brightest tie he has for their first meeting with the influential Gerold Hinterreiter. However, she neglects to remove the hairnet that is protecting her new permanent. Gerold's façade of wholesomeness as the leader of the Junge Union and of *honor et amicitia*—the ideals of his fraternity—is later exposed by Regina with the aid of some fruit schnapps, when he exclaims: "Amicitia et honor hin, honor et amicitia her . . . ich bin so geil wia a ganz Priesterseminar."[53] Regina's rejection of such advances ultimately leads to her father's political demise.

Zimmerschied realizes the impotence of strong audience identification tempered only by a satirization of the most offensive figures. To avoid this lameness he uses various alienation techniques to aid his audience in perceiving causal relationships. Some of these techniques are quite obvious, while others are buried in the framework of the traditional *Volksstück*.

With his use of dialect, Zimmerschied plays on both sides of the fence at the same time. As in the traditional *Volksstück,* he uses dialect to aid in identification, but he also very directly underscores the fact that, culturally, it has come to be seen as a social limiting factor. Wick has risen high enough on the political ladder to give his first speeches. Gerold comments as they are practicing: "Herr Wimmer, das Wichtigste ist: Sie sollen zwar Bayerisch sprechen, aber so, daß man merkt, daß Sie was besseres sind."[54] Gerold turns right around, however, and testifies that this "besseres" is totally meaningless:

> Achtzig Prozent unserer Kommunalpolitiker können sich wahrscheinlich selbständig keine zwei Sätze merken oder ausdenken. Aber dafür sind sie auch nicht da. Dafür gibts Berater, Zentralen, Vorlagen und Musterreden. Sie brauchen nur noch die Namen auszuwechseln. Und wenn alle Stricke reißen, machan S' an Witz über'n politischen Gegner.
> Und am Schluß Schnaps und Freibier.[55]

Zimmerschied exposes the abuse and exploitation of language by this system, thereby questioning the system's notion of communication altogether.

Throughout the first twelve scenes of the play, Zimmerschied has various moments in which the figures verge on breaking character to talk directly with the audience. The otherwise rapid-paced dialogue is interrupted by a monologue which contains an analysis of the situation. For example, just as Wick explained the rules of the game earlier in the play, he reveals at the end their overwhelming power:

> Du sitzt do drinn in der Versammlung und . . . Oisse mochst mid, nur des ned, des ned. [Referring to a vote which is to take place.] Auf oamoi wiad's schtad und oana redt von da Bedrohung der Gemeinschaft durch Verweigerer, durch asoziale Elemente.

> . . . Langsam, ganz langsam ziagt's d'an in d'Höh, an Arm. . . . Du woaßt du wead'stas
> wieda doa, du k'heast dazua zu den Ignoranten, schwammigen Feiglinge.[56]

To ensure that the means of alienation he has blended into his *Volksstück* have
their full effect, Zimmerschied alienates the entire notion of the traditional
Volksstück in his final two scenes. The audience is left in an uncomfortable, un-
familiar setting and the relief of a happy end remains absent. For the first time,
the scene is something other than the Wimmer home. In *Aufsteigers Totentanz*
("The Death Dance of the Parvenu") there is no identifiable location. A collage
of life-size photos of Wick's climb to "success" is set up on stage, around which
Wick and Irmgard dance in a "boleroesque" manner ending in a chaotic
Klanginferno. This contrasts with the deathly silence of the final scene, a room
in the intensive care unit of a hospital. The destructiveness of the system is exag-
gerated: Wick has suffered a heart attack or stroke, Irmgard has had a nervous
breakdown, and Regina, who had fled to India, is suspected of having tuberculosis.
Those playing the game as well as those trying to escape it altogether cannot re-
main unaffected. Irmgard's closing words underscore the didactic message.

> Freilich ham's uns einag'legt, desmoi. Owa glaubt's ma's s'nächste Moi mochan mia
> de Fehler nimmer, des garantier i eich.[57]

Her misconception that the "mistakes" are avoidable and not inherent in the
discrepancy between such a political system and its professed ideals of peace and
freedom focus the audience's attention exactly on the problem. At a bare minimum,
the rules must be changed, possibly the entire game.

 Both Polt and Zimmerschied recognize the populace as the potential source
of political and social change. By using the satirical *Volksstück,* they have at-
tempted to attract this milieu and make it cognizant of this potential. In doing
this, Polt and Zimmerschied have assessed the relationship of author, work, and
audience differently.

 Polt has concentrated on reaching large numbers of the populace. To do this
he has had to make compromises with the "rules" of mass media. This approach
has also distanced him from his audience while at the same time placing a larger
responsibility on them. He mirrors situations of everyday life and assumes that,
through his slight accentuations, the audience can and will look for and question
the source of these events. He underestimates the numbing quality of the very
same reality which encourages its citizens to leave politics (like everything else)
in the hands of the experts. His pieces have a release valve function, with little
potential for sustained reflection on the part of the audience.

 In contrast, Zimmerschied has realized that merely satirically demonstrating
the effects of the system may not be enough to help the audience establish con-
nections between these and the essence of the system. He uses the satirical method
along with other alienation techniques to engage the audience in their role as ac-
tive cast members in the satirical *Volks-Lehrstück.* According to Zimmerschied,
the possibilities of such a combination form are best tested on the local level.

Es ist eine tägliche Konfrontation mit einer Dichte von Vorurteilen und Machtkonzen-trationen, die dem liberaltätig gesalbten Großstädter schon fehlen. . . . Denn hier in der Provinz kann es noch provozieren, und über diese Provokation können, da die Zielgruppe überschaubar ist und die Kommunikation mit dem Publikum nicht nach der Vorstellung endet, Initiativen und Aktivitäten geschehen.[58]

The satirist must carefully weigh the ability and desire of the audience to deal with the discrepancies revealed within their everyday lives. The audience is the key to the didactic goal of satire. In a society where questioning the norm is seen as asocial behavior, the satirist cannot simply humorously relate certain events. The text must establish enough causal relationships so that the critique of the real controlling forces, not their manifestations, is the object of the satire's persuasive and unambiguous laughter.

Conclusion: The Volatile Art of Satire

Most of today's satirists have abandoned the radical shock treatment and are at-tempting once more to be humorous and mainstream. This strategy has advan-tages as well as dangers. Comedy appeals to a much broader audience; it can thus smuggle in subversive ideas. Yet when we look at today's satires, we also see the weakness of such a strategy, for all too easily laughter becomes an end in itself and distracts from—or even nullifies—the critical intent. Focusing their energy on understanding the joke, the audience loses the distance necessary for reflection.

Satire lives from negativity, but that is also its great weak point. The combi-nation of aggression and indignation with the pleasurable sensation of laughter makes for a touchy balance. The negativity can spur critical consciousness or numb its audience into mocking everything without reflection. If anything, such laughter serves only as a release valve for vague feelings of dissatisfaction and is ultimately affirmative in character. As Brecht said of oppositional culture: "Das gegen ihn gespritzte Gift verwandelt der Kapitalismus sogleich und laufend in Rauschgift und genießt dieses."[59]

The balance between affirmative laughter and destructive mockery rests on that elusive third element of satire: the ideal. The satirist assumes certain com-mon values in the audience: freedom, justice, equality, peace, freedom of the press, the right to work, self-determination. Satire works by holding up a negative image of the present for our judgment. The actual message remains unspoken. We must complete the picture by providing a valid value system as a foil to the one we find portrayed.

Yet where *are* these positive values satire attempts to engender? Asked over and over by his audience, "Wo bleibt das Positive?," Erich Kästner could only answer: "Ja, weiß der Teufel, wo das bleibt."[60] And yet, when chided for the cynicism, perversion, and destructiveness of his work, Kästner earnestly insisted: "Ich bin ein Moralist!"[61] The cynicism or negativity of the portrayal are not the

values of the satirist, but rather the characteristics the satirist wishes to decry. The audience has to do the work; the satirist has given us the problem to solve in the optimistic assumption that we will find the "right answer." But isn't such a concept terribly naive and even dangerous? Couldn't such satire, directed into a vacuum, lead to applause from the wrong camp? There is the example of a production of Brecht's *Die heilige Johanna der Schlachthöfe* which was seen by the bourgeois audience only as a critique of a crude form of capitalism long since overcome.[62]

Because satire is so dependent upon reception and interpretation, it is particularly unstable. The satirist walks the line between catering to the audience's desire for entertainment and provoking them to reconsider their own values. Critical satire induces at least some people in the audience not to laugh in agreement, but to boo in disagreement. Satire tests the limits of the audience's ability to self-criticism, deconstructing the illusory harmony of everyday life.

Looking back at our examples, we find that they often lack the elements of analysis necessary to penetrate existing power structures. And so today's West German satirists are in danger of missing the chance to elicit the critical laughter of genuine satire.

Notes

1 See Karlheinz Stierle, "Komik der Handlung, Komik der Sprachhandlung, Komik der Komödie," in *Das Komische*, ed. Wolfgang Preisendanz and Rainer Warning (Munich, 1976), pp. 244ff.
2 See Georgina Baum's interpretation of Jean Paul in *Humor und Satire in der bürgerlichen Ästhetik— Zur Kritik ihres apologetischen Charakters* (Berlin [East], 1959), pp. 45f.
3 See Helmut Arntzen, *Gegenzeitung* (Heidelberg, 1967), p. 7.
4 Friedrich Schiller, "Über naive und sentimentalische Dichtung," in *Schillers Sämtliche Werke*, Säkular-Ausgabe (Stuttgart, 1905) 12:194.
5 Karl Marx and Friedrich Engels, *Die heilige Familie* (Berlin [East], 1953), p. 15.
6 See Jürgen Brummack, "Zu Begriff und Theorie der Satire," *DVjs* 45 (1971): 282.
7 Herbert Marcuse, "Über den affirmativen Charakter der Kultur," *Kultur und Gesellschaft* 1 (1965): 80.
8 Ibid., pp. 89f.
9 See Gerhard Hofmann's discussion of Sigmund Freud's essay "Massenpsychologie und Ich-Analyse," in his *Das politische Kabarett als geschichtliche Quelle* (Frankfurt, 1976), pp. 183f.
10 See Arntzen, *Gegenzeitung*, pp. 12f.
11 Martin Buchholz, *Lacht auf, Verdummte dieser Erde* [audiocassette, published and distributed by the author] (Berlin, 1985).
12 Gerhard Polt and Hanns Christian Müller, *Deutelmoser* (Jupiter Records, 8276571).
13 *Wir werden weniger*, the 26th program of the Münchner Lach- und Schießgesellschaft, recorded at a performance in Marburg-Cappel, October 1982.
14 Die Drei Tornados, *Live bei Tante Häschen* (Trikont-Verlag, US 0104).
15 See Dieter Hörhammer, *Die Formation des literarischen Humors—Ein psychoanalytischer Beitrag zur bürgerlichen Subjektivität* (Munich, 1984), pp. 94ff. and 100.

16 See Hans Magnus Enzensberger, "Die Satire als Wechselbalg," in his *Einzelheiten* (Frankfurt, 1962), pp. 216–20.

17 Ibid., p. 220.

18 See Werner Schneyder, *Live* (Verlag Pläne, 88429-30).

19 See Stierle, "Komik der Handlung," pp. 244 and 246.

20 See Pavel Petr, "Marxist Theories of the Comic," in *Comic Relations: Studies in the Comic, Satire, and Parody,* ed. Pavel Petr, David Roberts, and Philip Thomson (Frankfurt, 1985), p. 60 (referring to Dupréel and Bergson).

21 See Jurij Striedter, "Der Clown und die Hürde," in *Das Komische,* ed. Preisendanz and Warning, p. 397; and Jürgen Henningsen, *Theorie des Kabaretts* (Ratingen, 1967), pp. 24ff.

22 Münchner Lach- und Schießgesellschaft, *Wir werden weniger.*

23 Franz Joseph Degenhardt, "Befragung eines Kriegsdienstverweigerers," in *Kommt an den Tisch unter Pflaumenbäumen* (Munich, 1981), n.p.

24 Werner Schneyder, *Live.*

25 Walter Benjamin, "Linke Melancholie," in his *Gesammelte Werke* (Frankfurt, 1972), 3:279–83.

26 See Walter Benjamin's critique "Karl Kraus," in his *Illuminationen* (Frankfurt, 1969), p. 404.

27 See Bernhard Jendricke, *Die Nachkriegszeit im Spiegel der Satire: Die satirischen Zeitschriften Simpl und Wespennest in den Jahren 1946 bis 1950* (Frankfurt, 1982).

28 Heidi Feinhold, ed., *Kohl-Witze: Erklärt ihm die Pointe nicht* (Frankfurt, 1984), n.p. (Kohl called himself a "verhinderter Bauer.")

29 Ibid.

30 Ibid.

31 See Peter Leukefeld and Dieter Hanitzsch, *Links verbrannt und rechts verkohlt: Politische Witze und Cartoons.* Zweite, aktualisierte Ausgabe (Munich, 1983); Pepsch Gottscheber (et al.), *Die geistig moralische Wende: Eine satirische Bilanz* (Frankfurt, 1986), Rolf Cyriax and Gisela Anna Stümpel, eds. ". . . in diesem unseren Lande": Deutschland nach der Wende* (Munich, 1983).

32 G. Brandes, quoted in Eduard Fuchs, *Die Karikatur der europäischen Völker. Erster Teil: Vom Altertum bis zum Jahre 1848,* 4th ed. (Munich, 1921), p. 326. See also Wolfgang Balzer, *Der junge Daumier und seine Kampfgefährten: Politische Karikatur in Frankreich 1830 bis 1835* (Dresden, 1965).

33 Hans Traxler, *Birne zaubert: Eine hochkarätige Performance aus dieser unserer Bananenrepublik. Junges deutsches Daumenkino* (Berlin [West], 1985).

34 Cyriax and Stümpel, ". . . in diesem unseren Lande," pp. 30–31.

35 Eduard Klöpf and Partner, *Rettet Kohl: Helmut Kohl muß Kanzler bleiben. Schlagende Argumente für einen begnadeten Staatsmann* (Frankfurt, 1986), p. 64. See also Klaus Staeck, ed., *Bahnbrechende Worte von Kanzler Kohl (Aufgeblähte Neuauflage)* (Göttingen, 1986).

36 Eckhard Henscheid, *Helmut Kohl: Biographie einer Jugend* (Zurich, 1985), p. 143.

37 Ibid.

38 Ibid., p. 206.

39 Ibid., p. 19.

40 Ibid., p. 210.

41 Ibid., p. 55.

42 W. A. Coupe, "Adolf Hitler and the Cartoonists," *History Today* 33 (January 1983): 26.

43 RRS, "Diese unsere Birne," *tz* 26 (January 1983).

44 Bertolt Brecht, "Hanns Eisler [Notizen für einen Beitrag zum Thema Volkstümlichkeit]," in his *Gesammelte Werke in 20 Bänden* (Frankfurt, 1967) 19:335.

45 Gerhard Polt and Hanns Christian Müller, *Wirtshausgespräche oder Die schweigende Mehrheit erzählt* (Zurich, 1985).

46 Hanns Christian Müller and Gerhard Polt, *Fast wia im richtigen Leben,* vols. 1 and 2 (Feldafing-Obb., 1982–83).

47 Polt and Müller, *Wirtshausgespräche,* p. 17.

48 Ibid., p. 24.

49 Ibid., p. 32.

50 Ibid., p. 33.

51 Manfred Bosch, "Nach dem Mund geredet und aufs Maul geschaut: Von der moralischen Anstalt Mundartschwank zum kritischen Volksstück," *medium* 2 (1974): 11–12.

52 Siegfried Zimmerschied, *Für Frieden und Freiheit—Ein Holzweg in vierzehn Stationen* (Munich, 1986), pp. 25, 27.
53 Ibid., p. 57.
54 Ibid., p. 63.
55 Ibid., p. 67.
56 Ibid., pp. 82, 84.
57 Ibid., pp. 103–4.
58 Siegfried Zimmerschied in a letter to Reinhard Hippen. *Deutsches Kabarett-Archiv* (20.7.1978), quoted in Klaus Budzinski, *Das Kabarett* (Düsseldorf, 1985), p. 284.
59 Brecht, *Gesammelte Werke* 20:37.
60 Erich Kästner, "Und wo bleibt das Positive, Herr Kästner?" (1930), in his *Gesammelte Schriften für Erwachsene* (Zurich, 1969) 1:218.
61 Kästner, "Fabian und die Sittenrichter," in his *Gesammelte Schriften* 2:197.
62 Wolfgang Preisendanz, "Negativität und Positivität im Satirischen," in *Das Komische,* ed. Preisendanz and Warning, 414f. Preisendanz himself witnessed this staging of *Die heilige Johanna der Schlachthöfe* in Zurich.

Doolsummsä and Berchbläidl: Laughter and Fitzgerald Kusz's Democratization of Poetry through Dialect

CHRISTOPHER J. WICKHAM

Dialect and Laughter

It has been said that laughter is an intensely personal thing.[1] It has also been said that laughter is social behavior and enjoys an echo.[2] "Laugh and the world laughs with you; weep and you weep alone." It has been said that laughter is behaviorally linked to domination: "He who laughs last laughs best." Or, in the words of an apparition in *Macbeth:* "Be bloody, bold, and resolute; laugh to scorn / The power of man, for none of woman born / Shall harm Macbeth" (4.1.78–80). Yet we also hear that humor flourishes among victims, who use it to taunt their oppressors or to comfort themselves in their misery. If laughter, as it is also said, results from contradictions, the incompatible, or the incongruous, then such apparent contradictions as these must themselves deserve at least a chuckle.

Laughter is clearly a very complicated matter and it becomes no less complicated when we consider the peculiar relationship between laughter and use of dialect. Why is it that dialect and humor are linked in such a way that to use dialect in literature frequently provokes laughter? Dietmar Ortlieb has maintained: "Im Ausland tritt der Dialekt als unfreiwilliger Clown auf."[3] Only "im Ausland?"—which I take to mean outside the area where a particular dialect is spoken. Or is there a close link between laughter and dialect within a dialect region? I shall briefly address the relationship between humor and dialect in general and then discuss the role of humor in the dialect poems of the contemporary Nuremberg poet, Fitzgerald Kusz. The emphasis will be on the period of Kusz's work which featured humor most prominently and consciously, the 1970s.

By way of clarification, when I speak of "dialect" in this context, I use the term in a broad sense. It refers to language identified by its regional specificity. Typically, it is a form of everyday, informal, spoken language with no accepted written standard. I have in mind principally the dialects of southern Germany and the other Upper German dialects: the Bavarian-Austrian, Franconian, and Alemannic regions.[4]

Just as there is racial and ethnic humor, so there is also regional humor. Indeed, the same story is often told in different communities with a different target

group. One person's Irish joke is another's East Frisian joke. Laughter at the expense of other groups, identified as "not us," is probably as old as laughter itself. We are talking here about jokes told by one group about another for internal consumption by the first group. Frequently, these will involve speech characteristics which identify the target group. They can be vicious; they can be gentle. This gentle example makes fun of the speech in Saxony: "Nu, wie heeßt 'n eechentlich Ihr Gleener?" "Gindr" [Günther]. "Nee, awr wie gonnt 'n Se denn nur so e Nam' gäm! Wenn Se nu emal Gindr rufn, da gomm doch alle Gindr gerannt."[5] The play is on the homophony in *Sächsisch* of the name *Günther* and *Kinder* (children) and this speech characteristic is used by one group to mock another.

Regional speech can also be used to provoke laughter for the purpose of reinforcing the identity and superiority of one's own group. This is the case when a Bavarian says: "Ein Engländer, ein Franzose und ein Bayer unterhalten sich über die Unterschiede zwischen Schreibweise und Aussprache":

"Sehr schwierig bei uns," erklärt der Brite. "Wir schreiben zum Beispiel *Bir-ming-ham,* sprechen aber *Bör-ming-häm.*" "Kein Vergleich," trumpft der Franzose auf. "Wir schreiben *Bor-de-aux* und sagen *Bor-do.*" "Ois nix!" erklärt der Bayer. "Mir schreim, *Wie meinen Sie, bitte?* und sprechen Ha?"[6]

A joke of this sort could be intended for internal or external consumption. It is a put-down for other groups and simultaneously an assertion of self for the Bavarian narrator. There is a significant difference between group humor intended for internal consumption and that intended for external consumption. It is related to the difference expressed in German by the distinction between "der bayerische Witz" and "der Bayernwitz" ("Bavarian humor" versus "a Bavarian joke"). When we come to Kusz, we will see that his dialect poetry is intended for internal consumption, and his use of humor reinforces group identity, but not at the expense of other linguistic groups.

When dialect prompts laughter, why does it do so? Is it because of the inherent properties of the linguistic material, its sounds and their combinations? Some would argue that *Sächsisch* (Saxon) is perceived as more risible than other German dialects because of its sibilants, or because it has some monophthongs where Standard German has diphthongs. Yet it is difficult to claim that the sounds themselves are laughter inducing. At best, one could argue that the sounds of *Sächsisch* relative to the sounds of other German dialects or to Standard German pronunciation strike the speaker of other varieties of German as comic. But this is because of the set of expectations speakers have, based on the phonological structure of their own language, not because of any absolute, objective characteristics of the phonology. In a similar case, Bavarians typically mock speakers of Oberpfalz (North Bavarian) dialect because of its diphthongs *ou* and *ei,* as in *brouder/breider* ("Bruder/Brüder") where Central Bavarian has *ua* and *ia* (from MHG *uo* and *ie*). How do you make an *Oberpfälzer* bark? You tell him there's free beer. He

answers: "Wou, wou!" The *Nürnberger* has the same diphthong but he is not
pilloried for it like the *Oberpfälzer*. Why not? Probably for reasons of status and
economic influence.[7] Nuremberg is a thriving metropolis; the Oberpfalz is an
economically disadvantaged region. This is apparent especially when the Ober-
pfalz is compared to the fertile Lower Bavarian plain along the Danube, Upper
Bavaria, and the capital, Munich. Prestige Bavarian is Munich Bavarian. In any
event, the sounds themselves, it seems, are not enough to account for the comic
effect of a particular dialect. Group perceptions, conditioned by the laugher's
own language patterns and by historical, social, and regional prejudices, play
a role also.

When dialect causes laughter, is it because of social implications? Dialect
is *perceived* as the language of the lower classes, especially of rural communities;
over the centuries, peasants have traditionally been a target of ridicule in linguistic
culture dominated, first, by feudal, then, by bourgeois values. Authors from Hans
Sachs and Andreas Gryphius to Thomas Mann and countless others have milked
the dialect speaker for laughs. But is it even true to say that dialect is *the* language
of the lower classes? In Germany, regional speech characteristics can be shared
by all social classes, and it is misinformed to regard dialect simply as the language
of lower classes or lower income groups. Captains of industry, government offi-
cials, lawyers, professors, and politicians take pride in their regional connec-
tions and dialects. The significant datum is rather that the rural and economically
weaker groups who speak dialect tend not to have a command of the standard
language which could, in theory anyway, give them more social and economic
mobility. To translate this into the controversial terminology of Basil Bernstein,
upper- and middle-class speakers who use an "elaborated code" may speak Stan-
dard German and a dialect; those speakers who have command only of a "restricted
code" are likely to use only dialect or a variety of German heavily colored by
dialect. This is particularly the case in the south. It is therefore true to say that
if a German speaks only dialect, the chances are he or she has little geographic
and/or social mobility and may belong to a lower socioeconomic group.[8] But
again the question remains, why should this association of dialect with a particu-
lar socioeconomic group give rise to laughter? The answer, one must assume,
lies in the need of the culture-makers to emphasize their own dominance and to
reinforce their status. It lies also in the fact that since the 16th century the linguistic
pacemakers, who have been mainly located in the cities, have preferred an in-
creasingly supraregional variety of German, have belonged to the aristocracy and
bourgeoisie, and have cultivated manners which, in their eyes at least, set them
apart from the unmannered social groups. These groups, whose struggle for ex-
istence was more important than their quest for high culture, would primarily
be country dwellers who in the course of time have become increasingly urban.

When dialect causes laughter, is it because of the crudity or earthiness of
dialect expression? Is it because of the directness of its gesture? As the language
of everyday speech, familiar communication, and intimacy, dialect has typically

not cultivated a level of expression comparable in elegance, poetry, complexity, sophistication, and intellectuality to that of Standard German, which was developed expressly for the purpose of literary, legal, metaphysical, academic, and philosophical discourse. To this extent, dialect has developed its expressive capacity most fully on the level of direct, spoken, personal interaction, and, as with all language, function and use have determined its development. If dialect is perceived as down-to-earth, even base or crude, it is because it is used, inter alia, for giving commands, for cursing and swearing, for encouragement and direct persuasion in face-to-face communication. It draws for its images on the experiential world of its users and reflects their preoccupations and prejudices in its lexicon and idiom. The connection between this language and experience is very tight. It is typically used unreflectingly and carries a high emotional charge. Fitzgerald Kusz claims that his first poem in dialect was written out of frustration at the fact that his girlfriend had just left him. He did not attempt to vent his feelings in Standard German; the emotional element of his Franconian dialect provided the necessary spontaneous outlet:

> suä ruutzbritschn suä elendichä
> suä dreeckbambel suä dreckerdä
> suä weisbild suä schbinnerts
> suä bläidä sunnä suä bläidä
> suä lusch suä groußä
> ä suä sulln
> ä suä
> suä[9]

Although one might argue over the aesthetic qualities of these lines as a "poem," there is no denying that the use of dialect intensifies the force of the emotion manyfold over an attempt to articulate the same content in Standard German. But *Kraftsprache* represents only one side of the expressive potential of dialect. *Plattdeutsch* and other dialects are, after all, used in church for prayers and sermons;[10] Kusz and others have developed the love poem in dialect to a high level; and one of the best-known dialect poems of all, Ludwig Thoma's *Heilige Nacht: Eine Weihnachtslegende,* uses Upper Bavarian to tell the Christmas story, transposing the events into a Bavarian cultural context.

When dialect causes laughter, it is because of the richness and colorfulness of its images? *Bilderreichtum* is a favorite word in the mouths of proponents of dialect, and it is true that the experiential world associated with the use and function of dialect draws on the visual, the concrete, the physical, and the realm of unmediated sensual perception. When abstract notions need expression they are rendered via concrete reference. The Bavarian Hamlet would not say "Sein oder nicht sein" but:

> Lewenddig odà gschdoàmà, ja, dees fràgd si:
> Wià hàsd às gmiàddlichà, wannsd schee geduidig sàgsd:

Nuà heàr auf mi, odà wannsd oàfach zuàdràhsd,
Schluß, aus Ebbfi amen. Dees wannsd dà iwàlegsd, dà kimsd
bfeigrà ins Schleidàn. Vàrregg Kaffäähaus! Gäh, hau di hi
und schlaf à Gsàtzl. Wei dees säi woàß i:
Bài mà schlaffd, duàd oàn nix wäh, dà heàsd und sigsd
und gschbiàsd nix meà. Dees wàar beschdimmd dees Allàgscheidà.[11]

A strong case can certainly be made for the richness of the pictures dialect is able to conjure up. But couldn't these pictures be equally well rendered by means of a literary language like Standard German? What is it about the connotative semantics of dialect that induces laughter from outsiders and from insiders?

When dialect causes laughter, is it because it is incongruous? Humor theorists list incongruity as a trigger for some types of laughter.[12] Doubtless, there are cases where a form of standard language is anticipated and the unexpected use of an inappropriate register prompts amusement. When Thoma's Josef Filser in his *Briefwexel* attempts to communicate affairs of state to his constituents—he is, after all, a member of the house of representatives—his Bavarian mode of expression consistently thwarts his efforts at elevated language. Again, the incongruity of dialect expression where something else is expected evokes an amused response:

Gelibthe Leser
Indem das es jez schon zum zweiten mahle ist das ich drukt wehrde mus es nichd gar so thum sein als wies habscheilinge mentschen behaupden und klaube ich schon das meine bolidik eine sähr guthe ist.
Disses ist die schprache nichd fon ein studirthen mentschen sontern fon einen bidernen landmahn wodurch mahn es weis das ich das härz auf den rächten fleg hawe und nicht dort wos der biamthe had der wo die bedirfnise insernes folks nichdmer siecht bahld iem die Briehlenglaßel anlauffen.[13]

In this example, much of the humor arises because a user of spoken language ineptly attempts to make the transition to written language. The spelling and the lack of punctuation contribute significantly to the effect.

It is important to ask whether to speak of "dialect" and laughter is not itself a transgression. Should we not rather speak of "dialects"? Is it correct to imply that the way in which the language of the Berliner, the Bavarian, the Saxon, or the Low German is associated with humor is in each case identical? Here we must distinguish between humor with an external versus internal orientation, the difference between the Bavarian joke (*Bayernwitz*) and Bavarian humor (*bayerischer Witz*). The former can generally be translated to target any region, race, or ethnic group of choice: for Bavarian, read Irish or East Frisian. The latter reflects the particular style of humor cultivated in a group: wit as an expression of culture. Dialect may be associated with either of these. In the former case, *which* dialect is used for the universally applicable joke is of no more than incidental interest. In the latter case, where the style of the humor is specific to

the region, the role of the specific dialect in its own cultural context demands closer examination. Few would deny the indebtedness to Bavarian culture in the humor of a Ludwig Thoma or Karl Valentin. Regional specificity lives also in stock joke characters, such as Tünnes and Schäl (in Cologne), Antek and Frantek (Upper Silesia), Klein-Erna and Heini (Hamburg), Graf Bobby and Mucki (Vienna), Frau Sarasin and Frau Merian (Basel), and Kare and Lucke (Munich). The humor of these figures lies not only in the language but also frequently in specificity of local reference and in their identity as social types.[14]

Context

Before proceeding to look at the Franconian poems of Fitzgerald Kusz, it is important to give some thought to the context of his work. The social and political context of the poems discussed here is the period immediately following the climax of the student movement in 1968. That movement, which was marked by its intellectualism, urbanism, internationalism, and almost austere gravity, showed little interest in the provincial, popular culture of regions, not to mention playful humor. Kusz tries to rectify the imbalance, retaining the social consciousness of the student movement but striving for a new audience and new artistic vehicles. At this time, the *Dialekt-Welle* was only just beginning to ripple.

The guiding questions of the sociolinguist can be of help in outlining the linguistic context of Kusz's writing. Who uses Franconian dialect? When? Under what circumstances? With whom? And for what purpose? According to the survey conducted by *Infratest* for the "Bayerische Dialektzensus" in 1975 under Kurt Rein, 77% of the 460 respondents in Franconia (Ober-, Unter-, and Mittelfranken) claim to speak dialect, and 7% are nondialect speakers. Of course, not all of these speakers use dialect all the time, but 80% of them say they use dialect "always," another 11%, "frequently." Taken together, this means that in the region that uses a dialect close to Kusz's two-thirds of the total population—i.e., dialect and nondialect speakers—use dialect "always" or "usually."[15] These are high figures relative to the rest of the area of the Federal Republic. The figures suggest that Franconian dialect is a completely adequate variety of language for everyday oral communication for the majority of the population.[16] A more objective test based on how people actually speak (shibboleth test), rather than whether they think they speak dialect, shows about one-third speaking a local or regional dialect, another third speaking dialect-colored *Umgangssprache,* and the remainder using Standard German or a dialect-flavored variety of Standard German.[17] It is significant to note that according to respondents' self-evaluation the lowest percentage of dialect speakers is not in the upper or upper middle class but in the middle class. It can be assumed that this group, with its upward aspirations, does not like to identify itself as dialect speaking.[18]

Three times as many of the respondents (62%) feel they can express themselves better in dialect than in Standard German; 20% say it depends on the situa-

tion. This begs the question: What situational factors make a difference? One-fourth of those surveyed say that standard language is best suited for objectivity (*Sachlichkeit*), while one-third say it depends, and the remainder disagree.

Asked whether they felt more comfortable among dialect speakers, half of the respondents (52%) said they did, while for 44% it made no difference. Most people with whom Franconians come into contact speak dialect. Among friends and acquaintances, the figures are over 90%, and over 80% of children, mothers, spouses, and fathers speak dialect. In answers to a question designed to test the relative emotional responses, Standard German was perceived to be an emotionally neutral language, and dialect was associated with predominantly positive feelings. This information needs to be seen in connection with remarks frequently made by poets and other dialect users alike, that they prefer dialect for giving expression to emotional content, whether positive or negative. Kusz himself has remarked that dialect fulfills a function of letting one stay in touch with one's feelings: "Es ist vielleicht eine Art, eine Sprache, die eher den eigenen Gefühls-haushalt regelt, wenn man in dieser Sprache aufgewachsen ist, als irgendeine andere."[19] Kusz's poem to his ex-girlfriend is an example of this.

The survey indicates that in Franconia the home is a significantly more important location of dialect use than the workplace. Nevertheless, 77% encounter dialect speakers in their work, though only 47% have dialect-speaking superiors. These superiors, in the perception of 41% of the respondents, speak better Standard German than they; only 9% have superiors with stronger dialect than they. This figure supports the assertion that social mobility is enhanced by ability to use Standard German, whether or not one speaks dialect. The question of social mobility or aspirations turns out to be a very important factor in parents' communication with their children. It is precisely the mid-middle class which prefers Standard German for addressing children; upper, upper middle, and lower classes use more dialect.

Kusz's Theory

Fitzgerald Kusz grew up in what he calls a bilingual environment. His father came from Berlin; his mother, from Franconia; neither of them, from Ireland. His name derives from a nickname given him by schoolmates because they thought he resembled John F. Kennedy. Kusz's dialect influences were therefore true to the pattern of material, intimate contact. Kusz credits his grandmother with bringing to him the tales and folklore of Franconia.[20] The dialect of his writing is that of the region around Nuremberg. Besides his dialect poetry, Kusz has turned his pen to translation of the plays of Hans Sachs, the *Volksstück*, Standard German poetry, radio and television plays, and some short prose.

There is an underlying current of humor in almost all of Kusz's writing, whether in dialect or Standard German, but it is the combination of humor and dialect in his *Mundartdichtung* which is of most interest here. Kusz's ideas about

writing poetry in dialect are directly traceable to his upbringing and education: the bilingual home, the storytelling grandmother, an acquaintance with the dialect writing of the *Wiener Gruppe* through an enlightened teacher, introduction to the sociolinguistic theories of Basil Bernstein at the University of Erlangen, and familiarity with Brecht's *Realismustheorie*. For Kusz, dialect has the potential to attract new audiences to poetry, to express content in dialect not normally articulated in that medium, and to present a critical perspective on the world of the dialect speaker from the inside. From Brecht comes the conviction that literature must be entertaining, and it is here that humor finds its place. Kusz sees his humor functioning as the bait which contains the critical barb: ''. . . so daß die Leute das zwar, durch den Spaß, schon runterschlucken, aber es bleibt dann auf halber Höhe im Hals stecken. Und wenn sie gelacht haben, dann fragen sie sich hinterher, ja warum habe ich da eigentlich gelacht? Ich hätte lieber weinen sollen.''[21] Kusz's image of catching his readers and listeners by deceiving them into thinking they're getting something different may not be flattering to his audience; on the other hand, he is trying to find a new audience for poetry and is not above resorting to subterfuge to do it.

Sociolinguists and dialectologists now tell us that dialect is not to be equated with the language of the lower social strata. Dialects, including Franconian, have levels of expression which correlate to other social factors, such as speakers' education and/or status as well as public and private function. Nonetheless, in the 1970s Kusz understands and treats dialect as an indicator of the consciousness of a particular social stratum. He refers to this group as *die Betroffenen*—those on the receiving end, victims. This interpretation of what dialect is comes out of the language-barrier debate around Bernstein's theories, in which it was argued that dialect-speaking children had difficulties in school that were directly attributable to their language. These children were typically from lower social classes and the key to their eventual success was seen to lie in compensating for their linguistic deficiencies. Kusz's response to this deficiency as a poet is to develop the literary potential of the dialect—''den Dialekt literarisch aufarbeiten''[22]— while at the same time drawing attention to the dangers attached to much of the folk wisdom expressed in dialect, its sayings and turns of phrase. To Kusz, there lies embedded in this lore, whose vehicle of tradition is dialect, a false ideological consciousness, which it is his task to expose. Kusz picks up on the brutal, inhumane, unreflecting, and, frequently, just imitated clichés of language and works with them to reveal the underlying patterns of thought.[23] The strong tie of dialect to emotion and spontaneous expression makes this a particularly attractive undertaking.

To question ''schichtenspezifisches Sprachverhalten''[24] is the thrust of the ''documentary'' direction in dialect poetry, of which Kusz (with fellow Franconian Lothar Kleinlein) was a major proponent during the 1970s. *Dokumentarische Dialektdichtung* does not set out to *document* dialect usage. It is anything but

conservationist or purist in its principles. Rather, it latches on to expressions or sayings which are heard, or might be heard, and which are typical for dialect usage, and sets them in a critical light. Such light is frequently cast when a Standard German title creates a tension between itself and the dialect text. This tension represents a recontextualization of the ''documented'' words and opens up the possibility for their reinterpretation. The effect is at first sight often humorous, but the barb lurks under the surface:

> Kultur
>
> dou bassn miä
> net hii
>
> dees iss woss
> fiä die bessän[25]

The poet sets a frame with his title: the Standard German word *Kultur*. Within this context, he quotes a voice expressing self-deprecation in dialect. The identification of dialect with this attitude and the situation of the attitude in this context prompt the reader or listener to ask: What is the relationship among the three? Why is it so? Ought it to be so? Is there not a culture which belongs to the dialect, of which the speaker should be proud? What are the *real* social divisions expressed in the words ''die bessän''? The success of this principle depends on the authenticity of the quoted dialect words and, even more so, on the recognition of that authenticity. Reduction to the very essence of the utterance is crucial and Kusz is the master of the compact formulation.

To aid his readers in recognition of the ''dialectness'' of such expression, Kusz uses a phonetically faithful spelling system. This serves also as a deliberate alienation device, and is perhaps intended to add to the humorous effect. But there is also a serious intent: to encourage the reader to read the unfamiliar-looking words aloud, and to become aware of their familiarity as spoken language. Dialect is, after all, spoken language and is often defined by its lack of a standardized written representation.

How does the so-called documentary technique of unmasking language habits relate to the notion of democratization? The term *Demokratisierung* is Kusz's own and turns up as the final thought in his essay ''Poetisch, linguistisch, sozialkritisch,'' published in the journal *Akzente* in 1976. It comes almost as an afterthought and is not well integrated into the argument of the essay:

> Allerdings bin ich momentan an einen Punkt gelangt, wo die mehr linguistische Beschäftigung mit dem Dialekt zugunsten der Poesie zurücktritt. Hier sehe ich auch *die* Chance der Mundartlyrik: sie könnte zu einer 'Demokratisierung der Poesie' führen, wenn es ihr gelänge, Inhalte, die bisher nur in der hochsprachlichen Lyrik üblich waren, auch in der Mundart *sagbar* zu machen und damit an ein ganz anderes Publikum heranzukommen, das bisher von Lyrik nicht erreicht wurde.[26]

Democratization of poetry is to come about, then, by means of transposing into dialect, for the purpose of reaching new audiences, content not previously expressed in dialect. Dietmar Ortlieb attacked this program in a subsequent issue of *Akzente,* claiming that merely to translate what is conceived in the standard language into dialect for propagation among the masses is a misuse of dialect. Dialect is a language without classics, he maintains (mistakenly). He sees in dialect a chance to find fresh images and formulations which have been obscured by the language of the great standard language writers. The case that a language and its poetry should ideally grow together and emerge from the same range of social experience is a strong one. Dialect poetry should in this view grow out of the experience of the dialect-speaking community. However, if we deny the possibility of translation or transposition or rendering into dialect, we must logically also reject attempts at transposition of poetry from one language to another. It is surely an arch-conservative restriction to say that ideas from outside a language community should not be imported into its literature. The issue should not be one of origin but one of appropriateness and suitability of expression. Kusz's aim with his view of democratization of poetry is closely related to the goals of the documentary style. Both seek to expand the horizons of speakers who use only dialect, precisely in order that notions which do not spontaneously occur in the sometimes rigid, clichéd formulations of dialect can be imported. In Kusz's writing, this means a simultaneous expansion of the formal possibilities of dialect poetry.

Underlying Kusz's view of democratization is another element, one not explicitly articulated in his theoretical pronouncements. Alongside the quest for social emancipation through dialect runs a hint of *Klassenkampf.* The poem "die fränkische schweiz" can be understood this way:

> wemmä vonnem berch rundäschaud
> und drundn ann sichd
> schreidmä "doolsummsä" nundä
>
> wemmä undn im dool is
> und droom ann affm berch sichd
> schreidmä "berchbläidl" nauf[27]

In this reading, the landscape of the title becomes the social landscape of the text and the class landscape of the subtext. The subtext becomes clearer when one realizes that in the same collection Kusz has a series of six poems entitled "Soziohlbaddnä." "Social partner" was the preferred term of reference of the social democratic government in the 1970s for employer/employee relations. Although it would be wrong to attribute to Kusz the intent to incite revolution, an awareness of the inequities of class structure is present. There is a division into "us" and "them," where the voice of the poems invariably is that of the underdog. This voice, however, frequently represents a questionable point of view which is held up for scrutiny:

Soziohlbaddnä aans

wenns dä scheff sachd
mouß woä saa
weils dä scheff sachd
. . .
wenns di budzfrau sachd
mouß ned woä saa
weils di budzfrau sachd[28]

In summary, democratization of poetry extends to the emancipation of dialect speakers in that their language is proven capable of expressing, in its own voice, content borrowed from other language forms. In addition to experimentation with forms inspired by standard language poetry, Kusz himself writes descriptive nature poems, love poems, children's rhymes, and personal statements about his relationship to his son—especially in his later work. Democratization of poetry calls for a questioning of the ideological ballast inherent in clichéd sayings, phrases, and popular wisdom of the dialect speaker. And democratization of poetry urges appropriation of poetic expression by dialect speakers and reconstruction of attitudes between social groups, especially economic groups.

Kusz's Practice

In order for this theory to work, certain preconditions have to be in place. To attract an audience to a kind of poetry that has not existed before requires innovation. Kusz's plan involves three components: use of dialect; a distribution strategy that focuses on readings in parks, bars, and other public places; and a liberal application of humor.

Kusz's humor takes many forms. The very sounds which give the phonology of East Franconian its identity provide the poet with material for letting the dialect speaker smile at him- or herself. Kusz draws on his familiarity with the work of the *Wiener Gruppe,* but takes his focus on sound further. He is interested in more than just the material of language. It must say something. These poems are not critical of the sounds they play on; rather, they relish the uniqueness of Franconian phonology. They can, however, combine their enjoyment of themselves with a critical edge attacking entrenched attitudes:

dou moumä

obbä dou moumä
doch woss machn
dou koomä net
zouschauä
dou mou doch
woss gmacht wern

ä su gäihts nimmä
dou mou doch
woss gmacht wern
ä su gäihts nimmä
dou moumä doch
woss sa mou
mou sa dou
moumä dou
moumä dou
moumäwoss dou
dou moumä[29]

The *ou* diphthong comes into its own, and it does so in the two key words of the poem, "müssen" and "tun," where the *dou* is also the dialect work for *da*. The poem protests against inactivity and chooses as its weapon the sound which seems phonetically to embody lethargy, the *ou*.

Besides finding humor in the fabric of language, Kusz utilizes that tradition of humor which exploits the richness of dialect expression in areas verging on the taboo in Standard German or not typically encountered in Standard German poetry. This tradition goes back at least to Johann Lauremberg's *Veer Schertzgedichte* of 1652. Compare:

es abboddheislä vo meinä oma
woä im gaddn gschdandn
middn afferä wiesn
als klobabiä hammä
di nämberchä noochrichdn gnummä
wäi i glaa woä
houi angsd ghabd
iich fall nei
weil es luuch su grouß woä
im summä houds gschdunkn
und di würmä senn
im scheißdreeck umänandägrabbeld
im windä woä allers gfruurn
und ä jedä schnauferä
is wäi ä weiße fohnä
in di kollde lufd nausgfladderd
vorn woä dä abbodd immä offn
ned ämall a vuurhang woä droo
obbä dou däfüä houd mä aa
di berch gsäing
vo dä fränkischn schweiz
wenns greengd houd woäns grau
wenn di sunnä gschienä houd woäns blau
wenns gschneid houd woäns weiß
obbä aa manchmall im mai

wenn di kerschn bläihd hamm
bamm scheißn ä blick aff die landschafd:
su houd mä es oongenehme
midm nüdzlichn väbindn könnä[30]

Here, everyday bodily functions are paired with the tradition of the idyllic. The humorous effect arises from such references as *scheißdreeck* in two incongruous contexts: first, in a poem; second, in juxtaposition to a eulogy of wonderment at the scenery. In this poem, which we might title "The Call of Nature," Kusz provides a textbook example of a modern *Anti-Heimat* poem (Peter Pabisch). *Anti-Heimat* not because it is directed critically against his home; on the contrary, the depth of affection the poet holds for this countryside is unmistakable. It is an *Anti-Heimat* poem because it rejects the unidimensionally positive worldview of the traditional *Heimat* poem. Kusz's poem does not deny the less pleasant realities of life, as traditional *Heimatdichtung* does. *Heimat* has two sides here: the unpleasant and frightening necessity of using the outhouse and the delight in being able to contemplate the countryside. It is not insignificant that the appreciation of the one is only possible as a consequence of suffering the hardships of the other.

Besides dipping into the traditional pot of fecal imagery for humorous effect, Kusz also gives us everyday situations which contain an inherently humorous component. The situations depend for their humor on human behavior; they are snippets of daily life which are formulated in such a way as to provoke reflection:

beddlä in dä fußgängäzone

wenni edz mein houd ned aufhock
ba derä hidz
nou gräichi schbädesdns
innerä schdund enn sunnäschdiich
obbä dann houi nix meä
wou di laid es geld neidou könnä
iich koo doch ned einfach
mei händ aufhaldn
wäi schaudn des aus?[31]

The beggar's monologue at first seems like an amusing dilemma, but on reflection uncovers levels of prejudice of which the reader is initially unaware. The final line leaves open the question whether the beggar declines to hold out his hand simply because it is unseemly, or whether he calculates that if he does so no one will put anything in it. Why shouldn't the beggar have a little pride and sense of what is appropriate? The situation provokes a smile, and the smile prompts the question: Why is that amusing? The answer tells us something about ourselves.

The domination of fantasy by the media is a frequent topic of Kusz's portraits from the modern urban existence of his dialect speakers. His collection *ä daumfedern affm droddoa: Stadtgedichte in Landnürnberger Dialekt* (1979) contains many sketches of people as victims of forces in society over which they

have no influence. These poems reflect his view of dialect as the language of the *Betroffene:*

> stehimbiß
>
> ä maddlä ißt midderm
> gäberlä ä borzion bommfridd
> mid kädschabb
> nach dä schul.
> wäis iän glann fingä
> däbei wechschbreizn doud!
> wäi wenns ihr schwarm
> ass der BRAVO
> eigloodn hädd
> zu kawiar und sekd![32]

The models and standards governing the ideals and fantasies of Kusz's figures derive from the mass media. Kusz directs his attention to this, but does not scorn it. His affection for his figures is unmistakable.

Though Kusz denies being influenced by traditional dialect poetry, it is appropriate for us to consider how his poetry stands in relation to the writing of the "classic" poet of Nuremberg dialect, Johann Konrad Grübel. Grübel's three volumes of *Gedichte in Nürnberger Mundart* appeared between 1790 and 1803. He remained the pivotal figure for vernacular poetry in Nuremberg for 170 years. During this time, all local poets acknowledge their debt to Grübel. Kusz, on the other hand, comes to dialect poetry not through the Grübel tradition but from a theoretical position influenced by Standard German writing and by international traditions. The two are indeed as far apart as their times. Nevertheless, humor is an element which unites them, though it takes different forms. Grübel's long-winded, rhymed, narrative verses, with unshakable iambic and dactylic meters, paint good-humored pictures of life in Nuremberg at the close of the 18th century. They are safe, kindly portrayals of people, creatures, habits, and situations, rarely critical, generally benevolent, and consequently—for modern taste—bland. Sometimes, there is a moral or a general truth implied, as in his most famous poem, "Der Käfer," but this is the exception rather than the rule. It is seldom that Grübel's wit is couched so successfully in verse as it is in "Der Schlosser und sein Gesell":

> A Schlosser haut an G'sell'n g'hat,
> Der haut su longsam g'feilt,
> Und wenn er z'Mittog gess'n haut,
> Dau ober haut er g'eilt;
> Der Eierst in der Schüss'l drin,
> Der Letzt' ah wider draus,
> Es ist ka Mensch su fleißi g'wöst
> Ban Tisch in ganz'n Haus.

öiz haut amaul der Master g'sagt:
G'sell, dös versteih' i niet,
Es is doch su mei Lebtag g'wöst
Und, wall i denk', die Ried:
Su wöi mer ärbet, ißt mer ah;
Ba dir geiht's nit asu,
Su longsam haut no Kaner g'feilt,
Und ißt su g'schwink wöi du.

Ja, sagt der G'sell, dös waß i scho,
Haut All's sein gout'n Grund;
Des Ess'n wörd halt goar nit lang,
Die Aerbet verzi Stund.
Wenn Aner möißt den ganz'n Tog
In an Stück ess'n fort,
Thöt's aff die Letzt su longsam göih,
Als wöi ban Feil'n dort.[33]

When Kusz picks up the *Meister/Lehrling* relationship, the result suggests less tolerance on the part of the *Meister* and more frustration on the part of the *Lehrling*. Significantly, Kusz gives us the point of view of the underling:

lehrling

däi ziggereddn
schmeckd erschd richdi
wemmä zeä schdund im saddl
ghockd is, ä loochäfeiä oozind
enn kaffee asserä bleechdassn drinkd
und inn sonnenundägang beobachd
obbä aff di schnelle affm klo
daß dä masdä ned modzd
iich waaß ned[34]

For all his importance to the popular culture of Nuremberg during the 19th and 20th centuries—and in spite of favorable reviews from the literary pontiff in Weimar, Goethe—Grübel had very little influence on the wider development of dialect poetry.

The humor of Kusz's writing frequently results from his selection of unlikely or incongruous images. A familiar image which receives a humorous twist in a love poem is the blackbird, harbinger of the dawn:

Liebe IX

vuri wochn
wäimmä uns gern ghabd hamm
houd vuäm fensdä
wossma desdweeng aa

> weid offn gloun hamm
> ä amsl xungä
>
> däi wochn
> wousd fodd bisd
> läßds mi scho um väirä
> nimmä schloufn
> obwuhl ess fensdä zou is.[35]

In a sense, this is a programmatic poem. Like the bird song, dialect has long been a comfort as the vehicle of *Heimatdichtung;* it now has a role of provocation. At the same time, Kusz reminds us of the importance of context. The same bird song in different circumstances has a different value; it means one thing when the lover is there and another when she is not. Context is a crucial part of Kusz's aesthetic. Not only does he use nonliterary language for literary purposes, injecting a foreign yet extremely vital medium into an established communication context (poet–reader/listener), but he also depends on the context provided by his titles to give some of his poems any sense.

A sound awareness of context is also necessary for that brand of humor which depends on incongruity and surprise. This is, for instance, the essence of the *Pointe,* or "punchline," technique, which has been a staple of traditional dialect poetry at least since the early 19th century. Kusz utilizes this principle. Sometimes, he is able to make use of the reversal of a *Pointe* to put across a message:

> dä hä lehrä
>
> dä hä lehrä houd gmaand
> du bisd gscheid
> miä solln di affd obäscholl dou
> woss waaß denn deä woss dees kosd
>
> dä hä lehrä houd gmaand
> es weä schood um diich
> ass diäa kennerd woss werrn
> obbä woss werd ass uns
> wennsd erschd woss bisd?
>
> dä hä lehrä houd gmaand
> fleißi bisd und aufbassn doussd aa
> und machn dousd wossädä haßd
> dees is uns ess läibsd
> weil des braxd ämall
> in dä foobrik[36]

A final style of humor deployed by Kusz is more intellectual in flavor. Kusz is well aware of literary theory and traditions. His work contains numerous allusions to Brecht and also, implicitly, to Adorno, Rilke, and C. F. Meyer, among others. This intellectualism takes Kusz out of the immediate realm of the *Betrof-*

fene and suggests an acceptance, on his part, that the major audience for dialect poetry is the audience for poetry, not the audience for dialect. That is to say, it is the well-educated middle-class individual who represents the core of his audience. Research has consistently confirmed that the readers of dialect poetry are to be found in the same social groups that produce dialect poetry: teachers, students, clergy, doctors, and highly educated professionals.[37]

In addition to literary allusions to the tradition of Standard German letters, Kusz brings an intellectualism in his use of language. Perhaps "intellectualism" is too strong a word, but a knowledge of English is necessary to appreciate the macaronic "besatzungsgedicht." It offers a slice of reality from the Franconian region where American military personnel are a part of daily life. The result is a sensitive cameo in an interlanguage:

> mai honeylä
>
> when you come am sunndoch
> I bake dä enn xundheidscake
> when you ned come
> I cry mai bed full[38]

This poem uses the humor inherent in language contrast to create the mood of an intimate moment. Indeed, it suggests that language is an imperfect medium of communication for this couple. Their relationship is based on an international code of communication which may in fact have little to do with verbal language. The long-established humor principle of incongruity is at work here. A few well-placed, misplaced words give pause for a smile and for thought.

Kusz would not be Kusz without the variety of humor that pervades his poetry. The sound poems of his early days, inspired by the concrete poets, especially the *Wiener Gruppe,* often have a deeper side to their superficial, amusing, phonetic appeal. His use of the long-standing traditions of crudity, verbal aggression, and *Kraftsprache* is rarely gratuitous, and most frequently has a critical point to make. The situations and characters he observes in their everyday context may amuse, but they also have a poignancy and sometimes tragedy about them which prompts the response: "Ich hätte lieber weinen sollen." Kusz's command of Franconian is such that the wealth of imagery that characterizes the dialect and gives it life comes into its own and is simultaneously placed under scrutiny in his poetry. The traditional punch line or reversal often serves to debunk accepted folk wisdom. But at the same time that Kusz deploys his dialect background, he doesn't deny his intellectual roots and succeeds in placing literary and linguistic tradition in a new light by playing it through the medium of dialect. Thus Kusz makes use of both emotional and intellectual modes of humor.

Ultimately, the critical questions have to be asked. How successful is Kusz in terms of his own program and theory? And what is the real value and accomplishment of his poetry in dialect, especially as it involves humor?

Commentators and poets alike have been quick to recognize the fatal flaw in the "documentary" mode of critique through poetry: simply quoting language fragments back at their speakers inevitably elicits the response: "Ja, so ist es."[39] Its role is one of reaffirmation of prejudices. The satisfaction in recognizing one's own voice tends to override such subtle cues to critique as a carefully chosen title or juxtaposition of contradictions—especially in an audience not used to identifying such things. The danger is that the dialect speaker who typically uses dialect unreflectively—the sought-after "new" audience—will not reflect on the dialect poem. Those whose education and training allow them to see the point are those whom sociolinguistics identifies as the upper and upper middle classes, who typically have a good command of Standard German and are therefore not Kusz's target audience. This is not only preaching to the converted, it also encourages a patronizing view of the intended audience.

But perhaps the patronizing attitude is already there in Kusz's precept. Is not the intellectual, the teacher, preaching from his privileged position to the unenlightened masses? His repeated in-jokes and academic allusions would support this view. However, we should not forget that Kusz identifies closely with his target audience. He sees himself as one of the dialect community, and his affection for the dialect user is unmistakable. His failing lies rather in not fully recognizing the intricacies of the relationship between dialect usage and social group.

What are the problems with Kusz's use of humor? Humor theorists tell us that laughter is to be seen as a social corrective, "that is, as useful in maintaining group standards and values."[40] How is this view of the affirmative role of laughter to be reconciled with the use of laughter for social criticism? First of all, the "groups" referred to here have to be understood as ranging in size from two individuals to a whole society. Such a group can therefore be an oppositional group. When a group shares laughter—and laughter is principally a shared activity and a form of communication—it shows its favorable appreciation of a particular stimulus and reinforces its own value system. We do not usually laugh when we have negative feelings; we do not even laugh if tickled by someone we do not wish to be tickled by. In so far as laughter is a positive response, it implies some level of agreement with the stimulus. If laughter implies agreement, it surely is in conflict with the intent to promote critical reflection. The challenge in using laughter is to make the humor attractive enough to grasp the audience's attention, but not so distracting that it obscures the critical point.

Kusz's writing and his humor are directed toward a specific segment of a Franconian-speaking audience. What of the laughter it may engender externally? If, as Ortlieb contends, dialect is an involuntary clown when it leaves its own territory, does this mean that dialect poetry will induce laughter for the wrong reasons when received externally? Is there a danger that Kusz's "fränkischer Witz" will become a "Frankenwitz"? The answer is that it really doesn't matter. With his fellow dialect poets, Kusz has demonstrated that dialects have a

role to play in language art that goes beyond their use as everyday spoken language, beyond their role as a medium for burlesque and slapstick comedy, and beyond their exploitation as a vehicle for *Heimattümelei*. The expansion of humor in dialect poetry beyond the witty punchline and the *Kraftsprache* of verbal aggression to sound poems, macaronic experiments, and alienation effects marks a part of Kusz's own considerable achievement. It is to Kusz's credit that he has recognized the limits of his experimentation, and in the 1980s has moved on to enable his dialect to develop its own poetic voice without having to depend on humorous tricks. The significant emancipation Kusz's poetry has achieved is the liberation of dialect poetry out of the ghetto of the safe and harmless into a greater awareness of itself as poetry.

Notes

1 A. A. Thomson, *Anatomy of Laughter* (London, 1966), p. 15.

2 Henri Bergson, *Le Rire: Essai sur la signification du comique* (Paris, 1932), p. 6.

3 Dietmar Ortlieb, "Mut zum Dialekt oder Reiz der Exotik?," *Akzente* 23 (1976): 369–71.

4 As so often when discussing German dialects, it is necessary to make an exception in the case of Switzerland. Because the role of Standard German is more restricted in Switzerland than in other parts of the German-speaking world, and because dialect commands wider usage and range of function, dialect in Switzerland is less frequently incongruous and, therefore, less closely associated with humor.

5 Lutz Röhrich, *Der Witz: Figuren, Formen, Funktionen* (Stuttgart, 1977), p. 266.

6 Ibid., p. 287.

7 Cf. Ludwig Zehetner, *Das bairische Dialektbuch* (Munich, 1985), pp. 164ff.

8 Cf. ibid., p. 198.

9 Fitzgerald Kusz, "Poetisch, linguistisch, sozialkritisch," *Akzente* 23 (1976): 139–43, and *morng sixtäs suwisu nimmä: Gedichte im landnürnbergischen Dialekt der fränkischen Mundart* (Rothenburg, 1973), p. 33.

10 Dieter Stellmacher, *Wer spricht Platt? Zur Lage des Niederdeutschen heute: Eine kurzgefaßte Bestandsaufnahme* (Leer, 1987), p. 40.

11 Ludwig Merkle, *Bairische Grammatik* (Munich, 1975), p. 121.

12 Patricia Keith-Spiegel, "Early Conceptions of Humor: Varieties and Issues," in *The Psychology of Humor: Theoretical Perspectives and Empirical Issues,* ed. Jeffrey H. Goldstein and Paul E. McGhee (New York, 1972), pp. 4–39; here, pp. 7ff.

13 Heinz Beier, *Bayerische Literatur in Beispielen* (Munich, 1983), pp. 228f.

14 Röhrich, *Witz,* p. 218.

15 Reinhard Rascher, "Das Fränkische im Alltag, in der Schule und in den Medien," in *Das fränkische Dialektbuch,* ed. Eberhard Wagner (Munich, 1987), pp. 105–63; here, p. 108.

16 Ibid., p. 109.

17 Ibid., p. 117.

18 Ibid., p. 120.

19 Gerhard W. Baur and Hans-Rüdiger Fluck, eds., *Warum im Dialekt? Interviews mit zeitgenössischen Autoren* (Berne and Munich, 1976), p. 105.

20 Kusz, "Poetisch," p. 139.

21 *Warum im Dialekt?,* p. 95.

22 Ibid., p. 98.

23 Cf. Wilhelm Staudacher, "Nachwort," in Kusz, *morng*, p. 70.

24 Kusz, "Poetisch," p. 142.

25 "Culture / / we don't fit in there / that is for our betters." Kusz, *morng*, p. 13.

26 Kusz, "Poetisch," p. 143.

27 "franconian switzerland / / when you look down from a mountain / and see someone below / you shout 'valley dud' / / when you're down in the valley / and see someone up on the mountain / you shout 'fool on a hill.'" Fitzgerald Kusz, *liichdi nei und schlouf: Gedichte im landnürnbergischen Dialekt der fränkischen Mundart* (Rothenburg, 1976), p. 54.

28 "social partner one / / if the boss says so / it must be true / because the boss says so / . . . / if the cleaning woman says so / maybe it's not true / because the cleaning woman says so." Ibid., p. 26.

29 "we must / / but we must / do something though / we can't / look on / something / must be done / it can't go on like this / something / must be done / it can't go on like this / we must / what must be / must be / we must do / we must do / we must do something / we must." Kusa, *morng*, p. 47.

30 "my grandma's outhouse / used to stand in the garden / in the middle of a field / we used the nuremberg news / as tp / when i was little / i was scared / i'd fall in / because the hole was so big / in summer it stank / and the worms / wriggled around in the shit / in winter it was all frozen / and every breath / fluttered out in the cold air / like a white flag / the front of the outhouse was always open / not even a curtain was across / but the advantage was / you could see the hills / of franconian switzerland / when it rained they were gray / when the sun shone they were blue / and when it snowed they were white / sometimes in may too / when the cherries blossomed / take a shit and enjoy the landscape / that's how we were able to combine / business with pleasure." Fitzgerald Kusz, *mä machd hald su weidä: der gesammelten gedichte zweiter teil* (Munich, 1982), p. 105.

31 "beggar in the mall / / if i don't put my hat on now / in this heat / i'll get a sunstroke in an hour / at the latest / but then i'll have nothing left / for people to put money in / i can't just / hold my hand out / what would that look like?" Ibid., p. 110.

32 "snack stand / / a girl is eating a helping / of fries with ketchup / with a fork / after school. / see how she sticks / her little finger in the air! / as if her idol / from BRAVO magazine / had treated her / to caviar and champagne!" Ibid., p. 61.

33 "The Locksmith and His Journeyman / / A locksmith had a journeyman / Who filed as slow as slow, / But when he ate his midday lunch / You should have seen him go; / The first to get into his plate, / The last to fill his face. / No man worked harder when he sat / At table in that place. / / Then once the master said to him: / I just don't understand. / I think that all my life we've had / This saying in our land: / How you work is how you eat; / But that's not what you do, / There's no one ever filed as slow / And ate as fast as you. / / The journeyman said, yes I know, / There's reason to my rhyme; / Eating lasts not long at all / Work's forty hours time. / If I would have to spend the whole / Day eating all the while, / Then I'd do that as slowly as / Today you see me file." Johann Konrad Grübel, *Sämmtliche Werke*, ed. Georg Karl Frommann (Nuremberg, 1857; rpt., Neustadt an der Aisch, 1984), pp. 141f.

34 "apprentice / / this cigarette / only tastes real good / when you've been in the saddle / for ten hours, light a camp fire / drink coffee out of a tin cup / and watch the sunset / but a quickie in the john / so the boss doesn't complain / i dunno." Kusz, *mä machd*, p. 111.

35 "Love IX / / last week / when we made love / a blackbird sang / outside the window / that we deliberately / left wide open / / this week / now you're gone / it wakes me up / at four in the morning / even though the window's closed." Kusz, *liichdi nei*, p. 13.

36 "the teacher / / the teacher said / you're smart / we should send you to high school / what does he know about what that costs / the teacher said / it would be a shame for you / you could really do well / but what happens to us / when you've made it / / the teacher said / you work hard and pay attention / and you do what he tells you / that's what we like best / because you need that later / in the factory." Ibid., p. 43.

37 Cf. Fernand Hoffmann and Josef Berlinger, *Die Neue Deutsche Mundartdichtung: Tendenzen und Autoren dargestellt am Beispiel der Lyrik* (Hildesheim and New York, 1978), p. 355.

38 Kusz, *liichdi nei*, p. 52.

39 Cf. Hoffmann and Berlinger, *Die Neue Deutsche Mundartdichtung*, pp. 64f.

40 Keith-Spiegel, "Early Conceptions of Humor," p. 33.

The Yiddish Are Coming! The Yiddish Are Coming! Some Thoughts on Yiddish Comedy

IRVING SAPOSNIK

Philip Roth was right. Put the *id* back in the *Yid,* he counseled in *Portnoy's Complaint,* and, at the same time, don't forget to restore the *oy* to the *Goy.* Yiddish comedy, like the culture of which it is such an integral part, has hidden the *id* in laughter, refined it away in stories, anecdotes, fables, legends, folktales, and one-liners. Not surprisingly, therefore, Yiddish comedy finds itself somewhere between the *id* and the *oy;* or, to put it more in the recognizable terms of comedy, it is caught in the middle between the scream and the punchline.

The Yiddish scream begins in the frustration that comes from centuries of Jewish history: exile, dispersion, wandering, living on the margin, walking the tightrope between an unrealized heaven and an unfulfilled earth. This primal scream begins in youth and lasts a lifetime, but it is rarely heard, even in the most private corners of the Jewish world. It is, instead, kept to one's self, internalized, suppressed; although the mouth may be poised, the voice of rage is kept mute.

Instead, another voice cries out from Yiddish mouths: a voice that may shout but never screams, a voice that directs its rage inward, a voice more likely to groan and gripe, to *kvetch,* to argue directly with God as well as with people, to declare, in the voice of Woody Allen, that God is at best an underachiever, or, in the voice of that old Yiddish proverb: "If God lived on earth, people would break His windows."

Yiddish comedy, therefore, like Yiddish itself, is born (borne) out of compromise, created with a keen awareness of the gap between the goal and the achievement, between the road not taken and the eternal road, between earthly practice and heavenly promise. Since Yiddish is a mediator between home and synagogue, as it was created to provide a nexus beyond the synagogue between the Jewish people and their God, so, too, Jewish comedy serves as a secular commentary on sacred text. As Yiddish is enhanced by a Hebraic subtext in a Germanic context, so, too, Yiddish comedy is enriched by its mix of rabbinic idealism and worldly laughter.

Yiddish comedy is simultaneously beset and animated by these contradictions. Its characteristic gesture is a shrug-of-the-shoulders optimism, and its verbal expression is best contained in the highly expressive "nu?" which is both

question and statement. Yiddish comedy is the comedy of a people caught in the middle, whose raison d'être has been historically to muddle through that middle. Yiddish comedy is a comedy of survival in a world in which Jews have been eternal victims; it is a comedy that attempts to reconcile, but never resolve, the fourfold dilemma of Jewish exile: the theological, historical, cultural, and linguistic conditions that have made it difficult to be a Jew ever since being a Jew was made difficult.

The Jews of Eastern Europe, caught as they were between the Russian Czar and the Polish peasant, faced their contradictions with characteristic humor. While the Torah taught them the specialness of being the Chosen People, their Slavic neighbors taught them to ask the question: "Chosen for what?" Was there ever a time in Jewish history when the gap between the real and the ideal was so apparent? Was there ever a time when the promise seemed so distant, and the premise, so removed? Sholem Aleichem's Tevye ponders for many when he inquires of God: "I know it is a great honor to be chosen, but couldn't you have chosen someone else?"

The quest for an answer, or even a simple response, became as important as the hoped-for end to exile. Rev Levi of Berdichev, like Tevye an eternal questioner, pleads for his people: "What have you against Your people Israel? Why do You pick on Your people Israel? Sweet Father, there are many other nations to pick on, so why us?" Why have you scattered us across the earth, why have you cut us off from our historical, cultural, and religious homeland, and forced us to be strangers in a strange land? As still another Yiddish voice asks: "When will an end come to our having to drag the exile on our backs, when will we be able to stand once again in our own land?"

Exile and dispersion to the Eastern European Jews seemed eternal. Only in the synagogue, where they learned of past glories and future promises, could they find any solace, and only in the home, where they could close around their family and shut out the rest of the world, could they find comfort. The synagogue and the home became their sanctuaries, the inner sanctums where they could speak their special languages, conduct their special services, and worship their special God. Yet synagogue and home could never be exactly the same, for one was the house of God. And so, although both were special, only the synagogue was sacred; although both had their special language, only one language was holy.

Yiddish as the language of the home (and of the street) was a lesser language from the beginning. Profane and domestic, it was the language of women and children, used in translation but never in divine discourse, used at the table but never at the holy ark. And even as it became more accepted, it was often looked down upon as a jargon, a sublanguage born in exile and fated ever to reaffirm the mundane and the earthly.

Yet even as Yiddish was looked down upon, even as it was reproached for being inferior, it developed an alternative Jewish view of the world. If Jews could pray only in Hebrew, they could plead in Yiddish; if the Hebrew God was august and paternal, the Yiddish God at least listened. If exile was the eternal Jewish

condition, then the Jews could at least make the best of it. Yiddish culture, though it may affirm exile, taught the Jews how to survive that exile; though it may glorify home and family excessively, it made that home and family as central to Jewish life as the synagogue. Best of all, no doubt, Yiddish culture developed a comedy unlike any other Jewish comedy that had been before, a comedy that emerged from poverty and despair to celebrate life; a comedy that came close to tears but rarely cried, a comedy that came close to screaming but laughed instead. Yiddish comedy, like all else in Yiddish culture, became an earthly response to heavenly silence, a verbal (and sometimes visual) gesture of assertion that, despite all, it's good to be alive.

In time, Yiddish comedy developed identifiable characteristics: words more often than gestures generated laughter; laughter was generally produced by such stock characters as the Shlemiel, the Shlimazel, the Shadchan, and the Shnorer; and these characters usually laughed at food, family, business, poverty, and, most often, themselves. It was, after all, Jews and their jokes that Freud was thinking of when he remarked in *Jokes and Their Relation to the Unconscious:* "I do not know whether there is any other instance of a people making fun to such a degree of its own character."

Yiddish comedy, likewise, developed forms to contain that laughter. Whether in proverb, folktale, or stories of the Hasidic masters, Yiddish comedy found ways to draw laughter out of the turmoil of Jewish experience, to revise the course of Jewish history, if only temporarily, with a wink and a smile; to make the present more pleasant. The proverb, for example, spoke to the Jewish experience with the wisdom of generations: "So many Hamans and but one Purim"; "When a poor man eats chicken, one of them is sick"; "A Jew's joy is not without fright." The folktale, especially the Chelm stories, pointed out the follies and foibles of Jewish theology, the pitfalls that await those who walk the earth but keep their eyes on the stars. If waiting for the Messiah was a low-paying task, as one of the Chelm stories suggests, it nonetheless was steady work. And, finally, the Hasidic story offered a comic wrestling with God's laws, a question-and-answer dynamic between disciple and master which taught, more often than not, that the expected lesson was in the give-and-take and not in the enigmatic response.

From proverb, folktale, and Hasidic story come the masterpieces of Yiddish literature, told by the master writers: Mendele the Bookseller, Sholem Aleichem, and Isaac Loeb Peretz. Each in his own way, and with different emphasis, used the folk material to create a comic literature whose brilliance is matched only by its brevity. Rarely has a literature of such intense creativity been written over such a short period of time and with such economy. Yiddish comic literature, like the Yiddish joke, is a short but focused expression that says much in little, that glows gemlike, with an intensity usually reserved for poetry.

Mendele, the grandfather of Yiddish literature, as Sholem Aleichem called him, found his comic view in satire. Biting, caustic, irreverent, he defied those who would be nostalgic about Jewish life and instead pointed out its smallness, its provinciality, its otherworldly foolishness. His most famous creation, the would-

be world traveler Benjamin the Third, like many a future Yiddish hero, is a dreamer, a believer in an idealized world and his ability to reach that world. But like that famous traveler whom Charlie Chaplin was to revive in film after film, Benjamin is left walking on his eternal road, a wanderer in search of the never reachable.

Peretz, the intellectual force of Yiddish literature, speaks in a different voice. In story after story, he presents a cosmic comedy, a comedy whose laughter is divine as well as earthly, a comedy that attempts to probe heavenly secrets. Steeped in Hasidic lore, Peretz becomes a comic cabbalist whose laughter is both logical and theological. In *Bontsha the Silent,* perhaps his most famous story, he questions the rabbinic insistence on obedience as a virtue. In *If Not Higher,* he questions the efficacy of earthly deeds as well as the worth of heavenly reward. Maintaining his customary ironic distance, Peretz is a caustic observer of Jewish life, whose laughter, much like that of his angelic prosecutor in *Bontsha,* is both loud and bitter.

The third in this master trio of storytellers is no doubt the most famous, Sholem Aleichem. His name is a greeting, the Yiddish version of hello (and goodbye), and his stories are filled with the warmth of a salutation, narrative calling cards into the comic complications of Eastern European Jewish life. Less satirical than Mendele, and less caustic than Peretz, Sholem Aleichem uncovers the comedy of the Yiddish world with a subtlety unmatched by any other writer. At once complimentary and critical, embracing and embittered, Sholem Aleichem writes with all the insight of an insider, exposing the follies of his world, yet leaving it much dignity. Yiddish life in his stories comes to resemble a comic epic, a chronicle of the vagaries of Jewish fortunes in the modern world. Furthermore, he creates the one character in all of Yiddish literature who takes his rightful place among the great comic characters of all time.

The Tevye stories are Sholem Aleichem's masterpiece. In eight stories written over a number of years, Sholem Aleichem follows Tevye's wanderings from the inner core of Eastern European Jewish life to his expulsion as a refugee. Unlike Mendele's Benjamin, Tevye is forced to wander, forced to uproot himself from his familiar surroundings and make his halting way into the unknown. Tevye is not only a space traveler, his journey is temporal as well. For his life mirrors the changing times for the Eastern European Jew: as he confronts the challenge that each of his daughters presents, he is forced to adjust to new values and new relationships. And adjust he does. Even as one daughter marries a lowly tailor, another a radical whom she follows to Siberia, a third a non-Jew, a fourth a boor of a businessman, and a fifth commits suicide—even as all this occurs, Tevye is willing and able to bend the old values to meet the modern conditions. As Sholem Aleichem's Yiddish "everyman," Tevye becomes the new Jewish hero, a little bit shlemiel, a little bit shlimazel, but, all in all, a survivor in a world that constantly threatens his identity and his existence.

The Tevye stories are the epitome of Eastern European comedy, as they incorporate many of its impulses. These stories, and others by Sholem Aleichem, bring together the characters, the style, and the forms that previous Yiddish comedy had developed. Only now do they become the stuff of a full-blown literature ready to meet the world. The shlemiel, the shlimazel, the shadchan, and the shnorer all find their place in Sholem Aleichem's stories, as do touches of proverb, folktale, and Hasidic story. Taking these forms, these styles, these impulses, Sholem Aleichem designs a comedy that is his and yet not his alone, a comedy by a Yiddish master that belongs to the entire Jewish people, and more.

The story that best illustrates Sholem Aleichem's comic powers is not a Tevye story at all, but rather one that remains a masterpiece, albeit divorced from a recurring central character. "On Account of a Hat," like the Tevye stories, contains several characteristic Sholem Aleichem touches; and yet, it is a story that stands on its own, providing a model of the Eastern European Yiddish world, without a necessary before and after. The time of the story is set prior to the Passover celebration, and Sholem Shacnach, a typical Sholem Aleichem shlemiel, has for the first time in his life completed a successful business deal and is on his way home for the holiday. Absent for too long, and looking forward to his arrival, he wires his wife to tell her that he will be home for Passover without fail, but, of course, forgets that he lives at the end of the railroad line, if not at the end of the world. Forced to wait for his connection, he falls asleep at the railroad station, gingerly placing himself on a bench next to a Russian official. Awakened shortly before his train is about to depart, and missing the head covering that all Jewish men are commended to wear, he absentmindedly snatches the hat of the still sleeping official. Much to his surprise, as he hurriedly makes his way to the train, crowds of people bow to him, conductors defer to him, he is placed in the first-class carriage and, for the first time in his life, is treated with respect. Shocked beyond belief, he cannot account for all this strange treatment until he happens to glance at himself in a mirror and sees that he is wearing the official's hat. Convinced that he cannot be Sholem Shacnach since the hat identifies him as someone else, he leaps from the train, misses his connection, arrives home after Passover, and becomes the comic butt of his community.

Out of this raw material, Sholem Aleichem fleshes out a multilayered story that, as Ruth Wisse so well observes, may be read as (1) the plight of the diaspora Jew, (2) a mockery of authority, and (3) a comic quest for identity.[1] "On Account of a Hat" is all this and more. And the Sholem Aleichem touches make it so. First and foremost, there may be the comedy of the Jewish calendar and the centrality of Passover. As the holiday of freedom, Passover is the major spring celebration in the Jewish calendar and, celebrated as it was in Eastern Europe, it must have had a special irony to it. For the Jews of Eastern Europe could not but feel the grim contrast between the exodus from Egypt toward the Promised Land and their own miserable captivity. Falling, as is often the case, close to

Easter, Passover was also a special time for pogroms, and many a seder was disrupted by pillage and persecution. The Passover of the past and hoped-for future was dimmed by present anxieties.

Yet, despite the tension of the season, the humor of the story prevails and much of this humor is conveyed by the telling and the tellers. There are, in fact, two narrators in this story: the dominant authorial voice, identified both with the author and with a character in the story of the same name, and the putative author, a neighbor of Sholem Shacnach, identified only as a Kasrilivke merchant, who presumably tells Sholem Aleichem the story. It is this second voice that sets the tone for the ensuing comic dialogue between author and character which establishes a comic dynamic serving as a framework for the inner story. In fact, we have two stories here: (1) the comic adventures of Sholem Shacnach, and (2) the chance encounter between Sholem Aleichem and the merchant who serves as the comic commentator on the narrated action. Although not directly a part of the action, Sholem Aleichem and the merchant act as a comic chorus, setting tone, mood, and scene, and summing up the action at the end. The impulse is Talmudic: dialogue precedes action and, in fact, imparts to the action essential meaning.

The comedy of Yiddish life also comes from Sholem Aleichem's use of his mythical town, Kasrilivke, his model of the Eastern European shtetl. Kasrilivke is the *locus classicus* of many of his stories, a typical shtetl at the edge of the world, at the end of the line, that represents both the isolation and the fragility of Jewish life. At times resembling Chelm, Kasrilivke is the Yiddish world in a nutshell, an out-of-the-way corner which thinks of itself as the center of the earth. When Sholem Shacnach returns to his Kasrilivke neighbors at the end of the story, it is difficult to say who is more the fool, he or they. He, at least, has traveled through an adventure which he hardly understands, while they, in their provincial smugness, disbelieve the possibility he unknowingly proved.

Sholem Shacnach, for all his attempted worldliness, is the quintessential Yiddish (and Jewish) comic character, the character that replicates itself with unerring accuracy from the earliest incarnation of the shlemiel to Woody Allen. A literary relative of Sholem Aleichem's Menachem Mendel, Sholem Shacnach is a would-be schemer who succeeds only in tripping himself up. Although he travels, he goes nowhere; although a businessman, he hardly ever succeeds in making money. He exists on the fringes of life, the eternal *nachschlepper,* unable to relate successfully to a world in which he is a constant outsider. Ever a foreigner, he is alien to Jew and non-Jew alike: ever old beyond his years, he is nonetheless a child-man, the lovable innocent that appears over and over again as Yiddish hero and stand-up comedian alike. We laugh at his foibles and smile at his antics, all the time knowing that he is us.

Sholem Aleichem brings Yiddish comedy to its highest achievements. In ''On Account of a Hat'' and in the Tevye stories, he achieves what few other Yiddish writers have: a synthesis of comic devices, comic impulses, and comic characters that illustrate the best and the worst of Yiddish life. In Sholem Shacnach and

Tevye, he creates a model of the diaspora Jew and elevates "Das kleine Menschele," as Mendele called him, to near tragic proportions. Caught between the dream of a promise and the nightmare of the everyday, these characters walk a lonely road to nowhere. The more life changes for them, the more it remains the same. Their life, like Tevye's in the final scene of *Fiddler on the Roof,* is a journey on a circular stage: the body moves wearily on, but the end is nowhere in sight.

Sholem Aleichem's comedy, like much of Yiddish comedy, reinforces the circular movement of Jewish history. If, as someone once suggested, Yiddish "is the melody of the Jewish soul," it is a plaintive tune oft repeated. Yiddish comedy, like Yiddish life, is a search for beginnings, an attempted re-creation of a preexilic past, a glimpse into the future, only to return to what once was. Like the hoped-for coming of the Messiah, it is, if nothing else, at least steady work. Yet, to use the same metaphor, it is also lonely work. For all its social and communal emphasis, Yiddish comedy is essentially a lonely comedy: its biblical fathers are Abraham arguing with God so that Sodom and Gomorrah may be spared, and Jacob wrestling with the angel and emerging triumphant but maimed; its biblical mother is Sarah laughing at her pregnancy in old age, even as she is about to become the mother of the Jewish people.

More recently, its heroes, while less noble perhaps, are equally engaged in coming to terms with heavenly and earthly shortcomings. God is taken to task in Yiddish comedy as much, if not more, than people may be, and both are held accountable for an ethic that places *menschlickeit* above all. To be a *mensch* is to be human, but not too much so; it is to be disciplined, but with common sense; it is, above all, to understand that laughter is the greatest expression of our humanity. Laughter speaks where, sometimes, words fail; it is the essence of that comic and cosmic response that Jews have bestowed upon history. More eloquent ofttimes than words, laughter is the beginning and end of Yiddish comedy, for, more than anything else, it insures survival.

Whether it is Tevye telling his story to Sholem Aleichem, or Jackie Mason telling us about the world according to him. Yiddish comedy is an existential force. Full of the pain that experience necessarily brings, full of the agonies of Jewish history, it nonetheless never loses its sense of humor. Cry if you must, it says, but first laugh.

Note

1 See Ruth Wisse, in *The Best of Sholem Aleichem,* ed. Irving Howe and Ruth Wisse (Philadelphia, 1979), p. xxvi.

"Tutto nel mondo è burla": Humor in Music?

STEVEN PAUL SCHER

Musical humor? There is no such thing, of course. What an outlandish proposition, especially when we encounter it unawares, in its bald immediacy: an anomaly at best. In literature and the visual arts, painting and sculpture, we need not strain our imagination. There is much that strikes us as comic or humorous, though not without qualification.[1] But humor in *music?* Precious little comes readily to mind, except perhaps a few fleeting instances here and there. That is, if we believe the professional "comicologists" who—when not altogether silent on the topic, which is most of the time—virtually deny music's ability to convey humor intelligibly, without enlisting the aid of other media, particularly verbal and visual ones. In fact, theoreticians of the comic, of wit, humor, and laughter—among them noted philosophers, aestheticians, and psychologists—have been, on the whole, conspicuously uninterested and noncommittal in matters musical.[2] Most disappointing of all, musicologists, who perhaps ought to know better, have also failed to overwhelm us with illuminating insights on the subject.[3]

Admittedly, we are dealing here with a gray area of aesthetics: the notion of musical humor not only sounds but *is* elusive. Yet it is a notion that deserves a hearing. It may be useful to begin exploring the potential richness of this notion with a motley assortment of brief illustrations while keeping theoretical reflection to a minimum. As a classic example of harmless musical fun, the unadulterated banal humor that emanates from the celebrated "Duetto buffo di due gatti," attributed to Rossini,[4] is easily identifiable. Composed for two meowing operatic singers (usually sopranos) with piano accompaniment, this amusing trifle is so memorable because it is so unsubtle. And its intended parodistic effect is unmistakable.[5]

To be sure, Rossini was an inimitable master of skillfully crafted scenic situations imbued with genuine humor, a lone monument of sustained comicality in 19th-century music. Indeed, none of his ensembles is better suited to provide musical justification for the title of the present volume than the zany, effervescent septet concluding act 1 of his comic opera *L'Italiana in Algeri* (1813), which never fails to bring down the house in "laughter unlimited." In this final tableau,

The phrase "Tutto nel mondo è burla" in my title is the opening line of the final fugue ensemble concluding Verdi's opera *Falstaff;* the Shakespeare-inspired text is by librettist Arrigo Boito.

the characters are so utterly confused about the newest plot developments that they can no longer sing a coherent text. Spellbound, they start singing nonsense syllables that imitate the various noises they imagine hearing. The ladies hear bells ringing in their ears and the men hear a cock crowing, hammer strokes, cannon shots, and the like: din-din, cra-cra, tac-tac, bum-bum.

ISABELLA, ZULMA, ELVIRA:

Nella testa ho un campanello	In my head a bell is ringing,
Che suonando fa din din.	. . . Ding, ding, ding, ding!

LINDORO:

Nella testa ho un gran martello	In my head a clock is ticking,
Mi percuote e fa tac tac	ever going tock tick tock!

TADDEO:

Sono come una cornacchia	I am like a dizzy raven
Che spennata fa cra cra	Crowing, cawing, caw caw caw!

HALY:

Nella testa ho un gran martello	In my head I have a hammer
Mi percuote e fa tac tac.	Ever pounding knock, knock, knock!

MUSTAFA:

Come scoppio di cannone	Like a mighty cannon roaring,
La mia testa fa bum bum.	So my head goes boom, boom, boom![6]

Perhaps Joseph Addison hit upon the truth when he claimed in the *Spectator* that "nothing is capable of being well set to music that is not nonsense."[7]

Leroy Anderson's *The Typewriter,* a single-movement mini-concerto scored for typewriter and orchestra and assisted by a triangle and a ratchet to signal carriage returns, exemplifies an altogether different species of musical humor. Though intriguing, the kind of acoustic mimesis in this typical product of mid-20th-century American popular music is likely to induce mild amusement at best.

John Cage's 1942 composition entitled *CREDO IN US,* decidedly more serious in intention, is likewise at a safe distance from "laughter unlimited": that Cage spells the title in capital letters points to the inherent ambiguity of the word "US." The score calls for muted gongs, tin cans, an electric buzzer, tom-toms, piano, hands on wood, and radio or phonograph; in his performance instructions, Cage even specifies that "(if radio is used, avoid news programs during national or international emergencies, if phonograph, use some classic: e.g. Dvořák, Beethoven, Sibelius or Shostakovich)."[8] The recorded performance, for example, uses excerpts from Dvořák's *New World* Symphony. As we shall soon see in more analytical detail, Cage's unusually scored piece demonstrates the mechanics of a rather transparent strategy composers favor when they intend to produce a comic effect—in this case, primarily satirical—fraught with sociopolitical implications. Just before the anticipated arrival of a concluding cadence, the original quote played on the phonograph from the well-known Dvořák symphony suddenly fades out and gives way to a startling cacophony that would be any percussionist's

Figure 5. Beethoven, Symphony No. 5 in C Minor, op. 67 (movement 4: mm. 415–44)

2. An Mälzel.

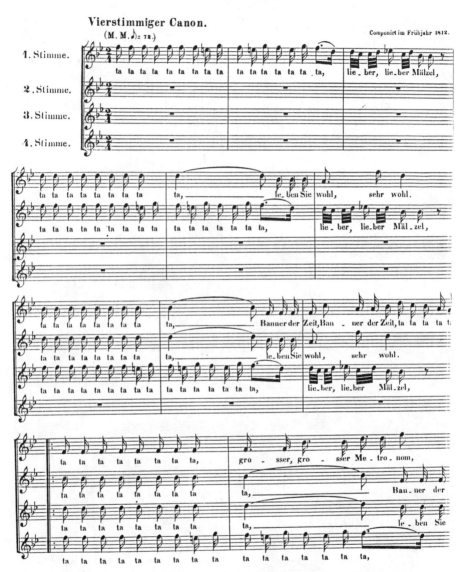

Figure 6. Beethoven, "An Mälzel," WoO 162

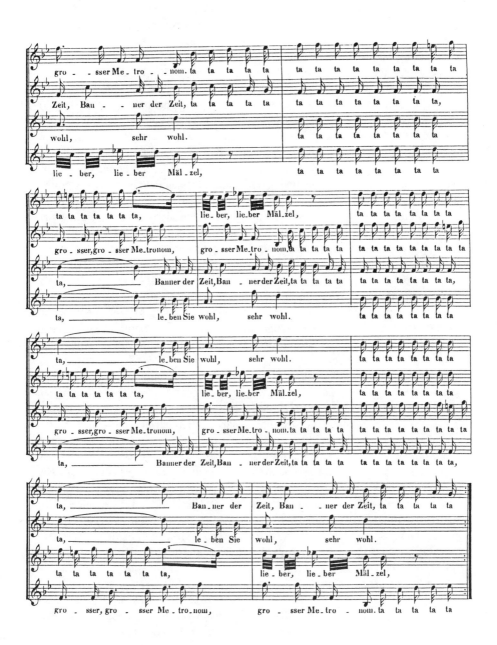

delight; and the listener's justifiable expectation is so severely thwarted that the result is some sort of laughter, however guarded, embarrassed, or angry.

The presence of intentional comicality in venerable canonic works of the classical repertory is rarely acknowledged unequivocally. How do we react in this context, for example, to the interminable concluding bars of Beethoven's Fifth Symphony (fig. 5)?[9]

No intimate knowledge of Beethoven's compositional habits is necessary to recognize that excessive repetition is employed here as a comic device of musical rhetoric. Beethoven certainly knows how to assure his listeners over and over and over again about the definite finality of his Finale's final C-Major chords. Similarly exaggerated closures abound in his symphonic writing, and one might wonder why he resorts to this type of deliberate overstatement to make his point. The answer is simple and well documented, even if ardent worshipers of the Beethoven mystique[10] and of the composer's familiar, larger-than-life image as the brooding titan may well refuse to accept it: forever a practical joker and punster in life, Beethoven also took every musical opportunity to express his effervescent humor, often through blunt self-parody.[11] However hard to believe, he did compose dozens of occasional musical gags like the choral canon entitled "An Mälzel" (1812) (fig. 6),[12] a classical companion piece to Leroy Anderson's typewriter music, poking fun at his friend Johann Nepomuk Mälzel, the inventor of the metronome. The melody of this trifle became the first theme of Beethoven's later, more poignantly humorous tribute to Mälzel: the second, "Allegretto scherzando," movement of the Eighth Symphony.

But accumulating diverse examples, however entertaining and instructive, is a temptation that must be resisted if we want to get a firmer grasp on a subject as elusive and indeterminate as humor, especially musical humor. So let us suspend the flow of examples for example's sake and embark on a bit of aesthetic speculation, hoping that a little theory, taken with a grain of salt, will not detract from proper appreciation of the illustrations still to come. The crucial question is, of course, whether it is possible to find some guiding principles that may light our way through the complex labyrinth of musical comicality. It is for good reason that competent scholarly attempts to do just that have been scarce indeed; the occasional relevant dissertations and individual treatises tend to focus on aspects too specialized and narrow to yield more than modest illumination.[13]

As far as I could ascertain, only the Polish Marxist musicologist Zofia Lissa, a devout disciple of Roman Ingarden, has taken on the considerable multidisciplinary challenge of devoting a large-scale investigation entirely to the theoretical underpinnings of this intriguing phenomenon. Her 1938 Krakow *Habilitationsschrift* entitled *O istocie komizmu muzycznego* ("The Essence of Musical Humor")[14] is still the only serious study of musical humor—pun intended—that attempts to provide a comprehensive and systematic overview informed by the relevant philosophical, aesthetic, psychological, and musical issues. Lissa's

pioneering work has gone virtually unnoticed in the West. Under the title "Über das Komische in der Musik," she included what seems to be a streamlined version of her 1938 study (unfortunately, without bringing it up to date) in an 1969 collection of her selected essays, *Aufsätze zur Musikästhetik,* published in East Berlin.[15] It tells us something about the persistently elusive nature of our topic that Lissa's opening statement of 1969 still holds today: "Eine Theorie der Komik, die sich ausschließlich auf das Komische in der Musik stützt, gibt es bisher nicht" ("A theory of the comic that is based exclusively on what is comic in music does not yet exist.")[16]

In much of what follows, I benefited from Zofia Lissa's thoughtful outline of the possibilities and limitations of the field and from her sober—sometimes all too sober—analytical remarks, though I hope that my own approach will prove to be less cumbersome and time-bound. Also, I intend to avoid at least some of the pitfalls that loom large before anyone who dares to enter the slippery terrain of comic theory. First of all, I shall heed Samuel Johnson's wise observation that "comedy has been particularly unpropitious to definers,"[17] and devote only a minimum of space to terminological distinctions and definitions. Many past comicologists have fallen victim to this understandable and most common of methodological errors: they start by devising their own definitions of terms such as humor, wit, and laughter and proceed to base their speculations on these preconceived notions, frozen into axiomatic formulas, which they then foist on their empirical evidence.[18] Second, I shall try to keep in mind that "we cannot talk about what *is* funny, but rather what people find funny."[19] Clearly, the real problem for critics seems to be the frustratingly elusive element inherent in comicality: namely, that the comic is always subjective and highly dependent on personal taste. Critics concur only in the obvious, characterizing the comic as "some sort of subjectively realized contrast."[20] And third, I shall keep reminding myself that whenever we inquire about what is comic in music, we must sharpen our critical awareness and for each given context consider our norms and expectations anew; we must reconcile ourselves to the fact that musical humor—at least most of the time—turns out to be more subtle and harder to detect than other kinds of humor. In fact, we are apt to encounter a type of humor in music that does not strike us funny at all in the conventional sense, but possesses a capricious, mercurial, or whimsical quality that will be perceived only under certain circumstances and by certain individuals as humorous. In such cases, the effect can be humorous even if it does not elicit actual laughter.

Given the infinite variety of comic possibilities, I can identify, discuss, and illustrate only some salient types of specifically musical humor. That in the course of this desultory process I shall have to gloss over or leave unexplored many fascinating types and details needs no apology. Probing the nature and mechanics of the phenomenon itself, I shall focus on three leading questions: (1) Why is it that certain passages or, sometimes, even longer stretches of music strike us

as funny, amusing, droll, or comical: in other words, as humorous? (2) What exactly is it that we find humorous in these instances? (3) How are these musical instances constructed so that they bring about a comic or humorous effect?

Huizinga's brilliant interpretation of the age-old cliché that "the essential nature of all musical activity is play"[21] alerts us to how important it is to realize at the outset that playful, light-hearted, joyous music—like so much of, say, Haydn, Mozart, Weber, or Mendelssohn—is usually just that, and not necessarily humorous. To be sure, it may make us understand better why we perceive certain pieces or passages of music as "happy," if we regard specific features in such music like the tone and register of the instruments employed, how their roles are balanced in relation to one another, and the musical intervals used. "These features somehow remind us of the way we feel when we feel happy, they make us imagine feeling happy, or indeed they may arouse actual emotions of happiness. But 'the way we feel when we feel happy' is not readily described and it is difficult to analyse in general terms just what features of music regularly correspond to that feeling."[22]

What makes music "happy" may not be easy to articulate. But to account for what constitutes humorous music proves to be even more of a challenge. A few generic distinctions may be helpful at this point. It is customary to think of music broadly in two basic categories: absolute music, also called abstract music, which is nonreferential since it possesses no extramusical connotations, *and* texted or vocal music, which is referential since its overall effect depends on the extramusical connotations of its text. But there is also a third, hybrid category: namely, program music, which is neither just absolute music nor full-fledged texted music and which becomes particularly relevant when we consider humor in music. It is a type of purely instrumental music inspired by, or based on, "a nonmusical idea, which is usually indicated in the title and sometimes described in explanatory remarks or a preface."[23] Where do we locate in our scheme program music such as Liszt's *Faust* Symphony, Berlioz's *Harold en Italie,* Dukas's *L'Apprenti sorcier,* Richard Strauss's *Till Eulenspiegel,* or Ravel's *La Valse?* Since both texted and program music possess semantic connotations and absolute music is essentially asemantic because nonreferential, it might be appropriate to distinguish between semantic and asemantic music.[24] It is in semantic music, of course, that we find the most obvious instances of musical humor: in opera, singspiel, oratorios, cantatas, lieder, and operettas, as well as in titled instrumental music such as tone poems and even in film music. When we come to asemantic music— purely instrumental music for individual instruments, chamber ensemble, or symphonic orchestra—the hermeneutic challenge becomes significantly more complex and intriguing. For this reason, although the problems concerning the nature of the comic in texted music and program music are by no means uninteresting, I shall focus primarily on the phenomenon of asemantic, or autonomous, musical humor.

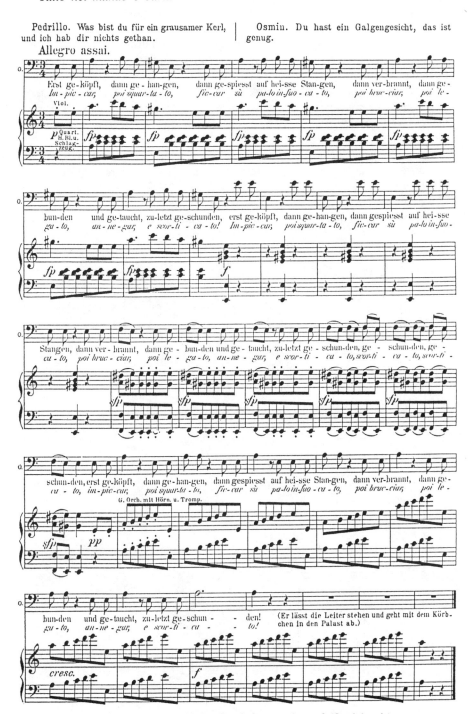

Figure 7. Mozart, *Die Entführung aus dem Serail,* from act 1, no. 3 (Osmin's aria)

What are some of the characteristic preconditions that determine the nature of the comic experience in the diverse manifestations of musical humor, to some extent in both asemantic and semantic music? First of all, the comic effect must be intended, consciously devised by the composer to elicit a specifically comic reaction from the listener. Take, for example, Mozart's wonderful buffo character Osmin in *Die Entführung aus dem Serail* (fig. 7). Whenever he is on stage, no matter how threateningly he may rave about his awful instruments of torture and plot revenge, his musical presence exudes nothing but sheer comic relief. Mozart exaggerates Osmin's character traits so delightfully that we never take him for the avenging menace he is supposed to be—but isn't, of course, due largely to Mozart's music.[25]

Contextual incongruity or contrast, whether in the form of an unpredictable occurrence or a sudden deviation from the expected norm, is a common element

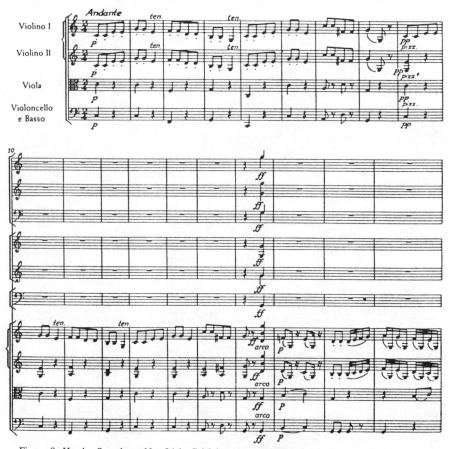

Figure 8. Haydn, Symphony No. 94 in G Major (movement 2: mm. 1–19)

of musical humor. "Psychologists tell us that our sense of the comic is aroused by unexpected, incongruous happenings; by unusual and sudden interruptions of the natural or customary order of things. The resulting shock to our sense of what might naturally have been expected, if not too severe, causes us to smile or to give more boisterous evidence of our amusement."[26] The beginning of the "Andante" movement of Hayden's well-known Symphony No. 94 in G Major (fig. 8), composed with the narcoleptic London audience in mind and dubbed "Surprise" for good reason, still provides the most transparent illustration and hardly requires further commentary.[27]

Haydn's oeuvre in particular is an inexhaustible resource for autonomous musical humor of this sort, including the more sustained type.

Let us now turn from the rather obvious example, based simply on a contrast in musical dynamics, to a more esoteric and subtle case of musical wit, the rondo-finale movement marked "Presto" of Haydn's String Quartet No. 30 in E Flat Major op. 33/2 (fig. 9), which earned this work the nickname "The Joke." Though the real jest comes only in the coda section, we can best appreciate the humorous ingredients by listening to the entire movement, all of which lasts barely over two minutes. If we then focus on the coda itself and observe closely how Haydn constructs this last sequence of musical events, we can easily discern the underlying pattern of contextual incongruities that produces a sustained comic effect by purely musical means. After the last episode section of the rondo, the trifling main theme recurs once more, leading us to expect that this final repetition will conclude the movement. But no! All of a sudden, out of nowhere, after a pregnant pause, two totally unexpected, pathetic adagio snippets appear, as if things were grinding to a halt, however implausibly. Is the piece finally over? No, we are in for yet another surprise. After a two-bar pause, the main theme reappears, except that this time it is broken down into four two-bar clauses, with two-bar pauses in between clauses. And just when we finally decide that this must be the end, the first two-bar fragment of the theme sounds again and the movement ends, suspended in midair. Or is it going to start all over again?[28] No question, this is sophisticated asemantic musical wit, the comic Haydn at his best. Though utilizing essentially the same basic pattern, the Cage example described earlier seems crude and simplistic in comparison.

The degree to which the comic incongruity is perceived depends heavily, of course, on the degree of musical competence the listener brings to the experience: familiarity with musical periods, styles, conventions, genres, and forms will facilitate recognition of those instances in which composers, for whatever reason, deviate from the norm. If, for example, the listener of Cage's *CREDO IN US* is not familiar with Dvořák's *New World* Symphony, most if not all of what Cage intended with his composition will prove elusive. Nevertheless, the technique itself of inducing a comic effect in music, always adjusted to the respective individual context, has remained standard practice until today. As we have seen, it is essentially a basic pattern of tension-relaxation that may be sketched

Figure 9. Haydn, String Quartet No. 30 in E Flat Major, op. 33/2 (movement 4: mm. 97–172)

out as follows. It usually starts with the listener's suddenly heightened expectation of the unexpected, actually with the expectation (or secret hope) that the unexpected will turn out to be something expected after all. But this expectation is thwarted by the fact that what follows is indeed something unexpected. In other words, the original expectation of the unexpected is fulfilled all the more effectively, since it was not expected as such. As a result, the initially heightened awareness, after a momentary sensation of surprise or mild shock, dissolves into physical confirmation of relief which may signify pleasure, perplexity, or indignation, usually in the form of a smile or laughter.

It seems quite a jump from a Haydn string quartet of 1781 to Béla Bartók's Divertimento for String Orchestra (fig. 10), composed in 1939. But the Bartók work is thoroughly classical in its comic spirit, very much a musical "diversion" in the 18th-century sense of the rich connotations of the Italian verb *divertire* that Da Ponte was so fond of employing in his libretti for *Don Giovanni, Figaro,* and *Così fan tutte.* Lo and behold, Bartók's Finale is also in rondo form and, toward the end of the movement, the turbulent flow of a "vivacissimo" section is unexpectedly arrested by a caustically humorous episode ("Grazioso, scherzando, poco rubato") which draws on the contextual incongruity technique for parodistic purposes: "It is signalised here by the introduction of a schmaltzy pseudo-Viennese polka, quite slow, clearly related to the main theme, with the violins playing pizzicato, the cellos and basses plucking their polka accompaniment, and the violas commenting with a couple of wry glissandi."[29]

I invoke yet another, even more typical, Bartók work in this connection, especially since it also features strategies of autonomous musical humor that I can mention here only in passing, such as the exploitation of the potential incongruity in certain harmonic and rhythmic designs and instrumental and orchestral colors. The infamous passage occurs in the fourth movement of the Concerto for Orchestra (1943), entitled "Intermezzo interrotto" (fig. 11). While composing the concerto in New York, Bartók heard a broadcast of Shostakovich's then brand-new Seventh (*Leningrad*) Symphony. He was so appalled by the insipid triviality of the theme representing the Nazi invaders—so unworthy of Shostakovich's

Figure 10. Bartók, Divertimento for String Orchestra (movement 4: mm. 449–539)

stature as a composer—that he decided to incorporate a mini-travesty of it in his own work in progress, possibly without equal as a vitriolic and irreverent instance of sophisticated musical wit. This is not humor that is funny; the effect, verging on the burlesque, is rather shocking. Besides juxtaposing blatantly antithetical moods, Bartók achieves his parodistic intent chiefly through brilliantly orchestrated incongruities in instrumental sound and imitative timbre or tone color: "Howls of laughter from the woodwind, rude noises from the lower brass, and then a viciously swirling circus background throw the violins' attempt to make the theme respectable into a contemptuous light; it does not sound distinguished even when put upside down—indeed it sounds even more ludicrous."[30]

Even when the interruption is over and the earlier nostalgic, serene mood returns, Bartók's disturbing episode lingers on in our consciousness and recalls fictitious twelve-tone composer Adrian Leverkühn's memorable comment, prompted by his own verbal Wagner parody, in Thomas Mann's *Doktor Faustus* (published in 1947 but written contemporaneously with the concerto, also in American exile):

Und ich Verworfener muß lachen, namentlich bei den grunzenden Stütztönen des Bombardons—Wum, wum, wum—Pang!—ich habe vielleicht zugleich Tränen in den Augen, aber der Lachreiz ist übermächtig—ich . . . bin von diesem übertriebenen Sinn für das Komische [bei Wagner] in die Theologie geflohen . . . um dann eine Menge entsetzlicher Komik in ihr zu finden. Warum müssen fast alle Dinge mir als

Figure 11. Bartók, Concerto for Orchestra (movement 4: mm. 61–136)

ihre eigene Parodie erscheinen? Warum muß es mir vorkommen, als ob fast alle, nein, alle Mittel und Konvenienzen der Kunst *heute nur noch zur Parodie taugten?*[31]

(And I, abandoned wretch, I have to laugh, particularly in the grunting supporting notes of the bombardone, Bum, bum, bum, bang! I may have tears in my eyes at the same time, but the desire to laugh is irresistible . . . I fled from this exaggerated sense of the comic [in Wagner] into theology . . . only to find there too a perfect legion of ludicrous absurdities. Why does almost everything seem to me like its own parody? Why must I think that almost all, no, all the methods and conventions of art today *are good for parody only?*[32])

Musical quotation— that is, composers quoting from other composers in their own compositions, whether in the original form or strategically distorted—has also been a common source of humor in music. A celebrated example of this musical version of intertextuality is Mozart's quotation of his own Figaro's famous aria "Non più andrai farfallone amoroso," along with two other operatic hits of the day, in the supper scene of *Don Giovanni.* The Shostakovich episode in Bartók's concerto is only one of many instances of the type of subtle musical humor that may also be regarded as the composer's private joke, shared only by the initiated few who are familiar with the context.

But a private joke can also be innocent and accessible, just fun for fun's sake, as in Jacques Ibert's delightful divertissement of 1930, which employs compositional devices similar to Bartók's for comic effect, though not without a satirical sting: acoustic mimesis of nonmusical sound like a horse laugh and the absurdly

Figure 12. From Debussy, "Golliwog's Cake-Walk"

incongruous quotation of Mendelssohn's hackneyed ''Wedding March,'' which suddenly turns into a grotesquely distorted military march. At the other extreme, a private musical joke can be even more esoteric than Bartók's, as in the case of the parodistic Wagner reference buried in Debussy's famous piano piece ''Golliwog's Cake-Walk'' from the *Children's Corner* collection (fig. 12). It is an ingenious satirical hint of the *Tristan* chord (the performance instruction reads: ''avec une grande émotion''), inconspicuously embedded in the compositional texture.[33]

That in the latter part of this essay I have been talking more about musical parody, and have used the designation ''humor'' less frequently, is no coincidence.

Instances of parody are simply more common and more accessible in music (especially, if one is in the know!) than those of pure humor (whatever that may be). In fact, humor in music seems virtually inconceivable without some element of parody or self-parody. Both humor and parody—along with satire, irony, and caricature as well as the burlesque and the grotesque—are subspecies of the comic, of course. But in music the notion of parody seems to be more encompassing; for optimal effect, it usually draws on many or all of the basic ingredients simultaneously. This is the reason, I assume, why we look in vain for distinct treatments of humor in music, even in the relevant musical literature. The authoritative *New Grove Dictionary of Music and Musicians,* for example, has no separate entry for humor in music, which means—for all practical purposes— that the notion does not exist. Instead, the entire spectrum of the comic in music is covered—with memorable British brevity—under the heading "Parody" in a double entry of barely three pages that distinguishes between a narrow and a broader meaning of the term. In the narrower sense, parody is "a technique of composition, primarily associated with the 16th century, involving the use of pre-existent material."[34] So far so good. But the *New Grove*'s broader definition of parody is too much of a catchall; its broadness renders it ultimately useless for meaningful discrimination:

> A composition generally of humorous or satirical intent in which turns of phrase or other features characteristic of another composer or type of composition are employed and made to appear ridiculous, especially through their application to ludicrously inappropriate subjects. Parody, in the non-technical sense of the word, has been a frequent source of humor in music, often aimed at the correction of stylistic idiosyncrasies or exaggeration. Some composers have even been prepared to parody their own work.[35]

I started out by claiming that there was no such thing as musical humor. That was a rhetorical straw man, of course, a contextual incongruity only to be knocked down later—with some relief, I trust. I only hope that my attempt at focusing

Figure 13. Mozart, *Ein musikalischer Spaß,* K. 522 (movement 4: mm. 450–58)

on the nature and mechanics of autonomous musical humor as a distinctive, not always expressly parodistic manifestation of the comic has given more of a sense of humor in music than mere generalizations can suggest. I shall conclude with a reminder of what I regard as the ultimate knockdown in music and what by itself could be the subject of another essay: the outrageously dissonant and therefore hilariously funny final cadence from Mozart's *Ein musikalischer Spaß* ("A Musical Joke"), K. 522, the most often invoked but perhaps least well-known compendium of sophisticated musical humor (fig. 13).[36]

Notes

1 The finest recent critical treatment of this topic is Paul Barolsky's *Infinite Jest: Wit and Humor in Italian Renaissance Art* (Columbia, Mo., 1978). According to Barolsky, "from the art of antiquity to the satire of Dada, surrealism, and more recently, pop art, there is an extensive history of humor and wit in Western art." But he also confirms the "curious fact that while scores of books have been written about the history of criticism of humorous or comic literature, considerably less attention has been paid to wit and humor in art" (p. 1). For the handful of relevant titles, see Barolsky's bibliography, pp. 217–22.

2 The literature exploring the phenomenon of comicality is vast and cuts across disciplinary boundaries. Traditionally, it seems, theorists of the comic—from Aristotle through Kant, Flögel, Jean Paul, Meredith, Theodor Lipps, Bergson, Freud, and Johannes Volkelt to Heinrich Lützeler, Elder Olson, Wolfgang Preisendanz, and Norman N. Holland, to mention only a prominent several— either omit consideration of the realm of music altogether or register serious doubts concerning the plausibility of musical comicality, broadly defined. For a characteristic sampling of general disregard as well as negative opinions, see Zofia Lissa, "Über das Komische in der Musik," in her *Aufsätze zur Musikästhetik: Eine Auswahl* (Berlin, 1969), pp. 93–137. A rare exception is Werner R. Schweizer, who in his comprehensive psychological study *Der Witz* (Bern, 1964) devotes a separate section to "Der musikalische Witz," pp. 87–99. For initial orientation on comic theory, see Paul Lauter, ed., *Theories of Comedy* (New York, 1964); E. H. Mikhail, *Comedy and Tragedy: A Bibliography of Critical Studies* (Troy, N.Y., 1972); Reinhold Grimm and Klaus L. Berghahn, ed., *Wesen und Formen des Komischen im Drama* (Darmstadt, 1975); Wolfgang Preisendanz and Rainer Warning, ed., *Das Komische* (Munich, 1976); and Reinhold Grimm, "Kapriolen des Komischen: Zur Rezeptionsgeschichte seiner Theorie seit Hegel, Marx und Vischer," in Reinhold Grimm and Walter Hinck, *Zwischen Satire und Utopie: Zur Komiktheorie und zur Geschichte der europäischen Komödie* (Frankfurt/Main, 1982), pp. 20–125.

3 Specific treatments by musicologists and musicians of the diverse aspects of musical comicality have been few indeed. The following is a representative selection: K. Stein, "Versuch über das Komische in der Musik," *Caecilia* 10 (1833): 221–67; Robert Schumann, "On the Comic Spirit in Music" (1835), in *On Music and Musicians: Robert Schumann*, ed. Konrad Wolff (New York, 1946), pp. 57–59; Paul Dukas, "Comedy in Music" (1894), in *Composers on Music: An Anthology of Composers' Writings*, ed. Sam Morgenstern (London, 1956), pp. 344–47; Karl Storck, *Musik und Musiker in Karikatur und Satire* (Oldenburg, 1913); Anton Penkert, "Die musikalische Forschung von Witz und Humor," in *Kongreß für Ästhetik und allgemeine Kunstwissenschaft, 1913* (Stuttgart, 1914), pp. 482–89; Richard Hohenemser, "Über Komik und Humor in der Musik," *Jahrbuch Peters* (1917): 65–83; Henry F. Gilbert, "Humor in Music," *Musical Quarterly* 12 (1926): 40–55; Theodor Veidl, *Der musikalische Humor bei Beethoven* (Leipzig, 1929); Wolfgang Steinecke, *Die Parodie in der Musik* (Wolfenbüttel, 1934); Hans H. Eggebrecht, "Der Begriff des Komischen in der Musikästhetik des 18. Jahrhunderts," *Die Musikforschung* 4 (1951): 144–52;

Norman Cazden, "Humor in the Music of Stravinsky and Prokofiev," *Science and Society* 18 (1954): 52–74; Ferruccio Busoni, "Beethoven and Musical Humor," in his *The Essence of Music and Other Papers,* trans. Rosamond Ley (New York, 1957), pp. 134–37; John Kucaba, "Beethoven as Buffoon," *Musical Review* 41 (1980): 103–20; and Hubert Daschner, *Humor in der Musik* (Wiesbaden, 1986).

4 The *New Grove Dictionary of Music and Musicians* (London, 1980) 16:249 lists this duet under Rossini's works "of uncertain authenticity."

5 Marie von Ebner-Eschenbach must have had something like this duet in mind when she quipped: "Die Katzen halten keinen für eloquent, der nicht miauen kann." ("Cats consider no one eloquent who cannot meow."). Quoted in Heinrich Lützeler, *Über den Humor* (Zürich, 1966) p. 13.

6 Gioacchino Rossini, *L'Italiana in Algeri,* libretto by Angelo Anelli (New York, 1966), p. 11.

7 Quoted in Wim Tigges, ed., *Explorations in the Field of Nonsense* (Amsterdam, 1987), p. 6.

8 John Cage, *CREDO IN US* (score) (New York, 1962) p. 1.

9 Ludwig van Beethoven, Symphony No. 5 in C Minor, ed. Elliot Forbes (New York, 1971), pp. 115–16.

10 See William S. Newman, "The Beethoven Mystique in Romantic Art, Literature, and Music," *Musical Quarterly* 69 (1983): 354–87.

11 For detailed documentation, cf. Kucaba, "Beethoven as Buffoon."

12 WoO 162, in *L. van Beethovens Werke: Vollständige kritisch durchgesehene überall berechtigte Ausgabe* (Leipzig, 1862–65), xxiii/256/2.

13 For the handful of recent dissertations, see Linda R. Lowry, "Humor in Instrumental Music: A Discussion of Musical Affect, Psychological Concepts of Humor and Identification of Musical Humor" (Ph.D. diss., Ohio State University, 1974); David Weintraub, "Humor in Song" (Ph.D. diss., Columbia University, 1974); Charles E. Troy, *The Comic Intermezzo: A Study in the History of Eighteenth-Century Italian Opera* (Ann Arbor: UMI, 1979); Steven E. Paul, "Wit, Comedy, and Humour in the Instrumental Music of Franz Joseph Haydn" (Ph.D. diss., Cambridge University, 1980); Günter Lafenthaler, "Gedanken zum Begriff musikalischer Komik in den sinfonischen Dichtungen von Richard Strauss" (Ph.D. diss., University of Vienna, 1980); and Cassandra I. Carr, *Wit and Humor as Dramatic Force in the Beethoven Piano Sonatas* (Ann Arbor: UMI, 1985). For further titles, see n. 3 above.

14 Listed in the *New Grove Dictionary* 11:27.

15 Lissa, *Aufsätze,* pp. 93ff.

16 Ibid., p. 93.

17 Samuel Johnson, *The Rambler,* no. 125. Quoted in Lauter, ed., *Theories of Comedy,* p. 254.

18 For a circumspect and informative critical discussion of some influential definitions of the comic, see chapter 1 in Bruce Duncan, "Dark Comedy in Eighteenth-Century Germany: Lessing and Lenz" (Ph.D. diss., Cornell University, 1969).

19 Ibid., p. 5.

20 Ibid., p. 4.

21 Johan Huizinga, *Homo ludens: A Study of the Play-Element in Culture* (Boston, 1955), p. 162.

22 Anne Sheppard, *Aesthetics: An Introduction to the Philosophy of Art* (Oxford, 1988), p. 36. Curiously enough, in spite of the fact that since Aristotle the tragic has been considered the other side of the comic, we virtually never speak of "tragic" music. True, there is Brahm's *Tragic Overture.* However, what is really tragic about this piece of orchestral music other than the vague associations prompted by its title?

23 *Harvard Concise Dictionary of Music,* comp. Don M. Randel (Cambridge, 1978), p. 402.

24 Lissa, *Aufsätze,* pp. 108–14.

25 Mozart, *Die Entführung aus dem Serail* (piano score) (Leipzig, n.d.), p. 29.

26 Gilbert, "Humor in Music," p. 41.

27 Quoted in Daschner, *Humor in der Musik,* p. 147.

28 Haydn, String Quartet No. 30 in E Flat Major, op. 33/2, Edition Eulenburg miniature score, pp. 17–18.

29 John McCabe, *Bartók's Orchestral Music* (London, 1974), p. 56. The parodistic allusion to Johann Strauss's famous "Pizzicato Polka" is unmistakable.

30 Ibid., p. 60.

31 Thomas Mann, *Doktor Faustus* (Stockholm, 1947), pp. 208–9.

32 Thomas Mann, *Doctor Faustus* (New York, 1948), pp. 133–34.
33 Claude Debussy, "Golliwog's Cake-Walk" (London, 1969), pp. 3–5.
34 *New Grove Dictionary* 14:238.
35 Ibid., p. 239.
36 W. A. Mozart, *Ein musikalischer Spaß*, K. 522, in *W. A. Mozart: Neue Ausgabe sämtlicher Werke* (Kassel, 1955.), Series 7, Werkgruppe 18, pp. 253–54. See also Irving Godt, "Mozart's Real Joke," *College Music Symposium* 26 (1986): 27–41.